Women, Disability and Identity

Women, Disability and Identity

Editors

Asha Hans
Annie Patri

Sage Publications
New Delhi **Thousand Oaks** London

First published in 2003 by

Sage Publications India Pvt Ltd
B-42 Panchsheel Enclave
New Delhi 110 017

Sage Publications Inc
2455 Teller Road
Thousand Oaks, California 91320

Sage Publications Ltd
6 Bonhill Street
London EC2A 4PU

Published by Tejeshwar Singh for Sage Publications India Pvt Ltd, typeset by Instill Technologies, Kolkata, in New Baskerville and Futura and printed at Chaman Enterprises, New Delhi.

Library of Congress Cataloging-in-Publication Data

Women, Disability and Identity/editors, Asha Hans, Annie Patri.
 p. cm.
 Includes bibliographical references and index.
 1. Women with disabilities—Social conditions. 2. Women with disabilities—Cross-cultural studies. 3. Discrimination against people with disabilities. 4. Sex discrimination against women. I. Hans, Asha. II. Patri, Annie, 1974–

HV1569.3.W65 W65 362.4'082—dc21 2002 2002068342

ISBN: 0-7619-9700-8 (US-Hb) 81-7829-176-2 (India-Hb)
 0-7619-9701-6 (US-Pb) 81-7829-177-0 (India-Pb)

Sage Production Team: Amarjyoti Dutta, Rajib Chatterjee, Neeru Handa and Santosh Rawat

I live in a cocoon of social making
Peeping out of the world from behind a curtain.

I search for orbits
Outside those traversed.

I find my sisters in solidarity,
Those with less possession
Of vision, speech or hearing.

It's time we moved together,
To locate
Spaces in the public sphere
And in the private worlds of men and women.

Pursue till we locate them
If we go together we know we can
Make this cradle of humanity ours.

—Asha Hans

Contents

Part III Locating Women's Agencies in Differing Spheres and Systems

Part IV Facilitating Strategies and Entitlements

Preface

We began working on this book in 1999, after a conference that was organized by the Shanta Memorial Rehabilitation Centre (SMRC) in Bhubaneswar.* The conference was an attempt to focus on the subject of gender disparity and our understanding of related issues within the field of disability. The book emerged out of the several questions raised and the visions conceived by the participants at the meeting. The groups at the conference were disabled men and women, policy makers, implementing officials and grass-roots workers. They were people with disabilities, belonging to different races, colour and gender, and came from both the developed and developing countries.

After a series of debates and discussions, their collective thinking was that both disability and feminist studies and research had left out the issues of gender related to disability. It was the vision of Ashok Hans, the executive president of SMRC, who encouraged us to analyse some of the issues raised at the conference and produce it in book form. It was not an easy task, but we took up the challenge created by

*SMRC is a voluntary organization of disabled people working mostly in the area of spinal cord injury. Based in Bhubaneswar, the centre functions under the charismatic leadership of Ashok Hans, one of the pioneers of the disability movement in India and a person known globally for his work with spinal-injured people in poor rural communities. On 13 March 1999, SMRC organized a conference on women with disabilities. Among the issues highlighted at the conference were the total disregard of women with disabilities by the feminist movements and the absence of writings on the subject by the disabled in developing countries.

the consciousness raised at the meeting. We attempted to collect a series of articles which would identify and focus on issues of women with disabilities.

We the editors and contributors have tried to use our visions and analytical skills to the best of our capabilities. It took us nearly two years to give a final shape to this volume and thus share our knowledge, experience and understanding with others. As editors, we recognize that the ownership of this knowledge belongs to the totality of our writers. We acknowledge with gratitude the writings of our collaborators, which have contributed to our own political and analytical evolution in this particular field. In a world bound by the parameters of masculinity and politics of exclusion, it has been both a challenge to our creativity and an educational experience.

Bhubaneswar Asha Hans
 Annie Patri

Introduction

Asha Hans

Activists and scholars have acknowledged the expanding of borders of feminist research to include women with class, ethnic, national and other diversities. This widening sphere means that awareness about women's problems in many sectors including the home, the workplace and other domains are slowly and steadily unveiled before us. In spite of the increasing range of issues that are being recognized as important, we note that a space for disabled women has yet to be found in serious feminist research (Hillyer, 1993). We discovered that as a social group disabled women have hardly found a place in any existing theory. This induced us to conclude that we need a space demarcated for women with disabilities in present-day research.

Keeping this perception in view, the book has been divided into four sections. The first, Images and Values, attempts to locate disabled women's place in society. In the first part of this section we look at this place, in terms of values placed on perfection of women's bodies in the real world of medicine, in this case genetic research and usage. In the second part of the section, we review and interpret images, which results in stereotyping of roles. In the second section, Mirroring a Reality, we collated women's own voices on where women locate themselves in their environment. In the third, Locating Women's Agencies in Differing Spheres and Systems, we brought together writings which would highlight, specifically in the sector of disability, women's status, and enterprise to change. In the last section, Facilitating Strategies and Entitlements,

we included writings from different parts of the globe, which contribute to our understanding of women's efforts and mechanisms used to positively challenge existing discriminations.

In our search for contributors to the volume, we discovered that although disability studies has found a common cause with a number of other disciplines, including anthropology, sociology, and cultural studies, the intersection between the disabled in the feminist context of the developed and developing world has yet to be charted. This is a marked omission when one considers that it is an important element that joins us across the globe, as all of us are potential members of this group (disabled) and could belong to it at some point or another. In our effort to understand this dimension of feminist research, we found that while research on women with disabilities from the developed world was available in some measure, this field had been totally neglected in the developing countries.

A volume specifically designated to issues related to women's disabilities, we soon found after we started the book, runs several risks. The first problem is of inclusion and exclusion, challenging the divide between academic and non-academic work and perceptions. We were faced with a question: Should we include only academic analysis or go beyond that and include the voices of the disabled? The issue that confronted us was: Do the non-disabled understand the problems of the disabled? Do they have the right to speak for them? At the conference it had emerged as a major concern. The disabled felt that they could put forth their problems in a better way themselves, and though they did not mind support they would have to fight their battles themselves. We therefore decided that we would balance the academic work and voices in our effort. This could have been done by interviewing women with disabilities and analysing their views and perceptions. As it was an edited book we decided that we would let the women speak for themselves. We were hesitant to speak on behalf of the disabled women. We understood that while we could discuss and debate upon their work, and in the process enrich the subject, we recognized that the speaking out by the disabled would provide authenticity to the writings. We found that it had been earlier tried out very effectively (Browne et al., 1985; Matthews, 1983; Rousso et al., 1988; Zola, 1982). The experiences, histories, and self-reflections of these women therefore remain central to the essays collected in the volume.

We do recognize that experience alone is not enlightening, though it is significant to our understanding; it requires both an interpretation and a conceptualization as well. It is with this in mind that narratives have been supported by portrayals, abstractions, empirical work and activism. There has therefore been a deliberate focus on questions of feminist terrain and organizational practices of feminist communities for whom disability is at their centre of praxis and knowledge. We have tried to map the struggles, autonomies and determinations of women with disabilities in all these forms.

Second, connecting all types of disabilities is difficult, as different disabled have different health concerns, but we believe that similar social and political concerns override different disabilities. The book therefore tries to span a number of disabilities without distinction.

Third, by not limiting ourselves to one group of disability or a region we have opened ourselves to criticism of trying to universalize. We recognize this concern but believe that bringing together different policies and concerns is important in providing a holistic approach to a subject. Bringing together can universalize but it also accentuates variations. Hekman's contention that changes in feminism and a paradigm shift are occurring within the orbit of feminist thought, and that in this we are shifting from our emphasis on differences to the exploration of differences (Hekman, 1999: 27), is an idea we believe we are trying to actualize.

A macro approach towards the subject was thus demarcated for this book. We recognized that this gendered world of the disabled needs to be explored, and we trust that this collection of essays will fill the gap in the evolving literature of global disability and feminist studies and research.

Definitions and Titles

'Disability', as the editors understand the term in the context of this volume, is not confined to congenital conditions but can be the result of accident, disease, and also the inevitable natural process of aging. In this sense, disability is a comprehensive identity category that cuts across all others and draws its membership from several other identity groups. Therefore, recognizing, and in its willingness

to fill this space, this volume will go beyond the construction of disability as only a 'health' and 'pathology' issue.

We noted that the specificity of disabled women's status has been linked to the general group of disabled, thus meeting the legitimacy of their claims to the experiences of different disabilities. For instance, those with hearing problems have commonality of issues, which are not gendered. We realized that within this setting, the placing of women within the general understanding of a disability sector, whether visual, locomotor or any other, is fragmented, as far as they were seen with gendered lenses. The disability-alone categorization was therefore insufficient to understand their problems. This is proved by the fact that disabled women are a nearly invisible element, not only in the general disability movement but more so in the women's movement. Through our experiences of working with the disability sector we have realized that women within the disability movement, at least in the initial phase, are included because it is politically correct to include women than for any other reason.

While as women they face similar problems, as disabled women they experience problems different from the non-disabled. Therefore, their problems need to be addressed by both the feminist and disability movements. Despite this, we noticed that within the women's movement at large they remained highly invisible. In the context of women with disabilities, the volume therefore attempts to provide a comparative, relational-based conception of feminism, which has been excluded from the general majority of a global feminist literature and movement. We believe these women are overlooked, disregarded and neglected as a group within majoritarian feminist strategies.

This study, therefore, does not confine itself only to women with physical disabilities, or with other specific disabilities. It does not exclude disabled women of colour or 'whiteness' or women of the minority world of indigenous peoples. It brings specific local experiences, identities, histories and organizations, which enable us to understand the existing forces of control, hegemonization, subordination and resistance. We believe that among the people of the world where women occupy a secondary or minority position, this is further entrenched among the disabled themselves, where women are secluded in another minority status.

We are cognizant of the fact that 'disability' undoubtedly gives people a minority status. For women with disabilities, it is not only the already highlighted case of a neglected minority of women and disabled in a majoritarian world of men and of the non-disabled. One of the reasons for this location, we believe, is the construction of their identities through images and values. To understand this positioning, we have to perceive the objective material reality of their location within a framework of social totality. To achieve this end, we realized that we have to begin at the beginning and move forward slowly by stripping away the images to get at the reality. Our journey would start from the gene and the manipulation of the biological agency to existing images that defy reality.

Values, Myths and Images

Concerns about genetic determinism in studies about natural selection have been numerous, as evolutionary biology has set many paths to study the phenomenon. Feminism also stepped into this field a long time ago and excellent material is available (Arditti et al., 1984; Degener, 1990; Gupta, 2000; Hynes, 1990; Mies, 1987). Ernst Mayr, a biological evolutionary theorist, classified 'evolutionary change' into two phases. The first is where the production of genetic variation takes place; for instance, through mutation. The second phase includes the sorting and selection of successful individual variants (Mayr, 1976: 3).[1] In feminist research both are important for us. Therefore, what is lacking and would be important at this stage is to include, in any debate we pursue on genetic determination, is the disability factor. Michelle's article in this volume fulfils this aim.

Michelle debates about the ideology of perfection that utilizes genetic technology and further deliberates on the profound impact this has had on women with and without disabilities. As feminists, activists and scholars we detect not only a sense of alienation and marginalization, but also dislocation that always accompanies such selective procedures. Women will no longer be seen as mothers of children who belong to them, but as mothers of society with responsibility that the child must be 'perfect'. The beginning of social control starts with medical research.

In the discussions of genetics, there is a sense that human disease can be treated and cured, and that the notion of human perfection is more widely held as possible than at any other time in history. The search for the perfect body is possible through genetic screening and usage. One is forced to go back to Herbert Spencer and realize how some things remain the same though magnitudes change, since his rejection of the talented but not so 'beautiful' novelist George Eliot. Justifying his stand, Spencer wrote that Nature's supreme end is the welfare of posterity and as a cultivated intelligence based on bad physique is of little use, he therefore could not marry Eliot even though she was gifted and they were in love (Paxton, 1991: 33). The search for beauty has always been part of human search. Through genetics, it is now becoming possible to produce the 'perfect' human. This search for the perfect can destroy many lives and reduce women's power and control over their bodies.

This social control is part of modernizing reproductive health techniques, as genetic screening is being introduced in many countries, thus bringing the problem out of academic discussions into our lives. What is important for this volume and the understanding of Fontaine's chapter is that she provides us with an understanding of the use of technology in social control.

While genetic screening assists in avoiding having children with disabilities, it takes away the little control women have over their bodies and the limited choices open to them regarding reproduction. As Ruth Hubbard has commented, women are expected to implement society's prejudices by 'choosing' to have the appropriate test and 'electing' to terminate if it looks as though the outcome will offend (Hubbard, 1986: 240). As disabled women, who rarely have even the 'general' rights, the establishment confers them with an 'outsider status' and differentiates them from 'normal' women by extension of the establishments, the politics of further exclusion, and by such deterministic policies that eliminate their very existence. It is the exigency of our times that forces us to incorporate in our discussions the psychic remnants of values starting before a child's birth to adulthood, which spans this world within a world. There is a growing tendency, argues a South Asian writer, towards eugenics being sanctified in the name of public health and improved quality of life (Alur, 1999: 12). The concern is therefore not only confined to the West, but is global. For this

new emerging field of stratifying gender relations, we need to initiate a serious challenge immediately. As dangerous is the attempt to improve the gene pool, its connection with eugenics brings in a racist character and produces anti-disability positioning.[2]

Though the State is very concerned with the birth of disabled children and presents it as a health problem, it is really the economies which underlie the decisions of the State. Foremost is the responsibility of the cost of meeting special needs of people with disabilities. The role of insurance companies further strengthens control over women. Michelle highlights the emergence of new power structures of the marketplace and the medical fraternity that will control the lives of disabled women. The State, medical structures and insurance companies together pose a danger to women. Goodfellow has very succinctly stated that DNA represents power (Goodfellow, 2000: 2). In a gendered context, this is very true. Michelle's chapter in this book confirms the emergence of these new power structures, which threaten women, especially women with disabilities. Insurance companies, who see the use of genetics as a way of reducing cost on extra medical care for children born with disabilities, would exert increasing pressures on women with genetic problems, and might even deny them coverage if they choose to continue to carry a child.

Michelle's seminal ideas on the role of the market and its power over women is a point from where further research can take off. The impact of genetic research and its relationship to disabled women is still at a nascent stage (Finger, 1984). We need more research on the subject to enable us to understand and assess its impact, and the genome project has provided urgency to our work. Michelle's chapter will, we are confident, provide the much needed discussion on a very significant ongoing controversy.

The perfect woman being designed from genetic technology fulfils the pursuit of cinema for perfect bodies. Whilst genes are now on the centre stage of feminist study, cinema and the use of female bodies do not necessarily need research to tell us it exists. Worldwide cinema and advertisement have used women's bodies as an income-generating strategy. Linking the two, genetics and cinema, is the identification of women's beauty, one a search for real perfection, the other of imaging. The first of these two chapters on cinema focuses on Hollywood and the second on Bollywood. Madeleine and Martin and Meenu Bhambani forcefully argue in this

volume that the imagery of 'perfect bodies' has always existed and continues to exist, and one of the reasons for this is the misuse of the most powerful visual medium in creating illusory images, which affect women with disabilities.

From a very young age, in general, gender is constructed through appearance. Beauty seems a gender-related category: 'looks are important but inconsequential for men, but they are a defining feature for women' (Tseelon, 1995: 78). Attractiveness is associated with better physical outcomes and women are more critically judged for attractiveness than men. A woman is expected to embody a 'timeless' cultural phantasy, but she is not really naturally more attractive than the man. The physically (un)attractive play the role of socially (un)attractive. While there are some exceptions, ugly or physically disadvantaged people are regarded as clearly disadvantaged (Tseelon, 1995: 79–85).

Madeleine and Martin base their findings on the general assumption that American popular culture has contributed to the worldwide devaluation of disabled people and representation of disabled women. The most common stereotype by far is the sweet and pitiable woman, but images of women exist as awe-inspiring, comical, and vengeful, which have also characterized Hollywood's disability depictions. Preoccupation with 'looks', they argue, has helped define most of the movie characterizations of women with disabilities. Though one could argue that this is also the case of representation of women per se, the writers go further and define stereotyping and discrimination of disabled women because of this representation of beauty. Cinema becomes an important medium in both stereotyping women's images in the public mind and in increasing the discrimination against the disabled. Both writers confirm that while men's disability is portrayed as acceptable, even when congenital, women's disability is treated only as transitory. Women with congenital disabilities are kept outside the scope of cinema and acceptance. Women with disability are shown without disability at the beginning of a movie, and become disabled during the narration of the story. Even in such cases acceptance is based on their having been beautiful, 'complete', and therefore acceptable at the end. In the majority of cases women with disabilities recover, an imaging so very far from reality that it makes women with congenital disabilities or disabilities which are traumatic but have no cure, such as spinal injury, unacceptable.

Hollywood's portrayals of disabled men and women, as seen in Madeleine and Martin's chapter, differ dramatically. Meenu's presentation of Third-World cinema in this context is also not very different. The disability roles in Hindi cinema changed from marginal roles to images of mothers with disabilities (usually blind). Later it shifted to women sacrificing themselves to men who become disabled. Beautiful heroines sacrifice themselves, but never do the cinematic portrayals extend to men sacrificing for women with disabilities. Later, as cinema again changed, women in supporting roles were portrayed with disabilities, and we see brothers shifting their responsibility and spending their time looking for grooms who would marry their 'disabled sisters'. As Bollywood matured and heroines began to be portrayed with disabilities, they were shown as being loved by the male protagonists of the films for reasons other than their disability. As new art films were introduced in Hindi cinema some sensitivity crept in, but the male orientation remained in place and congenital disability, as Madeline and Martin presented from Hollywood, continued to be reflected in Hindi cinema also.

From both the chapters we ascertain that the barriers in disabled women's lives fundamentally related to images affect their very being and reinforce the 'triple discriminations' (of being discriminated because they are women, are disabled, and are women with disabilities). The present imaging of women with disabilities, both in the majoritarian Hollywood cinema and the largest cinema of India known as Bollywood, produce social inequality. The construction of the images of beauty imposed differences and hierarchies culturally. These images being of unilinear value considers beauty as related only to physical aspects, and in the case of disabled women confine them as social categories who have no contribution to make to society, but always remain a burden.

An argument is given by Tseelon, in relation to gendered images, that a positive relationship between physical attractiveness and self-concept throughout the life span is reported consistently for both men and women, yet beauty appears to be gender related (Tseelon, 1995: 78). We acknowledge gender to be a societal norm and the images, which we reflect, are far from reality and require not only analyses but also deconstruction and reconstruction. This is possible if we strengthen our understandings with revelations of cognition of one's own location in societal situations, and

earlier writers such as Mead (1949) recognized the acceptance of others' acknowledgement in our social existence. The two articles on cinema in this volume confirm the argument, but go further in relating it to the field of disability.

We recognize that the process of biological selection, together with discontentment with cultural patterns, represented through images, language and values, are of significant importance in any analysis of feminist differences. Language and images produce stereotypes and feminist strategies have long been produced to challenge these images. The objections have been aimed at the use of women's bodies and, thus, presented as commodities in the consumer markets and socio-cultural environment. Giele, for instance, has argued that relevant reforms are of the sort that attempt to reorder cultural symbols, images and values to achieve better balance of 'female' and 'male' elements. The writer includes in the pattern of change a modification of language, loosening of stereotyping, departures from cultural goals and a new emphasis on alternative cultural goals associated with females (Giele, 1978: 17). Excluded from frameworks developed in a general feminist paradigm are women with differences. In this volume, we have contributed to this lacuna in our comprehensive understanding of stereotyping and role perception.

In our writings, we have been compelled to deliberate the connectivity between dialectic knowledge and representational readings of social phenomena. To mix myths and symbols with the empirical processes is to balance the concrete and the metaphysical. We, in the process, have discovered the paradoxes that frame feminine experience in both the West and the East.

Sandhya Limaye demonstrates how difficult these images are that we have of disabled women concerning their sexualities. Serious physical imperfections condemn a person to asexuality, writes Sandhya. In this section, we move from images wrongly construed to a reality. It is not that women with sensory disabilities do not face the same problems as all women do, but their problems increase, as they cannot understand why certain behaviour is expected of them. A visually affected girl's frustration can be understood when she says, 'I was informed that the vagina is located between the breasts'. This misunderstanding of their bodies leads to insecurity in relationships. Society places such women in a

specific mould where marriage is not possible and sexual abuse is considered as acceptable, normal, and so unavoidable.

Sexuality is a major issue in feminist discussions, as it has been considered taboo for a long time in the world of women. While some hurdles have been overcome, the value system concerning disabled women remains in place (Chib, 1997). A condemnation of women's sexuality remains deeply entrenched in many societies and cultures. Traditional sexual morality provided spaces where women were not only kept under control, but were also denied access to resources and a life outside the private. Disabled women continue to suffer in a number of ways due to discriminatory value systems in our society.

In this context, for instance, Lonsdale has argued in her widely read book, *Women and Disability*, that the premium attached to women looking a certain way is also manifested in the signals we receive about how we should not look (Lonsdale, 1990: 5). We would argue that it also means how we should behave. Beautiful women are 'sexy' and it is perceived that they have heightened sexualities. The possession of sexual needs by women, who are in some way not beautiful in the common sense use of the term, is conceived to be socially inadmissible. This value system impinges upon the self-image and self-esteem of some women. Society forces such women to define roles for themselves based on these images and values. This process of subjugation forges identities and restraints imposed by society. Whereas women may be born with disabilities or acquire them, society forces other disabilities on them, making it more difficult for them to escape the entrapments of physical/mental and socio-cultural inadequacies. For women who escape this, they have to challenge their multiple roles in both the family and society, as we shall see in the narrations of these young women.

Voices of Women with Disabilities

'My article', Vanda remarked, 'deals with the relationship between woman, disability and affectivity and consists of an analysis of such a delicate and controversial matter. In fact, I try to underline the psychological and human situations which arise inside a young

woman from adolescence onwards and the obstacles she has to face within and outside her family when feelings and drive become strong and pressing and most human and logical desires become strong and sometimes exasperated. I also try to say that both education and training can be very positive elements in solving a pressing problem such as that of being a woman with a disability and finding the courage to overcome a large number obstacles.' One understands Vanda's fear of putting into writing her anxieties and feelings and personal experiences. To open out to the world is not an easy task, as Vanda herself says, on a topic that is so delicate and engaging, so rich in feelings. Most of the writers in the volume would agree with Vanda's narration that the disabled woman virtually ceases to exist as a person and is excluded from being recognized as a woman in the fullest sense because she does not fit in with the model of women defined by society and dear to the collective imagination.

The narration of journeys undertaken by disabled women affect us individually and as academics and policy makers. It reminds us of individual struggles that have contributed to our reaching the heights of feminist learning and movements. It makes us realize how important these efforts are, and we have to acknowledge that without these women our achievements would have been inadequate and incommensurate with our needs. These women defied situational restraints and contested their positions to create transformations. It would appear that the changes that affect disabled women's lives both positively and adversely have been at the initiative of movements, voluntary efforts and families.

Our writings are, therefore, substantiated by the discourses, produced through contextualizing of issues by women such as Vanda who faced an enormous problem even in writing this article. When we started, we knew that the volume would lack insight and profoundity if we did not get some women like Vanda who could narrate their experiences. Narratives lend authenticity and are able to capture the uniqueness of women's lives. By documenting these experiences, we are providing a political history for future generations of activists and researchers. It is not only the concept of 'triple discrimination' but also 'gender and kinship' relations that locate this segment of feminists as well. Social changes, access to entitlements and specific processes of negotiation are clearly identified and examined by Renate, Stephanie, Vanda, and Lina. Renate's

apprehensions, not only for herself but also for her daughter, re-veal both the courage of women with genetic diseases and also take us back to the concerns raised in Fontaine's article. Faced with meeting the challenges of a disability and also being respon-sible for bringing a child into the world with the same disability is very difficult. Renate explains, 'Even genetic counselling which we sought amounted to no better statement than that the chances of the disease being transmitted to our children were 50 per cent. And yet I was longing so much for a second child. I had always wanted to have two children, but, after my stay in hospital in Ber-lin, had started to strongly suppress this wish, in fact had come to consider it to be impossible and even stupid.'

Renate's initial fears are not only medical but 'How will my hus-band react? Will we have the strength to continue together as a couple and family?' Family support for all disabled is very impor-tant. Renate met the challenges with her husband at her side.

Lina's article looks at a group of non-English-speaking back-ground (NESB) women with disabilities, a smaller minority within the minority group of disabled women faced with 'a triple dis-crimination'. A group culturally different yet with similar issues of access to resources and understandings. A group who needed to be made visible and would force us to question dominant cul-tures. Lina's group from Australia defines the different attitudes of family and society, which ranges from support to oversight to neglect to embarrassment. Lina's portrayal and, in this case, her exploration of the world of non-English-speaking disabled wo-men, make us aware of the miles we still need to tread; as I said, there are layers and layers to be peeled till we end our inquiries. One layer, which remains intact, is of rejection. We share Stepha-nie's concern for the labelling of a person with a 'physical disability' only when the disability is visible. Many are not, and Stephanie's problem of a non-visible disability creates tremendous hurdles for her. Like a trauma, Stephanie's disability overwhelmed her with its seriousness, but hidden behind a curtain of invisibility, she found that women with disabilities tended to hide theirs behind a self-imposed curtain around them, while disabled men did not. The men clearly used their disabilities to their advantage. Why this gendered difference? Women with disabilities, even those with higher education, she argues, are afraid to open up, as unlike men, women's path to a successful career is more difficult. A confessed

and visible disability would reduce chances in the job market. For women with an invisible disability, the problem lies elsewhere—in areas which are emotional, physical and attitudinal. The first can be overcome on a personal level, but the second and third need support and coalition building. Stephanie's is a courageous story of a fight against an insensitive administration, and proves that despite disability laws and national organizations disability remains a problem in many university campuses. The battle has started but the war not yet won, and the movement still needs to go forward.

The Evolution of a Movement

The evolution of movements and their agencies contribute to changes in women's lives. By including a whole section on this, we did not ignore theoretical positioning and policy implications. Feminism has made it possible to weave into a network all these dimensions. When we planned this book, we wondered how the State defines 'femininity', and if definitions should not be marginal but central to our purposes of finding a right place for disabled women. Consequently, we decided to study movements because we acknowledge that their potency creates change. The study of movements, even when institutionalized, is essential to our own and other people's understanding of the reason for transformation. Movements are acknowledged as they are based on value systems. An oft-cited view is that problems arise when these movements attempt to institutionalize the change. Any attempt to modify the existing order is perceived as a threat by the State and society. Therefore, we see that though there has been an accumulation of legislation globally, transition is slow and difficult. The women's movement, which started with so much fervour, steadily lost its momentum. What has remained is the large number of conventions which are adopted by states and disregarded at will by the same agency. One reason for the indifference of governments is based on a fear of social change which induces an economic burden.

There is also another dimension to this issue, which has been paid little attention. The legislation and services loosely labelled,

which when viewed from a global perspective, provides a 'universalism'. Universal awareness of gender justice has been brought into both the international institutional and voluntary sector levels. The steps undertaken in the Beijing Conference drew a large number of nations into this process.[3] The Beijing Plus Five Meeting at the United Nations, in which one of the editors (Asha Hans) was present, showed the breaking down of the consensus as the universal approach was condemned by many states as culturally inadmissible and unviable. Though states adopt legislation on these issue-based needs, they do not implement them for lack of either resources or socio-cultural imperatives. When states, protectors of citizens, limit themselves to state boundaries could women forge ahead to achieve their rights? We are at this stage forced to ask ourselves the important questions:

1. Is sisterhood universal?
2. If not, is a female revolution in this context still necessary?

This is a very important question in the context of women with disabilities. A movement, we perceive, is a significant agency utilized to bring about changes. Ann, Elizabeth, Salma, Cindy and Jacqueline answer the questions and define the role of movements and agencies. Movements and women themselves as agencies have been creatively utilized to reflect not only solidarity but also the urge of the community to alter and transform feminist goals.

Ann, a long-time disability activist from the United Kingdom, explores the status of women with disabilities in a world where there is no dearth of international conventions and national policies for women. The problem is that women with disabilities rarely figured in these conventions and policies until the Beijing Declaration. Ann's contribution to this volume is important as she outlines the Beijing Declaration (Platform of Action) which she considers as the core document for women with disabilities. The document sets an agenda for women's equal rights with men. It specifies women with disabilities as one of the groups facing barriers and a group with little access to information on their rights. This access to rights is specifically limited in case of the girl child born within a sex inverse ratio and with little access to her rights, including education. Ann's contention that now we have a document in place is supplemented by our argument that it is time to challenge

structures that impede its implementation and it is through the movements that its goals can be accomplished.

Salma, the next writer, is a leading activist of South Asia, and is known for her leadership of the South Asian disabled women's movement in general and visually challenged in particular. She is one of the few women activists to have broken the glass ceiling in a men's world. Salma finds herself at the top of the South Asian disability movement. Salma's portrayal of challenges and achievements compel us to agree that with determination, goals can be achieved in this neglected field by coalition building. In the article Salma explores the domain of triple discrimination from a region, where despite belonging to the category of women from developing countries, and that too being disabled, women overcome these disadvantages by uniting together. She traces the history of the inclusion of women in the disability movement in the region and the barriers faced by the group.

Salma's chapter, representing a view from the South and recommendations for change, is followed by a survey of the work of Mobility International USA, an organization of the North working for the cause of women with disabilities. Cindy Lewis, who projects MIUSA's work, bases it on the experience of the organization and develops arguments for change and strategies for development. The list prepared by MIUSA on disabled women's problems outlines the tremendous difficulties faced by these women. Among these, some may be construed as those faced by women in general and the picture is no different in a gendered world. At the same time, there are others, which are specific to women, such as marriage, abandonment due to disability, inaccessibility to shelters and rape centres, higher mortality rates, and complete invisibility and isolation, which are specific to women. In a world where women face problems vis-à-vis men, disabled women's problems are augmented due to their disability. What is highlighted in the chapter is the negligible attention paid to disabled women in development assistance. The chapter emphasizes method of coalition building of organizations working for disabled women, and how development agencies need to and could address the problems. Cindy raises a very important question which needs extensive debate: about specific development assistance to these women, or mainstreaming them. The answers have to come from disabled women

themselves. Their voices need to be sought, heard and incorporated in the planning process.

Jacqueline Huggins's chapter focuses on Trinidad and Tobago. She traces the history of the disability movement in the region and the problems faced. The women's movement forging ahead did not mean change in disabled women's lives. Opening of new education facilities and jobs for women still meant barriers with lack of transportation and lack of proper facilities at the workplace. Two dimensions which Jacqueline touches upon are isolation and abuse.

Elizabeth's chapter further adds to the efforts being made to examine abuse of women with disabilities as an increasingly recognized phenomenon. Women, we know, become disabled due to domestic violence, but Elizabeth shows that abuse is equally experienced by women in general, but is more prolonged for women with disabilities, and with more perpetrators. Elizabeth's models ensue a system where women with disabilities suffer due to categorization and failure of the community and provider to characterize abuse. Abuse in the context of disabled women is seen as different and could be unique. We included this chapter in this section because we believed that like genetics this is an issue that needs international attention by the women's movement. Unlike domestic violence, its parameters are wider and the context more threatening. Groups of women tortured and abused have no one to appeal to, and mental and physical limitations inhibit their mechanisms of protest completely.

In terms of magnitude, domestic violence continues to be the most invisible, but still the most substantial violence inflicted on women. It is essential not to underestimate the role of domestic violence and the interrelationship between power and gender. This is most significant within the marriage and household, as they affect women and household and affect their participation in public. In putting together the paper, Elizabeth has used a creative analytical framework. In her writing, she has deliberated on the interconnection between violence, sex and power in the world of disabled women. The abuse continues while the community, families and promoters of criminal justice look on, without attempting to arrest it. Disability raises questions on our value systems, social organizations and systems of governance. It provides the foundation for essential shifts.

One of the reasons for the intense disagreements, within the women of the general majority and of the minority world of disabled women, remains the role of the family as an institution. Though the role of the family has been subjected to sociological and psychological examination, it remains surrounded by controversy. (It has been attacked, defended and, therefore, resisted a constructive analysis at any time.) Has the role of the family been an issue for disabled women? After all, the family is a place which provides not only affection, but also emotional sustenance and physical care. For the disabled, the family also provides from the time of his/her birth a space, which would later be converted into societal space. At the same time domestic violence does take place mostly within the home. Though in some societies it is sacrilegious to discuss familial relationships, nonetheless, in the instance of disability, it is important that this private space be made public. Women in this space have no weapon to protect themselves, as most, unlike women without disabilities, are dependent on this space. Discriminatory social and political policies emerge from this private space. Many disabled inside this space are kept invisible by their families, to be hidden from the outside gaze, because they are ashamed of their disability. As they are usually invisible to the outside world, governments and movements find it easy to overlook, as they do not see. Discriminatory social and political policies emerge from this private space, while repressive character of family influences both psychological and economic functioning (Asch and Fine, 1988; Hanson, 1985).

Domestic violence and other forms of abuse will become visible only when the disabled women themselves speak out. One way out to create change is by sisterly solidarity, which is possible through many different enterprises. These writings confirm our belief that sisterly support is essential to our undertakings. We need to acknowledge it for it will provide women with suitable opportunities to make an entry into new worlds. At the same time it is a difficult task as in the context of women with disabilities the foundation of the movement itself is deemed incomplete because it has focused on political and ideological questionings and has never raised questions of 'triple discriminations'. Disabled women have been compelled to question this exclusion. They have started to question, as they did at the conference organized by SMRC, not only the structures of subservience, but also the neglect of their group

in those being set up to remove the varied discriminations. Though solidarity is very important, it is also time to look at the substance. Many disabled women are doing just this, questioning and forcing change.

Will these women succeed in drawing attention to their needs by challenging existing structures which inhibit their progress and sometimes even threaten their very survival? Going by Janeway's argument that women are the repository of the largest store of unused capabilities, they will surely be a resource of ideas and energy (Janeway, 1974). We believe that they can generate changes.

In a theoretical perspective, we need to ask what kind of analysis is appropriate to study this change in the context of general change. If sexual stratification were seen as class stratification (Mitchell, 1979; Rowbatham, 1973), I would argue that it applies as well in this world of disabled women, who fall at the bottom of the class pyramid. The movement has to acknowledge these women's undertakings and create an atmosphere of change, which is institutionalized. Though the women's movement recognizes that women should be knowledgeable and free to determine their lives, it is not always possible. Actual social change necessary to bring women into different spheres and structures has failed. This is more so in the case of women who form minority groups such as the disabled. They have very little power in the total structure of the women's movement. Rejection by a majoritarian world is a familiar story and far from arguing; this volume therefore projects the uniqueness of these women's ability to access what is theirs by right. The culturally and socially imposed differences disappear when women find their agencies to success.

Contingent Access to New Worlds

From movements to institutionalization, the trajectories to new worlds are flawed. Laws alone cannot change situations, but with organizational interventions, cohesion to solidarity, actions can be achieved. Related to this is the issue of access to entitlements. In the nineteenth century, when inevitable changes were brought about by the Industrial Revolution, the great drawback to female fulfilment among the middle and working class was their complete helplessness in securing means of subsistence. Many felt that

though enough opportunities were there for the taking, education, for instance, still remained a barrier. This argument compels us to see whether the situation has changed, or do some groups still reflect the pre-industrial stage situation.

The discussion in the section, Facilitating Strategies and Entitlements, suggests the relationship between existing economic exigencies and disabled women's lives. José Azoh, Catherine, Shoba, Emily and William have contributed to our understanding of agencies and their importance in the enabling of this group of women. In their writings, we experience women's occupation of new spaces, through changing values and negotiating differences in self-image, attitudes and motivations. Women undertake new activities and, in general, cope with challenges before them, both at the workplace and at home. They develop new linkages and associations with these agencies that contribute to their changed lifestyles. The strategies adopted prove that disabled women do exercise agency despite the obstructions and barriers, thus expanding their roles. Their changes, these papers indicate in different ways, are accomplished through education, training and paid employment.

José Azoh, convinced that the shift from a medical to a social model has already occurred, takes us from Elizabeth's models earlier discussed, but raises doubts of its efficacy especially in developing countries. She applies Mexico, an underdeveloped country, as a point of attestation and remarks that even when things move and situations change they still remain the same. State-initiated changes can go only a limited distance in achieving goals as long as material and mental dispositions are still persistent at the family level.

José Azoh's accentuation on knowledge as a means of control over intellectual resources, together with Shoba Raja's exploration, demonstrates women's power. Shoba, Emily and William in their chapter, 'Standing on Our Own Feet', demonstrate from another part of the developing world that the 'triple discrimination' will cease when women will have equal access to new worlds. The paper argues that access to entitlements is possible and what we need is entry to this world by larger numbers. Women's position, we understand, has to be forged by a twofold set of constituents arising from the role of gender and relations derived from society. It is necessary to understand the twin intricacies that shape the subordination of women.

To talk about praxis in an international context would amount to altering the units of analysis from local, national and regional to relations and processes across civilizations and cultures. We understand that local feminist praxis is necessary for grounding analysis in particular, but this does not improve our understanding of the local, in relation to larger cross-cultural processes. As Afshar suggests in her book, *Women, Development and Survival in the Third World*, the process of development does not carry internally consistent liberating measures. But it does allow struggles against oppression to take place within a context of greater relative prosperity, where there may be room for negotiations for better terms (Afshar, 1991: 2). The five phases of the Vecinos y [Neighbours and] Rehabilitation Research Project, conducted over a five-year period and documented by Catherine, Claudia, Lourdes and Susanne, reflects Afshar's ideas. The project provides the needs of persons with disabilities in Oaxaca, Mexico. Each phase of the Vecinos Project included participation of the local community, including grass-roots organizations. Phase V involved linking with the Associación de Mujeres con Discapacidad de Oaxaca (AMUDO) [Association of Women with Disabilities of Oaxaca] to explore the needs of women with disabilities in Oaxaca City. In the chapter, Catherine and others emphasize the changed opportunities for women in the socio-economic context, despite their limited education. Oaxaca is one such organizational movement which succeeded. Still women with disabilities worldwide speak in whispers. We need to ask, is institutionalization enough, or do we go further and talk of justice? Nevertheless, justice for whom and where? For all disabled women?

To understand the world of disabled women, we would argue that there would have to be a renegotiation of the existing boundaries of 'justice'. In this collection, we, therefore, foreground the missing part of the existing feminist search to stress on justice and ethics as the issues central to our analysis of the world of disabled women. John Stuart Mill's plea that we have had the morality of submission, and the morality of chivalry and generosity, and that the time has now come of the morality of justice (1869) still remains unfulfilled (Mill, 1970).

Do we need a feminist space for justice? Dreze and Sen argue that gender injustice is a major crisis facing humanity and we have to agree with them (Dreze and Sen, 1995). Martha Chen has linked

justice to women's work and argues that excluding women from work, which is necessary for their survival, is unjust (Chen, 1995: 55). Amartya Sen and others have suggested inclusion based on capabilities. Sen's contention is that when we think of justice, it means not what people do but are capable of doing (Nussbaum and Glover, 1995). Sen and his group of theorists, therefore, suggest that capabilities are of great value and need emphasizing. One of Sen's examples refers to people appearing in public without shame (Sen, 1993). We could, of course, lay it as the basis of our argument when discussing disabled women. The unemployment rate for disabled women in developing countries is virtually 100 per cent (CIDA). We therefore ask, why are disabled women not allowed into the workforce, even when capable? Is it because they are physically and mentally challenged? Is this their reason for exclusion and shame? While we share with women with disabilities their concern for exclusion, we are obliged to go beyond and consider Michele Le Doeuff's argument in 'A Little Learning: Women and (Intellectual) Work' that work which is very important to disabled women is no longer a well-defined subject and refers to a tangle of problems and its unstable categories (LeDoeuff, 2000: 97). Among this are the existing norms of physical appearance and mental capabilities and the concealment of these women behind a veil of invisibility.

This feminist research is part of our larger exploration for women's search for transformation. Women themselves, in their goal of transforming the societies they live in, we discovered, are joining the national and international mainstreams to bring about rapid changes. These experiences of women need to be recorded. There are issues in these debates, which are social, economic and cultural, and which are deeply involved in the transformation of traditional cultures. As women in these societies utilize an integrative approach to bring about change so that they do not become sub-categories, it is not surprising that there is also a strong opposition to their attempts at negotiating a new framework—a framework which includes them.

What we need is a framework that penetrates all levels unlike the Rawlasian theory.[4] We need justice, which is based on self-esteem. A theory based on humanist principles. Not all persons are born with equal 'capabilities' in the existing meaning of the term. A mentally retarded person might not be considered capable, but do such a

person's rights shrink because her/his contribution to society may be considered less than that of a 'normal person'? Who lays these standards of what is normal? Do the disabled have any say in this establishment of standards? Disabled women need to challenge these existing norms, which presupposes universal standards of capability. Do the demands of this group fit into the majoritarian voice of justice?[5] By asking that different voices be heard, are we fragmenting the theory and so destroying it? I would argue that hearing all these voices would undoubtedly make the theory profound. There are layers of injustice, which are hierarchically placed, and by removing injustice simply at one level does not make things better for all.

We recognize that though the right to work plays the most crucial role in women's lives, in disabled women's lives it is more so. Women subdued by tradition and physical or mental problems find it very difficult to overcome the double bind. We chose to focus on this right, as keeping women out of the workforce is the most important form of victimization faced by women. By providing them gainful employment could mean survival. When women do have access to this component, the influence in their quality of life is tremendous, as all the writers in the section on employment exhibit. Right to employment is, therefore, a question of justice, but we agree that linking it alone to the existing standards of capability does not produce solutions that are just.

In the context of employment, both education and training are very important components. Educating the girl child is always a problem in developing societies, though Shoba Raja shows how disability can have a positive impact in the field of education. The only question is whether this literacy is for indulging a disabled child who has so little or to provide an avenue for further independence and work. We are aware, as Nussbaum writes, of tradition perpetuating injustice against women in many fundamental ways, especially those central to our quality of life, including education, employment and self-responsibility (Nussbaum, 1995a: 1). In the early history of feminist struggle, women had to fight against tendencies of provision of education to girls, as Michele Le Doeuff says, which provided a double bind of learning lessons but learning nothing in terms of intellectual development (Le Doeuff, 2000: 97). It is important for us in the field of disability, not only in the developing world but also in the developed, to be

aware that women are not kept out of the new revolutions, especially the knowledge revolution. Power, as we acknowledge, is productive of knowledge.

Conclusion

For analytical purposes, it is important, therefore, that we ask ourselves whether all these women share a common history. We notice that the women of Trinidad and Tobago seem different from the indigenous women of Mexico. The history of South Asia is different from that of the history drafted by Cindy Lewis. In terms of context, we see that there are few differences, as all these women's struggles emerge in relation to their various disabilities and of being women. At the same time, when drawing on their trajectories of feminism, we come to understand that these have situated them in different positions, as their locations are linked to their struggles.

While we can see at one level a group of women internationally excluded and restrained, at another level we see individuals and collectivities engaging separately with different structures and histories. This is a challenge that any analytical framework, paradigm or theory would have to face. At the same time, we recognize the urgent need to move forward.

These writings, we conclude, assist us in rejecting universalisms and homogenization. They assist us in according diversity as an important part in any process. Theory built upon these differences provides us the foundation to a new viewpoint. In this politics of difference, those who are marginalized do not abandon their identity but exhibit it. In the old standpoint, disabled women were losers as no one paid attention to them. This perception was based on an inaccurate understanding that if there was a change in women's situation for the better, disabled women's condition was bound to improve. However, we see disabled women as a specific social group, willing to challenge the differential treatments and achieve heights not visualized.

In the world of gendered differences, we discovered another realm of women's exclusion and discrimination, and through this politics of exclusion, we learnt about restricted boundaries and painful terrain, which the disabled women have to traverse. In this process of learning and re-learning, we were also inspired and

awed by the transitions made by women with disabilities in their search for new worlds. A search for alternatives is essential for this transition from social and economic equality, discrimination, universalism and oversight. We need to ignore the hierarchy of differences among the majority and minority world of women.

Our search for answers in the field of disability is definitely a part of an overall perennial search for excellence and achievement in feminist research. To create conceptual frameworks in the context of gendered disability, it required getting information that was difficult to obtain, since the findings are related to sociological and cultural factors. Disabled people, and that too women, have to, we found, negotiate with the social and cultural issues confronted by them. These issues also intersected with a major intellectual project of the moment—the theorization representation. As for any identity group, the questions of how disabled people have been represented within the mainstream socio-economic and cultural systems, how they have chosen to represent themselves, and what sort of subject positions are determined by both sets of representations were taken up by the writers.

This was possible as we have tried to include both academic and non-academic writings. Our contributors are academics, activists and professionals working in the field of disability. Both academic work and the voices of disabled women themselves, we realized, had to feed into each other subtly, and we hope we have been able to do so adequately. The challenge of negotiating these differences within feminist research and discovering multiple sites was critical to our consciousness, and we have tried to achieve it in this volume.

Notes

1. The beginning of this story of genetic development goes back a long time in history and has passed through various phases. Genetics was initially a work of mathematicians, who were interested in studying the codes of inheritance. The work of Watson and Crick broadened the field of genetics. Genetics began to be converged with molecular biology and the search for genetic markers was thus initiated. In a gendered perspective, it became important as the biological separation into male and female is controlled by DNA. This was significant as

Goodfellow remarks that 'gender' as the arbitrary social division be-
tween masculine and feminine is a social construct that involves inter-
action between an individual and the society (Goodfellow, 2000:
4).Further, in the scientific field, where males dominate by sheer
numbers, gendered research that is unfavourable to women is likely to
be high.

2. In the context of this book, the most important issue is the use of ge-
netic technology and its linkage to a return to eugenics and disability.
Jyotsna Agnihotri Gupta cites data from Japan where between 1948 and
1995, 16,520 handicapped women were sterilized, sometimes against
their will. In Sweden doctors were allowed to sterilize physically and
mentally challenged people as well as those who suffered from heredi-
tary disorders (Gupta, 2000: 482). Taken in the context of Australian
bioethicists Peter Singer and Helga Kuhse, disabled people rank below
chimpanzees and pigs in the hierarchical classification of life forms be-
cause they do not possess the fundamental characteristics of human be-
ings, namely, 'rationality, autonomy and self-consciousness'. They,
therefore, recommend 'euthanasia' for severely disabled children (De-
gener, 1990: 95–96 in Gupta, 2000: 485). The relationship of this new
reproductive technology is therefore not only of immense importance
to women but also to disabled children and women who are doubly
threatened, being women and being disabled.

3. The Beijing Conference was organized in 1995 to discuss women's is-
sues. It was attended both by governments and by NGOs. The United
Nations started the process of these activities in 1975 when the Interna-
tional Women's Year was announced and 6,000 participants met at Mex-
ico to discuss the state of women's status worldwide. This was followed
by 1976–85 being declared the Decade of Women. One of the major
documents to emerge was the Convention on the Elimination of All
Forms of Discrimination Against Women (CEDAW), 1979. The end-of-
the-decade meeting took place at Nairobi in 1985, where Forward-
Looking Strategies for the Advancement of Women (up to 2000) was
adopted. In 1992, the first of the world's meeting involving the United
Nations, governments and NGOs took place at Rio de Janeiro. Women
attended the Earth Summit at Rio in large numbers. The International
Conference on Population and Development held at Cairo in 1994
linked demographic issues and the advancement of women through lit-
eracy, health and nutrition. The specific women's meet after Nairobi
was held at Beijing where a decision was taken to review the process af-
ter five years at the United Nation (The Beijing Plus Five Meeting).

4. Rawls ignored gender in his *Theory of Justice* (Rawls, 1971). For a femi-
nist critique of Rawls' theory of justice, see S.M. Okin (1989), who ar-
gues that under the Rawlasian paradigm, injustice against women
within the household is invisible. Justice, if not viewed within the fam-
ily, can only result in strengthening patriarchal norms.

5. Nussbaum, supporting universalism, concedes that many universalist conceptions of the human being have been insular in an arrogant way and neglectful of differences (Nussbaum, 1995b: 72).

References

Afshar, Haleh (1991). *Women, Development and Survival in the Third World.* London: Longman.

Alur, Sathi (1999). 'Women with Disabilities', *ActionAid Disability News.* 10(1 & 2): 11–16.

Arditti, Rita, R. Duelli Klein and S. Minden, eds. (1984). *Test-tube Women: What Future for Motherhood?* London: Pandora Press.

Asch, A. and M. Fine, eds. (1988). *Women with Disabilities: Essays in Psychology, Culture, and Politics.* Philadelphia, Pa.: Temple University Press.

Browne, Susan E., Debra Connors and Nanci Stern (1985). *With the Power of Each Breath: A Disabled Women's Anthology.* Pittsburgh: Cleis Press.

Canadian International Development Agency (CIDA). *Fact Sheet.* Public Participation Programme.

Chen, Martha (1995). 'A Matter of Survival: Women's Right to Employment in India and Bangladesh', in Martha Nussbaum and Jonathan Glover, eds., *Women, Culture and Development: A Study of Human Capabilities,* pp. 37–57. New Delhi: Oxford University Press.

Chib, M. (1997). 'No Sex Please. We are Disabled'. *Metropolis.* August.

Degener, T. (1990). 'Female Self-Determination between Feminist Claims and "Voluntary" Eugenics between "Rights" and "Ethics"'. *Rage,* 1(2): 87–100.

Dreze, Jean and Amartya K. Sen (1995). *Hunger and Public Action.* Oxford: Oxford University Press.

Finger, Anne (1984). 'Claiming All of Our Bodies: Reproductive Rights and Disabilities', in Arditti, Klein and Minden, eds., *Test-tube Women: What Future for Motherhood?,* pp. 281–97. London: Pandora Press.

Giele, Janet Zollinger (1978). *Women and the Future: Changing Sex Roles in Modern America.* New York: The Free Press.

Goodfellow, Peter N. (2000). 'Sex and Molecular Biology', in Colin Blakemore and Susan Iversen, eds., *Gender and Society: The Herbert Spencer Lectures,* pp. 1–12. London: Oxford University Press.

Gupta, Jyotsna Agnihotri (2000). *New Reproductive Technologies, Women's Health and Autonomy: Freedom or Dependency?* Indo-Dutch Studies on Development Alternatives – 25. New Delhi: Sage Publications.

Hanson, Marie (1985). *Living Outside Inside: A Disabled Woman's Experience: Towards a Social and Political Perspective.* Berkeley: Canterbury Press.

Hekman, Susan J. (1999). *The Future of Differences: Truth and Method in Feminist Theory.* Cambridge: Polity Press.

Hillyer, Barbara (1993). *Feminism and Disability.* Norman, Okla.: University of Oklahoma Press.

Hubbard R. (1986). 'Eugenics and Prenatal Testing', *International Journal of Health Services.* 16(2): 227–42.

Hynes, H. Patricia (1990). *Reconstructing Babylon: Essays on Women and Technology.* London: Earthscan Publications.

Janeway, Elizabeth (1974). *Between Myth and Morning: Women Awakening.* New York: William Morrow & Co.

Le Doeuff, Michele (2000). 'A Little Learning: Women and (Intellectual) Work', in Colin Blakemore and Susan Iversen, eds., *Gender and Society: The Herbert Spencer Lectures,* pp. 97–115. London: Oxford University Press.

Lonsdale, Susan (1990). *Women and Disability: The Experience of Physical Disability among Women.* London: Macmillan.

Matthews, Gwyneth Ferguson (1983). *Voices from the Shadows: Women with Disabilities Speak Out.* Toronto: Women's Educational Press.

Mayr, Ernst (1976). *Evolution and Diversity of Life.* Cambridge, Mass.: Harvard University Press.

Mead, Margaret (1949). *Male and Female: A Study of the Sexes in a Changing World.* New York: William Morrow & Co.

Mies, M. (1987). 'Sexist and Racist Implications of New Reproductive Technologies.' *Alternatives,* 12: 323–42.

Mill, J. S. (1970). *The Subjection of Women.* Cambridge, Mass.: M.I.T. Press.

Mitchell, Juliet (1979). *Woman's Estate.* New York: Pantheon Books.

Nussbaum, Martha (1995a). 'Introduction', in Martha Nussbaum and Jonathan Glover eds., *Women, Culture and Development: A Study of Human Capabilities,* pp. 1–36. New Delhi: Oxford University Press.

——— **(1995b).** 'Human Capabilities, Female Human Beings', in Martha Nussbaum and Jonathan Glover, eds., *Women, Culture and Development: A Study of Human Capabilities,* pp. 61–104. New Delhi: Oxford University Press.

Nussbaum, Martha and **Jonathan Glover,** eds. **(1995).** *Women, Culture and Development: A Study of Human Capabilities.* New Delhi: Oxford University Press.

Okin, S.M. (1989). *Justice, Gender, and the Family.* New York: Basic Books.

Paxton, Nancy (1991). *George Eliot and Herbert Spencer: Feminism, Evolutionism and the Reconstruction of Gender.* Princeton, N.J.: Princeton University Press.

Rawls, J. (1971). *A Theory of Justice.* Cambridge, Mass: Harvard University Press.

Rousso, Harilyn, Susan O'Malley and **Mary Severance,** eds. **(1988).** *Disabled, Female, and Proud!: Stories of Ten Women with Disabilities.* Boston: Exceptional Parent Press.

Rowbatham, Sheila (1973). *Women, Resistance, and Revolution: A History of Women and Revolution in the Modern World.* New York: Random House.

Sen, Amartya K. (1993). 'Capability and Well Being', in Martha Nussbaum and Amartya K. Sen, eds., *The Quality of Life*. Oxford: Clarendon Press.

Tseelon, Efrat (1995). *The Masque of Feminity: The Presentation of Women in Everyday Life*. London: Sage Publications.

Zola, Irving (1982). *Missing Pieces: A Chronicle of Living with a Disability*. Philadelphia: Temple University Press.

I
Images and Values

1

Perfect? An Analysis of the Global Human Genetics Fix

Michelle La Fontaine

What is the definition of perfect? The dictionary suggests: 1. in a state proper to a thing when completed; having all essential elements, characteristics, etc.; lacking in no respect; complete. 2. in a state of complete excellence; without blemish or defect; faultless. 3. completely suited for a particular purpose or occasion. 4. completely corresponding to a type or description; exact (Macquarie Dictionary).

This applies to all things animate and inanimate: humans, animals, plants and material objects like pieces of architecture and household goods. The comparison seems odd given that humans, animals and plants are living, breathing species while objects like pieces of architecture and household goods are simply items constructed and engineered for the aesthetic pleasure of humans and essentially to make life easier for them.

Humans seem to like tidy lives lived according to their specified culture even though many cultural practices are, uncontrollably, stifled (such as the perfect marriage ending in divorce) or seen by other cultures as barbaric (such as vaginal circumcision). Generally, we want everything to be 'nice' and we want to fit in, but this unfortunately is far from the reality.

Even though minority groups have been present in our world since the beginning of human existence, members of such groups are viewed as different and not well tolerated. The consequences of campaigns to obliterate those viewed as different have been diabolical, an

obvious example being the culling of Jews and other designated itin-
erates during World War II. Still we learn nothing from this experi-
ence, do little if anything about the experience, our intolerance
seemingly moving on as if nothing like this has ever happened, but
continuing to be disturbed when our perfect and genuinely happy
lives are threatened.

Human Perfection

Human perfection, in the biological sense, has long been sought af-
ter. Different cultures at different times in history have believed that
perfection was attainable and thereby attempted to achieve it by en-
gaging appropriate means. Perfection in human terms has always re-
lated to physical, emotional, sensorial and intellectual states.

Although our early and contemporary history has delivered to the
world talented and powerful individuals who have been affected by
debilitating biological differences, it appears that the public would
prefer existence without difference than existence with any form of
difference and the natural brilliance of these individuals. Included in
this group are Julius Caesar (emperor of Rome) who had epilepsy,
Ludwig van Beethoven (musician and composer) who became pro-
gressively deaf throughout his career, and Stephen Hawking (physi-
cist/discoverer of a theory of the evolution of the universe) who lives
with an excessively severe form of motor neuron disease.

In other words, it appears that the public in general wants perfect
bodies more than any other trait. At least they want the illusion of per-
fection. Anything that strays too far away from this is frowned upon
with disdain for 'there is a tendency for society to set standards on the
degree and nature of difference it will tolerate. What one may refer to
as "extremes" of [genetic] differences, that is the existence of changes
[to the genes] leading to conditions such as muscular dystrophy or
cystic fibrosis, have an assumed impact on the social order of life
which is deemed insurmountable' (La Fontaine, 1997: 7).

This is legitimized by the social inclination to connect perfection
with normality, and for women in particular with beauty. These are,
nevertheless, subjective terms—perfection, normality, beauty—which
mean nothing unless they are given meaning, and this is exactly what

happened from the time of the Industrial Revolution at the turn of the eighteenth century. Individuals who were perceived as different and who could not keep up with the new fast-paced factory environments were segregated. The differences became individual pathology and the notion of human difference became socially ingrained and feared. Hahn described these phenomena as aesthetic anxiety (the tendency of the general public to 'narcissistically reject deviations from "normal" physical appearances') and existential anxiety (the possibility of becoming disabled as more generally feared than death) (quoted in Oliver, 1989: 8).

By the late 1800s, medical science had constructed mathematical methods to quantify human variance, that is, ways in which human normalcy and abnormalcy could be viewed as fact. The work of Francis Galton, cousin of Charles Darwin, was central to this (Lewis, 1989). Believing that human eminence was passed from generation to generation, Galton encouraged female graduates to breed rather than pursue careers to improve human stock. To be perfect was being seen as a social necessity, and many countries were beginning to adopt Galton-led approaches to screen out those who were 'perfect' from those who were not. In fact, it was Galton who utilized the concept of eugenics in 1883, promulgating 'judicious matings ... to give the more suitable races or strains of blood a better chance of prevailing speedily over the less suitable' (Lewis, 1989).

Genetic Technology: Agent of Perfection?

In today's so-called modern, progressive age, the study of genetics, in particular the deployment of the Human Genome Project, has created the notion that perfection is indeed possible using logical positivist methods. Medical science has, therefore, reinforced the paradigm that extreme forms of human diversity are undesirable by offering the global space an opportunity to rid itself of 'anarchic bodies'. People who are socially constructed as disabled are a primary target of this schema, particularly those who have conditions of a genetic origin. This is because the greater the number of genetic conditions which can be marked on the genetic map, the greater the chances that

those conditions can be controlled, and supposedly the greater the chances that the mystery surrounding the human body can be unearthed. Women are implicated by this human genetic fix as objects of mass 'marketeering of products that promise perfection, including the reproduction of perfect bodies.

Various strategies have been and are being developed to attest to women that perfection and the elusive theory of normality are not only possible but also desirable and necessary (as was believed over a century ago). These grow rapidly as new forms of genetic technology come to fruition. One might call these strategies systems of perfection or more pertinently, systems of normality. However, in a traditional medical sense, these strategies are known as diagnostic tests and therapeutic interventions.

We are told that these tests and interventions are instituted to enable childless people to have children, to overcome male and female sterility, to overcome the lack of reproductive organs in females and to treat the matter of familial predisposition to transfer genetic conditions. These are considered to be medical problems that need to be fixed.

The 'problem' of transfer of genetic conditions is therefore being dealt with in a number of ways, both diagnostically and therapeutically. Genetic screening of individuals to detect conditions is becoming more prolific as more genes are identified. (The rough draft of human genetic code was completed in June 2000, and the final version is expected to be ready by 2003.) Devising a screening test or treatment for 'disorders' once a gene is identified is not straightforward, however (it could take many decades to sort through the information obtained), nor is it ensured (Henifin, 1993; Suzuki and Knudston, 1989).

Prenatal screening is becoming more refined and the techniques can detect the existence of genetic and chromosomal changes in a developing embryo or foetus at far earlier stages of development. This can be achieved by simple blood tests that do not carry the risks of amniocentesis for instance. The results of a recently developed test known as Aneu Vysion® are available within 24 to 48 hours. We also now see the use of three-dimensional ultrasound and this is helping diagnosticians come to conclusions with, once again, greater accuracy than conventional ultrasound technology.

Therapeutically, if a diagnosis of a genes-based condition is made, or, as mentioned earlier, an individual or a couple is deemed as carrier based on family history (depending on the inheritance pattern), 'remedies' are available to assist in the procreation of perfect children. There is an increasing use of in vitro fertilization (IVF) to delete what is known as 'non-viable' ovum or sperm. 'Non-viable' embryos are being culled using a technique called pre-implantation embryonic genetic screening. The use of surrogate ovum or sperm is practised, as is surrogate motherhood. Termination of foetuses and embryos is common, often late-term up to the moment of birth if a 'disability' is defined.

Sterilization is also used to curb the reproduction of non-perfect individuals. This is particularly so for women with intellectual disabilities, and in countries where it is unlawful to produce children with genetic conditions.

Genetic therapy also includes drug and gene therapies, and intrauterine surgical interventions on the foetus/embryo.

Social Utilization of Genetic Technology

As in the early attempts to develop programmes from the knowledge of human genetics (which were directed at improving the human stock, known as the 'old genetics'), the 'new genetics' (directed at the improvement of individual health) has prompted social groups worldwide to do the same. Screening in the first half of the twentieth century was stalled largely as a result of the Nazis' criminal use of screening techniques during World War II. The sophistication of knowledge as a result of the discovery of DNA in the 1950s opened the way for a clearer understanding of the workings of the body and the potential for new ways to justify the creation of human perfection or, as it is promoted, healthier lifestyles for all.

Governments, health institutions, biotechnology organizations, insurance companies, employers, drug companies and their shareholders, and the individual researcher are examples of groups in society that are benefiting from knowledge of the human genome. It is believed that the latter two groups constitute 95 per cent of the beneficiaries worldwide (CNN.com transcripts, 3 January 2000).

We find the existence of legislation that proscribes the use of genetic screening, termination of embryos and foetuses with genetic changes, and long-term contraceptive practices (in lieu of marriage) in China's 1995 maternal and infant health legislation (Xinhua, 1994). In the United Kingdom, termination of a foetus at fullterm is permissible if the foetus is defined as having a disability (Ralph, 1994). (There is anecdotal evidence of late-term terminations in other countries though it is not lawful.) The United Kingdom's [The] Abortion Act (1990) also 'allows forced abortion for people with disabilities who are deemed unfit to raise a child' (Davis in La Fontaine, 1997). In Australia, it has been suggested that debate should occur regarding employers' rights, insurance companies' rights and the notion of a forced abortion on the grounds of the existence of foetal genetic defects (Milburn, 1999: 1–2) with a view to regulating the presence of human genetic 'disorders' within the community.

There are questions about how genetic information will be (if not already) used by health insurance companies to deter the birth of children with genetic conditions. Will, for instance, health insurance providers deny a woman coverage if she chooses to continue to carry a child if she/he has been prenatally diagnosed with a genetic condition (La Fontaine, 1997)? People with pre-existing medical conditions must already undergo longer waiting periods than those without before becoming eligible for health insurance.

There is also concern that employers will utilize personal genetic data as part of their staff recruitment practices to determine individuals' abilities (Suzuki and Knudston, 1989) or suitability as an investment for an organization.

Genetic testing is being used for 'judicious matings', as Galton would have had it, in programmes such as that set up by a community in the USA. It is essentially a matchmaking business to ensure that genetically healthy couples are brought together (Willis, 1998). As a result, as Willis expressed it, the 'genetic wall-flower' is created.

Genes form the core of a future market economy. As soon as new genes are identified they are patented, their benefits accruing to the shareholders of companies. The recent escalation in gene identification spearheaded by Celera Genomics (81 per cent) saw Celera's stock climb from 53.18 to close at 240.12 in January 2000. Even

government leaders, in the United States and Britain at least, are encouraging gene patenting.

One of the most recent systems of perfection on offer is the auction of the ovaries of models on the World Wide Web. Model sperm is on the agenda for auction in the future. The American site, http://www.ronsangels.com, announces that it guarantees (for prices starting at US$15,000 up to approximately $150,000) the production of a highly attractive, healthy child. (There is no guarantee that a transaction can be ensured—see item 3.1 of the user agreement on the web site.) The individual who set up the company, Ron Harris, a photographer, purports to be an expert on beauty, whatever that means. 'This,' wrote Harris, 'is Darwin's natural selection at its very best. The highest bidder gets youth and beauty' (Goldberg, 1999).

Impact of Genetic Technology on Women

The new genetic technology has an impact on both women with and without disabilities. The impact also depends entirely on the cultural framework within which women are living.

Reputedly, women have a choice as to whether or not they wish to use genetic technology, at least in developed countries such as the United Kingdom. This choice is usually made in consultation with medical specialists, people trained to be experts in their fields whether they be obstetricians, gynaecologists, reproductive health specialists or geneticists. However, as we have seen, the 'business' of reproduction crossed with perfection/normalcy is creating new breeds of self-proclaimed experts in the field.

The ever-increasing proliferation of technological interventions to assist in reproduction means greater choice for women but it can also mean immense confusion. Some of this may be due to the belief system of the medical specialist whom a woman may be consulting, that is, beliefs about using technology for this purpose. Leuzinger and Rambert (1988) reported that these specialists and their beliefs fall into three categories. First, the 'technological' type who see testing, as a neutral tool; second, the 'traditional' type who would never use it; and third, the 'alternative' type who endorse the view that women

should make informed decisions. This may apply if a medical 'expert' is independent; however, government and hospital policies (although not necessarily publically available) may dictate how practitioners advise women regarding their choices. This in turn is dependent on the values of individual practitioners, health institutions, and governments towards the birth of people with genetic conditions.

Support for women who have entered this world of reproductive medicine varies according to the decisions they make (specifically in a political sense). Women who decide to continue a pregnancy following prenatal diagnosis of embryonic/foetal 'abnormality' are receiving less support than those who choose termination (La Fontaine, 1997: 104; Spiewak and Wüsthof, 2000).

The experience of women with disabilities is not well recorded, though what is known is that their fitness to be a mother can be determined by law (UK), and that the genetic counselling process is not particularly useful (Pastina, 1981). Reproductive issues are not seen as significant to their lives. Generally support for women with disabilities is poor—a matter of imperfect bodies potentially generating further imperfect bodies (Frohmader et al., 2000).

There is a problem of balancing women's rights and disability rights. The issues here are women's rights to control their own bodies and thus abort a foetus with a genetic condition if desired, and disability rights which demand that a foetus with a genetic condition should have the same value as any other foetus and therefore should and must have the opportunity to live. Degener (1990) has examined this conflict of interests between women and people with disabilities. She believes that women's rights to self-determination represses the rights of other groups because it denies those groups equality. In terms of people with disabilities, the use of prenatal diagnosis justifies women's right to abortion if a foetus is diagnosed with a genetic condition.

The question of whose body is it anyway beckons an analysis of whether a foetus is essentially a being in its own right with the mother's role being that of guardian or whether the mother as carrier is in effect the owner of the foetus with full ability to determine what happens to her possession. The difficulty here is that the notion of the foetus as an individual or as having its own personality is viewed as contingent with the values of the

pro-life mafia (Degener, 1990: 93). Could it not be possible that a woman is pro-choice and does believe that a mother is guardian to a foetus?

Whilst many women maintain the right to abort, many women also maintain the right to have children. In their zest to do so, women will go to great lengths if they (or their partners or culture) consider natural conception to be disturbed by familial genetic 'faults' or simply not possible at all for no apparent reason. The social pressure for women to bear children is enormous, and should this not occur or should this be implicated by socially defined 'unnatural' phenomena (that is, a child born with a genetic condition), women are portrayed as having lived tragic, unfulfilled lives.

Choice for Women or Social Power?

Although it was medical science that first identified and developed genes and gene technology, its acculturation by governments and commercialization by business globally takes the matter of genetic technology out of the hands of medical practice into the arenas of politics and corporation. It fits firmly within the capitalistic–economic framework, even though countries like China do not purport to administrate using this system (its rationale for implementing programs utilizing the technology is for the well being of individual mothers and children).

In fact, in the case of China, women have no choice whatsoever—the existence of legislation to prohibit the birth of children with genetic differences as mentioned earlier sees to that. In other countries, whilst choice exists, subtle and not so subtle messages engulf the minds of women such that the decision to reproduce under these circumstances is complicated by grief, guilt, horror and the need to be what is deemed as responsible. Henifin (1993) has suggested that women who refuse to terminate a foetus diagnosed with a genetic condition (or who refuse the use of genetic technology for that matter) may be liable for abuse.

The technology itself is impotent: it is the intention for its use, its manipulation by its advocates that has convinced and forced women to use it and sing its praises. It is big business, it provides 'viable'

population control and it enables the eradication of individuals who confront us with burden, suffering and pain which, though natural forces, are rejected by the majority of society who see them as having no place in the world.

Women's rights and the notion that women are the owners of their foetuses, and therefore that foetuses are their possessions (signifying an objectification of the foetus), plays right into the hands of hardcore proponents of the new genetics. This is because it gives the developers of the genetic technologies an opportunity to sell their wares.

Revisiting Perfection

Human perfection is not attainable. Those who think it is, are only fooling themselves. In a biological sense, mutations and traumatic accidents occur which cannot be predicted nor prevented. In a strictly human sense, we all have our faults and bad habits, the origins and causes of which are multi-dimensional.

Genetic conditions, though they are thought to be costly and dispensable, have, nevertheless, far more to offer to the global community than the global community could ever allow itself to comprehend. The quote 'life was not meant to be easy' is so true. Indeed, nor was life meant to be free of suffering, always happy or even-handed. However, a majority of the public (from individuals to governments, to countries developed and undeveloped, Eastern and Western) possess such strong desires for quick fixes that golden opportunities presented to them to achieve growth come and go unnoticed.

Life is not just made up of a sequence of genes, but a sequence of events that entice us to open our minds to let in the universe and its variance of nature. Unfortunately, this requires tolerance, responsibility, intelligence and maturity. This is something the collective society generally lacks, because power, control and possession are passionately and with disillusionment thought to be the manner in which we achieve success. Those members of the world with little or no power, control and possession in or over their lives in the sense thought of here are subjugated to endless cycles of harrow by cultures that endorse the notion of perfection of body and mind as the norm. Those who take a primary role in the procreation of body and mind, that is

women, are entangled in this web and must suffer the burden of perfection.

Not all women are caught up by the global human genetic fix. Martha Beck (1999) and Tierney Temple-Fairchild (Zuckoff, 1999) are two of the 10 per cent of mothers in the United States who carry foetuses with Down's syndrome and who resisted social pressure to abort. Hence, 90 per cent of women abort foetuses diagnosed with Down's Syndrome, a statistic similar to other countries, excepting China where it would more likely be 100 per cent given the legal obligation to abort.

Although Beck and Temple-Fairchild both have the means to support a child with high-support needs, they also had to reject these children, both being high academic achievers with solid career paths ahead of them. They too went through intense moments deliberating upon the reasons why a child like this should or should not be born; how the needs of the child would interfere with their professional and personal lives; how the child would cope with the medical and social disadvantages he or she would endure throughout life; how a child with high-support needs might intrude on the needs of less-demanding siblings.

However, in defying the social necessity for normality and perfection in their children, they defied insinuations about themselves as irresponsible, particularly by being in the minority of those who choose difference.

In fact, the experience of Beck and her partner, a Havard graduate and postgraduate researcher, is telling:

> What they did not realize is that they themselves were the ones who would be 'born' infants in a new world where magic is common-place, Havard professors are the slow learners, and retarded babies are the master teachers. (Beck, 1999: 7).

Kaplan (1994) has advised that one reason why genetic testing is used by parents is to give them reassurance that a foetus is genetically sound and therefore there is no need to consider abortion. Pastina (1981) tells us that women with disabilities who seek genetic counselling are treated like objects, like 'faulty' genetic foetuses.

Women must be thoughtful about what the term 'genetically sound' means and be brave and cautious in their determination to use genetic technology under the pretence of receiving a perfect child.

Women with disabilities must be treated and respected like women without disabilities and be given the same choices as any woman considering motherhood.

Choice is paramount, but it must be choice based on the reality of life with a genetic condition, not an assumed belief of the reality. This applies to all forms of conditions including those that result in early death, for it is not the death that is the tragedy—the tragedy is the belief that it is so.

After all, how do we know that genetic difference does not mean perfection?

References

Beck, Martha (1999). *Expecting Adam.* New York and Toronto: Times Books.

CNN.com Transcripts (3 January 2000). Burden of Proof, Millennium 2000: Bioethics [online]. Available from www.cnn.com/transcripts/ 0001/03/

Degener, T. (1990). 'Female Self-Determination between Feminist Claims and "Voluntary" Eugenics, between "Rights" and Ethics', *Issues in Reproductive and Genetic Engineering,* 3(2), 87–99.

Frohmader, C., A. Storr, M. Cooper and M. La Fontaine (2000). *Leadership & Mentoring Resource Kit for Women with Disabilities.* Prepared for Women with Disabilities Australia (WWDA), Canberra.

Goldberg, Carey (1999). 'Selling Fashion Models' Eggs Online Raises Ethics Issues', The New York Times on the Web (http://www.thenewyorktimes.com), 23 October.

Henifin, M.S. (1993). 'New Reproductive Technologies: Equity and Access to Reproductive Health Care', *Journal of Social Issues,* 49(2), 61–74.

Kaplan, D. (1994). 'Prenatal Screening and Diagnosis: The Impact on Persons with Disabilities', in K. H. Rotterberg and E. J. Thompson, eds., *Women and Prenatal Testing: Facing the Challenges of Genetic Technology,* 49–61. Ohio: Ohio State University Press.

La Fontaine, M. (1997). *Emancipating Difference: A Study of the Social Construction of People with a Genetically based Condition.* Bundoora: La Trobe University.

Leuzinger, M. and B. Rambert (1988). '"I Can Feel It—My Baby is Healthy": Women's Experiences with Prenatal Diagnosis in Switzerland', *Reproductive and Genetic Engineering,* 1(3), 239–49.

Lewis, J. (1989). *Removing the Grit: The Development of Special Education in Victoria, 1887–1947.* Bundoora: La Trobe University.

Macquarie Dictionary, The [online edition], s.v. 'perfect'. Available from www.macquariedictionary.com.au

Milburn, C. (1999). 'DNA: The Critical Questions', *The Sunday Age,* 11 July, 1–2.

Oliver, M. (1989). 'Disability and Dependancy: A Creation of Industrial Societies?' in Barton, L., ed., *Disability and Dependancy,* ch. 1., London: Falmer Press.

Pastina, L. (1981). 'The Impact of Genetic Disability', *Sexuality and Physical Disability Personal Perspectives*, pp. 32–34. St. Louis: C.V. Mosby Co.

Ralph, S. (1994). '"Existence without Life": Disability and Genetics', *Australian Disability Review*, 95(1), 3–16.

Spiewak, M. and A. Wüsthof (2000). Die Stille Selektion, Die Zeit, 2000. Available from www.Zeit.de/archiv/2000/1/200001.praenataldiagnos.html

Suzuki, D. and P. Knudston (1989). *Genethics: The Ethics of Engineering Life.* Sydney: Allen and Unwin.

Willis, E. (1998). 'The New Genetics and the Sociology of Medical Technology', *Australian and New Zealand Journal of Sociology*, 34(2).

Xinhua News Agency Domestic Service (1994). 'Chinese Laws—Mother and Child', Beijing, 27 October.

Zuckoff, M. (December, 1999). 'Choosing Naia', The Boston Globe Extranet. Available from www.boston.com/globe/nation

2

Hollywood's Portrayals of Disabled Women

Madeleine A. Cahill and Martin F. Norden

For over a century, the American popular cinema's portrayals of disabled people have been, more often than not, the troubled reflections of a nation uncomfortable with many of its own citizens. Hollywood's depictions of women have similarly been the skewed output of a patriarchal society simultaneously obsessed with and terrified by the feminine. On the relatively rare occasions when the popular film industry has attempted to tell the stories of disabled women, it has tended to produce only characters at the extremes: sweet and pitiable (and frequently cured by the film's end), awe-inspiring, or vengeful. The narrow character types and plot conventions that have become associated with disabled women in film illuminate the ways in which a sexist and ableist society has constructed disability, and these stereotyped characters and situations form this essay's main focus. Our essay is by no means a comprehensive, definitive study of Hollywood's representation of disabled women, but we believe the films we have chosen to discuss are representative of their times and yield considerable insight into the heavy devaluation of disabled women in the United States and other countries. In general, cinema is a medium that gravitates towards the superficial. Because films typically run two hours or less, film-makers must make their points quickly and, in the commercial cinema, have tended to do so with little subtlety or equivocation. Characters and plots are frequently painted with broad strokes, with appearance often standing in for character development. These trends were especially evident in the early, relatively non–verbal pre-feature film years (i.e., 1895–1912), which set the

patterns that still exist today in modified form. In this context, film-makers have often constructed characters outside of the mainstream as 'others' and imbued them with symbolic significance. In the case of characters with disabilities, Hollywood film-makers have often used the visible differences as a form of visual shorthand to illicit pity, fear, humour, or awe from the audience. The ways in which Hollywood film-makers have constructed disabled males and disabled females are quite different, however, and are worth examining at this juncture.

Cinematic portrayals of disabled men are, first of all, much more prevalent than those of disabled women. This phenomenon may be attributed in part to Hollywood's enduring fascination with war-related topics. During war and post-war eras in the United States, the number of men with disabilities populating the screen inevitably increased. These films revealed a range of disabling circumstances: Jim Apperson (played by John Gilbert) loses a leg in the World War I movie *The Big Parade* (1925); Homer Parish (Harold Russell) returns home with prostheses in place of hands lost in a World War II shipboard accident in *The Best Years of Our Lives* (1946); Oliver Bradford (Robert Young) struggles with facial disfigurement, a paralysed arm, and suicidal depression in *The Enchanted Cottage* (1946); Luke Martin (Jon Voight) and Ron Kovic (Tom Cruise) return from the Vietnam War in wheelchairs in, respectively, *Coming Home* (1978) and *Born on the Fourth of July* (1989). Responding to the assumed socio-psychological needs of the general population, Hollywood film-makers have usually designed these characters as troubled but noble and ultimately positive.[1]

No such obvious socio-historic factors correlate with the filmic portrayal of disabled women. This observation only partially accounts for the differences in the portrayals of disabled men and women, however, since Hollywood differs in its treatment of men and women—disabled or able-bodied—not only in number but also in the depth and breadth of their portrayals. As a number of theorists and critics have observed, typical female figures in Hollywood films are often objectified by the heterosexual male gaze. In other words, they are objects to be looked at and desired by mainstream males within the film's narrative world and by male audience members outside it. In the case of disabled female characters, the film-makers usually preserve their 'to-be-looked-at-ness', to borrow film theorist Laura

Mulvey's famous phrase (Mulvey, 1975: 17), by bestowing disabilities that do not adversely affect the women's appearance: blindness, deafness, muteness, or some combination thereof. The tradition of Hollywood movie heroines whose disabilities always affect their fates but never their looks is long indeed. Dorothy Gish's blind French-woman in *Orphans of the Storm* (1921), Virginia Cherrill's blind flower girl in *City Lights* (1931), Dorothy McGuire's mute servant in *The Spiral Staircase* (1946), Jane Wyman's deaf-mute farm girl in *Johnny Belinda* (1948) and blind socialite in *Magnificent Obsession* (1954), Audrey Hepburn's terrorized blind wife in *Wait Until Dark* (1967), Amy Irving's deaf teacher and would-be professional dancer in *Voices* (1979), Lynn-Holly Johnson's blind skater in *Ice Castles* (1979), Marlee Matlin's deaf rebel in *Children of a Lesser God* (1986), Uma Thurman's terrorized blind target in *Jennifer 8* (1992) and Madeleine Stowe's sight-restored musician in *Blink* (1994) are some notable examples that span the decades. Hollywood has occasionally represented women with mobility impairments but almost always as beautiful women languishing in wheelchairs or, that ever-popular spot for Hollywood gals, beds. Unbridled by such concerns as muscular atrophy, palsy, rigidity, or the aftermath of amputation, they look like they are merely resting and might leap up at any moment. Women are much more likely than men to be cured of their disabilities in Hollywood films, especially in movies produced before World War II. Here again, the difference may be related mainly to Hollywood's preoccupation with war issues; the injuries borne by male figures are often the result of battle and are so severe that they preclude the facile cure traditionally bestowed on disabled characters constructed as 'good'. (Indeed, none of the disabled-veteran films noted above shows its lead character restored to the ranks of the able-bodied.) Hollywood has typically insisted on maintaining the illusion of corporeal integrity for its disabled women; however, it has moved the women easily and often from a disabled to a 'cured' state, no doubt construing its actions as minor breaches of believability. Issues of sex and romance further separate Hollywood's representations of disabled women and men. In all of the disabled-vet films listed so far and in many other films that have bestowed the status of 'good' on disabled males (e.g., *The Elephant Man* produced in the 1980s), the men are shown as being loved by able-bodied women in either implicitly or

explicitly sexual ways. Reversing the genders of this pattern would be almost unimaginable in a Hollywood film. One may have to go back as far as 1909 to D.W. Griffith's *The Light That Came* to find a movie that approximates such a reversal. In that short film, a blind man falls in love with a woman whose face has been 'disfigured' by a scar. When she pays for the operation that restores his sight, he remains in love with her despite her non-standard looks. Even in this exceptional film, however, the woman's appearance is a critical factor; the hero fell in love with her only when he could not see her, or, in other words, during a disruption of her 'to-be-looked-at-ness'.

While American society in general and Hollywood film in particular have changed dramatically during the twentieth century, certain elements have remained relatively consistent. Specific standards of beauty for both sexes have shifted many times throughout the past hundred years; what has not changed is the narrowness of those standards for women in comparison to those for men, and the emphasis on female over male appearance, in both lived experience and popular culture. As we shall see, the preoccupation with 'looks' has helped define most of the movie characterizations of women with disabilities. These characterizations have tended to fall into a few narrow categories: the ingénue-victim, the awe-inspiring overachiever, the defender-avenger, the comical or horrible repellent, and the novelty. Many portrayals overlap several of these categories, but by far the most numerous are those that fall into the first two categories.

The disabled ingénue-victim is young and pretty; she is made helpless in some significant way(s) by her disability; often she is taken advantage of—even terrorized—by unscrupulous others; typically she is cured by the end of the film and thus reabsorbed into the mainstream. Occasionally this reabsorption results in an ability to see the world in a new way.

The awe-inspiring overachiever is often an attractive person who reaches a world-class level in a field such as sports or the arts only to be 'struck down' by an incurable disabling circumstance. Not at all average and often economically independent, she eventually 'overcomes' her disability with the same determination that presumably got her to the top of her career.

The defender-avenger, a much rarer find, will not tolerate the treatment typically afforded the ingénue-victim. She will strike back if

subjected to it, usually with fatal results. However, as is also typical of able-bodied Hollywood women, it is extremely rare to find a disabled woman in a Hollywood film who lashes out to defend herself. These women are most likely to act when someone they love is threatened, usually someone weaker, such as a child.

The comically or horribly repellent female is a staple of early Hollywood portrayals of disabled women, but may be found less and less through subsequent years. In silent film particularly, the medium's reliance on visual cues led film-makers to use characters' obvious physical attributes for cheap laughs or easy shocks. For example, *Two Ladies and a Beggar* (1909) presents a woman without legs as a prospective bride for a male beggar pretending to have no legs. He flees in revulsion in what is ostensibly the 'comic' climax of the film (Norden, 1994: 21). This standard silent-film 'gag' was varied throughout the silent-film era at the expense of women deemed repulsive for reasons of appearance, race, age, class, or ability. As the decades went on, organizations such as the National Association for the Advancement of Colored People (NAACP) and various ethnic anti-defamation leagues, coupled with sociocultural changes brought about by the civil rights and disability rights movements, heightened public sensitivities to the more blatantly offensive of these portrayals. As audiences began to grow uncomfortable with the ableist or racist premises of these comedies, 'repulsive' disabled or African-American women were replaced by women regarded as repulsive because of size, age, or general appearance. Another type of portrayal common in the silent-film era, but rare today, is the disabled woman as novelty. During its earliest days, popular film exploited disabled performers as novelty acts in the questionable tradition of the circus sideshow. For example, the 1902 one-reel film *Deaf Mute Girl Reciting 'Star Spangled Banner'* simply shows a young woman standing in front of an Old Glory motif and signing the words to the song. Though presumably intended to entertain or elicit wonder, or both, it at least neither ridicules nor pities the central figure.

As the cinema moved towards the feature film in the 1910s, the ingénue-victim came to dominate the screen and reached new heights in *Orphans of the Storm* (1921), one of at least seven silent-era adaptations of the nineteenth-century stage hit, *The Two Orphans*. In this D. W. Griffith film, Lillian and Dorothy Gish play sisters

Henriette and Louise, the latter of whom is blind. Set against the French Revolution, *Orphans of the Storm* dwells at length on the mishaps that befall the women as they seek a cure for Louise's blindness. Along the way, Henriette consistently infantilizes her sister; she refers to her as 'Miss Baby', for instance, and describes her as 'Blind—so helpless—like taking care of a baby.' Predictably, they find a doctor who restores Louise's eyesight. One of the last silent films to be made also deserves discussion here: Charles Chaplin's Depression-era masterpiece, *City Lights* (1931). At a time when the production of 'talkies' was well underway, Chaplin's choice to make *City Lights* as a silent film reflected his belief that he could express himself more fully and beautifully without words. The corresponding theme of the film is that the heroine can 'see' more clearly while blind than after her sight has been restored by the ubiquitous miracle operation.

City Lights tells the story of a blind flower seller and her relationship with Chaplin's familiar 'Little Tramp' character. Believing the tramp wealthy, the young woman falls in love with him; he in turn finds himself entangled in a number of comic situations while trying to raise money for a sight-restoring operation for her. Once she can see, however, the young woman—now more a saucy soubrette than a demure ingénue—teases the bedraggled tramp until she at last recognizes him as her benefactor.

This rather moralistic tale, which wags a finger at the superficiality of the young woman, reveals a rather hypocritical side of its filmmaker. Although the message of the film seems to be that appearances should not matter, *City Lights* presents yet another beautiful young woman whose looks are in no way affected by her disability. Chaplin himself underscored the importance of her appearance. 'Another difficulty was to find a girl who could look blind without detracting from her beauty,' he remembered in his autobiography. 'So many applicants looked upward, showing the whites of their eyes, which was too distressing' (Chaplin, 1964: 326).

Very rarely in film drama comes the avenging disabled woman; *The Sailor's Sweetheart* (1908), *Stella Maris* (1918), *Freaks* (1932), *The Devil-Doll* (1936) and *The Spiral Staircase* (1946) are among the very few examples that present this type. *The Sailor's Sweetheart*, in which a disabled mother becomes possessed of superhuman strength to save her daughter from the advances of a thug, is a one-reel film (Norden,

1994: 28). The others are feature-length films. The title role of *Stella Maris* is played by silent-era superstar Mary Pickford as a rather typically ethereal ingénue-victim: a wealthy and beautiful young woman unable to walk as a result of a mysterious malady. She is treated by many experts who mull over her case throughout most of the film. The film's second disabled character, Unity Blake, is in many ways the opposite of Stella and yet shares much in common with her, including their portrayer. Mary Pickford as Unity Blake is a spunky, homely workhouse orphan with a limp and a malformed shoulder. Designed by the film-makers as a plain young woman, she is not an object of ridicule but is often endearingly comic. Ultimately tragic but never helpless, Unity is a rare example of an 'unattractive' disabled woman who is neither villain nor comic foil.

Unity is beaten by an alcoholic woman for whom she works as a servant. Unity ultimately kills her employer so that her idol, Stella, will be free to marry the alcoholic woman's husband. Unity then kills herself, and Stella is, of course, cured. The film thus uses both the 'kill' and the 'cure' scenarios that characterize cinematic portrayals of disabled people throughout most of the twentieth century (Cahill, 1995: 41–51). During the so-called Hollywood Golden Age of the 1930s–40s, when a handful of big studios dominated the film-making scene and film-makers were obliged to follow a Production Code (a set of industrial guidelines that mandated the ways sensitive subjects could be treated, if at all), one director remained clearly out of the mainstream: MGM's Tod Browning. His best-known film remains *Freaks*, a revenge-driven melodrama set in a circus. In it and his later mad-scientist film, *The Devil-Doll*, Browning interrupted the dominant representational pattern of disabled women as ingénue-victims rewarded with miracle cures. In *Freaks*, disabled women are part of a 'gang' of circus performers who avenge the maltreatment of one of their own by killing one of the able-bodied evil-doers and maiming the other. In *The Devil-Doll*, a disabled woman named Malita (Rafaela Ottiano) seeks to continue her late husband's work by shrinking people to the size of a doll. In the process, she has no qualms about committing deception, robbery, and murder, ultimately coming to a 'just' end by blowing up the lab with herself in it.

Browning's depiction of violent, even insanely violent, disabled women went against the well-established patterns of Hollywood film

and challenged some of society's most ingrained beliefs about the helplessness of disabled women. Though Browning's films hardly advanced the cause of realistic portrayals of disabled women, the MGM publicity department ironically emphasized the 'authenticity' of *Freaks*; many of Browning's actors were actually international sideshow performers promoted by MGM as 'humans and half-humans ... strange and grotesque freaks and monstrosities' (Freaks Pressbook, 1932).

The film presents the competing themes of the 'freaks' as fully human and as emotionally twisted animals. For the most part, the circus performers are represented in a sympathetic manner. In addition, a pair of sympathetic able-bodied performers is contrasted with a set of cruel able-bodied performers, demonstrating the desirability of the former's behaviour. However, the freaks' revenge on the unsympathetic able-bodied people does more than show the penalty that cruel able-bodied should pay; it leaves the image of the freaks as being sub-human after all (see Norden and Cahill, 1998: 86–94).

A film that shows a disabled woman engaging in protective/defensive actions rather than aggressive violence is *The Spiral Staircase* (1946). This mystery film reflects its immediate post–World War II origins with its plot about eugenics gone awry (an insane professor systematically murders disabled women to rid the world of the 'weak') and its Freudian themes.

The Spiral Staircase focuses on a young, mute woman named Helen (Dorothy McGuire) who works as a servant in the household of the wealthy Mrs. Warren (Ethel Barrymore), an elderly disabled woman. The murderer eventually targets Helen, and the film concludes with a number of twists: the killer is revealed as Mrs. Warren's stepson, Mrs. Warren regains her mobility and strength just in time to shoot him, and Helen regains her voice and calls her doctor-lover on the phone. In so doing, Helen joined the ranks of the able-bodied and the heterosocial simultaneously. The film-makers would have their audiences believe that Helen's voice loss prevents her from communicating in any way; she uses no sign language and writes nothing until the end of the film. In fact, she does not even shake her head yes or no. In keeping with Hollywood's most popular trend of 1946, a year in which 25 per cent of the films contained references to pop psychology, Helen's voice loss is not physiological,

but psychosomatic. The film explains that she was unable to scream at witnessing her parents' death in a fire and has not spoken in the 10 years since. The childlike demeanour that Helen exhibits throughout most of *The Spiral Staircase* suggests that she was emotionally arrested at the onset of her disability. Her mannerisms are compliant and docile, and she appears quite immature. As Mrs. Warren remarks to her early in the film, 'You're such a little girl; I want to take care of you.' Throughout *The Spiral Staircase*, we learn little from Helen's point of view. Considering her position as the film's putative protagonist, she is portrayed as object rather than subject to a surprising degree. Even when the story of her parents' death is revealed, we see no flashbacks or hear no sounds that Helen heard; we see only her face, remembering, and hear the doctor's voice as he recounts the story in detail, trying to make her relive it. Even this defining experience of her life is not shown through her, but interpreted through a male professional who was not even present at the event. In fact, the only time we get a glimpse into Helen's mind is when she fantasizes about marrying Dr. Parry. In this daydream Helen seems concerned about her lack of speech; she is unable to say, 'I do.' In the world of popular Freudianism, this inability may symbolize her fear of marriage and her 'wifely duties'. Her disability, which would be seen as symbolic castration in a man, has left her infantile, immature sexually, and unable to function as a woman. And her first conscious act after regaining her voice—calling to her lover—carries the Freudian suggestion that in overcoming her disability, she is accepting maturation into heterosexuality. The implications here are disturbing: women's illnesses and disabilities are psychological, not physical; and they can overcome these disabilities with will power or if they are 'shocked' out of them. The psychosomatic nature of Helen's disability is one strain of a convention found in many films about disability; the film-makers take care to point out that their protagonists' disabilities are not congenital but have occurred through illness or accident. This consideration allows for easier audience identification (she is not inherently 'different' from mainstream audience members) and for the 'happy ending' that inevitably follows the reversal of the disability.

This filmic device also reflects the pattern of separating able-bodied and disabled people, prevalent in mid-century American

society. A country that owed its economic recovery and wartime triumphs in large part to a man in a wheelchair began making some progress, such as the post-war programmes designed to assist disabled veterans and civilians alike (Norden, 1994: 167–68), but it still prevented many of its disabled citizens from pursuing a full life. Those whose disabilities were congenital and irreversible were particularly shunned. Seen as somehow less than fully human, they became unlikely subjects for Hollywood films. A principally psychoanalytic understanding of women with disabilities characterized the popular culture of the era, and this understanding differed from contemporary interpretations of men with disabilities. Strong forces of post-war popular culture, influenced by Freud, advocated a view of womanhood as inherently pathological.[2] During the war, women who deviated from the traditional feminine norm could be seen as positive or even necessary contributors to the war effort (e.g., the many 'Rosies' who were welders and steam fitters). Immediately after the war, in a society that required women to return to their traditional roles, women who deviated from the norm were perceived as threats to the established economic, social, and sexual order. *A Woman's Face* (1941) is another film in which a woman is cured by a doctor who falls in love with her and brings her back into the fold of mainstream society. Herein, however, the woman's 'disability' is no more than a scarred face. Nevertheless, this 'disfigurement' has set her off on a life of crime, implicitly connecting disability with moral corruption.

Anna Holm (Joan Crawford) is a woman half of whose face was badly scarred in a childhood accident. Because of this scarring, Anna grew up embittered and ultimately turned to a life of crime. Within the course of the story, Anna meets two men as disparate as the sides of her face: one, a ruthless criminal, the other, an earnest plastic surgeon. The first convinces her to help him plot the murder of a child who stands in the way of his inheritance; the latter operates on her face, leaving her looking glamorous and, ultimately, restoring Anna's soul to its 'natural beauty' as her maternal instincts emerge in time for her to save the child. Here again, a film emphasizes the noncongenital nature of its lead character's disability. Anna is born beautiful; the scar is an accident. She is re-feminized by the eyes and hands of a man, who initially regards her only as a specimen on which he can exercise his skill. Once she has been transformed

physically, an awakening of Anna's more 'mature' feminine urges leads not only to the desire to be loved but the desire to return love. Towards the end of the film, Anna makes this declaration to her doctor-lover: 'I want to get married. I've always wanted to get married. I want to have a home and children. I want to go to market and cheat the grocer and fight with the landlord ... I want to belong to the human race. I want to belong!' It is hard to miss the film's implications: a person with any sort of disability is not fully human, particularly with regard to sex and romance. As with many films of this type, the heroine is only kissed once she has been transformed (see Cahill, 1995: 208–52).

The unveiling of Anna's scarless face is handled as a moment of great drama and triumph—a far cry from the actual experiences of women who have lived with facial deformity and attendant surgeries. For example, Lucy Grealy, who lost part of her jaw to childhood cancer surgery and who wrote about her experiences in *Autobiography of a Face,* was frustrated with the unrealistic dramatic convention of immediate surgical 'cures':

> People were always telling me about the 'wonderful things they can do today'. It was difficult explaining to them—even apologizing for the fact that plastic surgery wasn't like the movies. There was never a dramatic moment when the bandages came off, nor a single procedure that would make it all right (Grealy, 1994: 214).

The issue of the medical gaze and touch is critical to many other dramas that focus on women with disabilities, particularly during the middle of the century. Though present to some extent in earlier and later films, the medical gaze is notably centralized during this postwar era. In the immediate post–World War II period, both documentaries and fictional films focused on the progress made since World War I in the physical and mental/emotional rehabilitation of disabled veterans. The rise of the expert continued into the 1950s, a time of widening access to health care, growing complexity of medical technology, increased public understanding of medical issues, and dramatic medical breakthroughs. A faith in the power, objectivity, and benevolence of the medical expert reflected a society in which Jonas Salk, developer of the polio vaccine, was as well known to American audiences as baseball player Ted Williams or movie actor Rock Hudson. Issues of medical manipulation or objectification of disabled people (often evident in Hollywood doctors' patronizing

attitudes, as well as from film titles such as *A Woman's Face* and *Magnificent Obsession*) were not often examined critically by films until the 1960s.

Two notable films, in which the story of the medical 'expert' is as privileged as the story of the disabled woman, happen to star Jane Wyman: *Johnny Belinda* (1948) and *Magnificent Obsession* (1954). *Johnny Belinda* is the story of a deaf-mute woman who is raped, becomes pregnant, gives birth, nearly has her baby kidnapped, kills the rapist-kidnapper, and, ultimately, settles down with a sympathetic doctor. It well illustrates Hollywood's tendency to present disabled characters with little sense of community. The isolation of Belinda MacDonald, the film's heroine, is symbolized by the isolation of her family and her landscape; she lives with her father and her aunt on a farm on the outskirts of a fishing village, which itself is on an island. Her family is isolated collectively—farmers in a town of fishers—and individually. Her aunt is a 'spinster', her father a widower, Belinda without friends. Beyond the most rudimentary means, Belinda has not learned how to communicate with her father and aunt, nor they with her.

Enter the male medical professional, Dr. Robert Richardson (Lew Ayres), who, reflecting Hollywood's post-war sensibilities, does not cure the heroine's disability but relieves her of her isolation. The young doctor teaches Belinda sign language, and eventually her family learns it, too. The film insists, though, on the inadequacy of this language in comparison to vocal language. Belinda's first question after giving birth to her baby, Johnny, is: 'Can he talk?,' to which the baby replies with a wail, providing a 'happy' ending to the scene. A subsequent scene underscores the previous one when the doctor brings the baby a gift of a rattle, and the heroine smiles as her baby responds to its sound. Belinda's producing a 'normal' child seems to be an important way to reassure the audience and guarantee its acceptance of both Belinda and the film itself.

In *Magnificent Obsession*, Jane Wyman again plays a woman with a disability—this time blindness—who relies on the help of a kindly doctor. This film, however, is more of a romantic melodrama than *Johnny Belinda* (in which it is never clear if the doctor is actually in love with his patient, although he does marry her!). In *Magnificent Obsession*, a careless playboy (Rock Hudson) accidentally causes the

loss of eyesight of a wealthy woman. Racked with guilt, he eventually falls in love with her and, in a development worthy of any television soap opera, decides to become a doctor in order to restore her eyesight, which he does in due course.

The noble struggle of the awe-inspiring overachievers, those larger-than-life people who 'triumph' over their disabilities, was a common theme of post–World War II biographical films, also known as 'bio-pics'. *With a Song in My Heart* (1952) tells the story of singer Jane Froman (Susan Hayward) who lost a leg in a plane crash, for example, while *Interrupted Melody* (1955) follows the pre- and post-polio career of operatic diva Marjorie Lawrence King (Eleanor Parker). Two late films in this tradition, *The Other Side of the Mountain* (1975) and *The Other Side of the Mountain Part II* (1978), recreate the tale of Jill Kinmont (Marilyn Hassett), an Olympic skiing contender who was paralysed from the shoulders down in a 1955 accident. While these films deal more completely with some disability issues (the disabled women are the central figures in their own stories; no miracle cures emerge, etc.) and even, in the case of *The Other Side of the Mountain*, address issues of job discrimination, they nevertheless continue longstanding themes. For example, the protagonists are disabled as the result of an accident or illness, rather than congenitally, and the actresses who played these roles conformed to attractiveness norms of the day. As Ed Feldman, who produced the *Other Side* films, said of his casting of Marilyn Hassett as Jill Kinmont: 'We wanted a pretty girl … It is my belief that people relate to pretty things that are broken' (cited in Valens, 1975: 298). Changing social mores in the 1950s and 1960s led to the collapse of Hollywood's Production Code, and its loss of power led to an increased sense of realism in some films. An illustration may be found in the form of *The Miracle Worker* (1962), a film adapted from William Gibson's like-titled play and one of Hollywood's most famous constructions of the disabled experience. Based on a true story (and one too well known for Hollywood to completely falsify), the film dramatizes the process by which Anne Sullivan (Anne Bancroft), a sight-impaired teacher, and Helen Keller (Patty Duke), her blind and deaf pupil, learn to communicate with each other. Refreshingly, director Arthur Penn and producer Fred Coe (the same team responsible for the Broadway production of Gibson's play) glamorized neither of the film's leads. Though Sullivan and

Keller are extraordinary, they look like average people (though it is worth noting that Anne Bancroft is much closer in body type to Twiggy than to the actual Sullivan).

Unlike other films, *The Miracle Worker* presents a person both disabled and female as the 'expert' called in to help another person with a disability. In *Johnny Belinda*, for example, a representative of the establishment (an upper middle class, educated male doctor) is called in to aid someone totally outside the mainstream (a poor, rural, uneducated, mute young woman). In *The Miracle Worker*, the cards are more evenly dealt: a young woman from outside the mainstream (a survivor of a miserably poor orphaned childhood, and Irish at a time of anti-immigrant sentiment) is called in to help a privileged child (a daughter of powerful, wealthy, white American Southerners). What they have in common is their struggle with disabilities and their girlhood; Anne's flashbacks to her frightening childhood link her to Helen. In these ways, the film shows a glimpse of the possibilities of community that able-bodied people rarely recognize among those with disabilities. In addition to offering a heightened sense of realism, films of the 1960s and 1970s also began including more graphic portrayals of violence. The disabled-woman-in-peril motif found new life during this period, most famously in *Wait Until Dark* (1967). In this film, Audrey Hepburn played a recently blinded woman who must battle frightening criminals who have broken into her apartment in search of hidden drugs. Reflecting to some extent both the anti-authority and women's liberation sensibilities of the era, the film does not have a sympathetic doctor around to offer a miracle cure, romance, or a well-aimed pistol shot, thus leaving the heroine to fend for herself for a change. The movie allows the Hepburn character to possess the resourcefulness and strength to succeed at this task, but in some other ways she is just one more example of a Hollywood heroine whose disability puts her at risk but does not get in the way of her being terribly cute.

Some other examples of this genre, which often centred on blind women, include *Blind Fear* (1989) and *Afraid of the Dark* (1992), and the British-made *Witness in the Dark* (1959) and *See No Evil* (1971; aka *Blind Terror*). While films about imperilled blind men have been just as numerous, they tend to have heroes who are actively and even professionally involved in fighting those who threaten them. For example, an entire subgenre of blind detective movies includes *Eyes*

in the Night (1942), *The Hidden Eye* (1945), and *23 Paces to Baker Street* (1956). Many other films with blind male protagonists endow their leads with physical power and/or intellectual expertise. A spate of such films in the early 1990s included *Blind Fury* (1990), in which a blind Vietnam vet tackles the Mafia; *Blind Vengeance* (1990), in which a blind bounty hunter tracks down a murderous outlaw; and *Blind Man's Bluff* (1991), wherein a blind professor solves a murder of which he was wrongly accused. In contrast, the imperilled blind woman rarely is granted the power of physical prowess or professional expertise. Unlike the blind male detective who may be sought out by the criminals because he is a threat to them, or who may actively choose to involve himself in a dangerous case, the blind woman in peril is more likely to be a hapless target, an innocent who happens to be in the wrong place at the wrong time.

During the upheaval of the 1960s and 1970s, the women's rights movement and the disability rights movement took their place beside other social movements that forever changed the socio-political landscape. Hollywood, typically, was somewhat slow and superficial in addressing these changes. With an occasional nod to issues of women's independence or race relations, the Hollywood 'dream factory' continued to churn out more of the usual material on women and disability. Standard portrayals produced during the time include: *A Patch of Blue* (1965), in which a beautiful young woman, blinded in an accident, finds mutual acceptance with a handsome black journalist; *Ice Castles* (1979), in which a beautiful young skater is blinded in an accident, but rekindles love with her handsome beau; and *Mask* (1985), in which a beautiful young blind woman loves a young man rejected by many others because of his disfigurement, caused by craniodiaphyseal dysplasia.

Children of a Lesser God (1986) is notable in that it presents a community of disabled people—virtually unseen in Hollywood film (with the dubious exception of *Freaks*). Ten of the 16 main characters in the film were played by deaf actors, reflecting an expanding awareness in Hollywood of the political importance of self-representation. This film is also rare in that it deals with politics of ableism, albeit in greatly diluted form compared to its stage-play incarnation. *Children* is about the romantic relationship between a deaf woman and a speech

teacher. He wants her to speak, but she refuses, feeling that it is an unnecessary concession to a hearing world that has never made significant concessions to her.

Children also avoids portraying disabled people as unnecessarily noble, which almost all of the previous films do (*Freaks, The Devil-Doll,* and *A Woman's Face* are among the exceptions), but it follows many of the patterns of other films. The expert who enters the world of the disabled woman is positioned in power in relation to her: male, older, educated, upper class, and having the authority of his profession. The disabled woman is younger and works as a janitor at the school she formerly attended. Predictably, the film insists on the attractiveness of its female lead, as the film-makers replaced the actress who created the role on Broadway with one considerably younger and more conventionally 'pretty'. Perhaps most offensively, the film's hearing audience was prioritized over its deaf audience; all the film's signing was spoken but not all speech was signed, and, despite the protests of disability activists, the vast majority of the theatres exhibiting the film did not show subtitled versions.[3] Though it began as a breakthrough play, foregrounding the experience of deaf people yet crossing over in its appeal to able-bodied theatre audiences as well, *Children of a Lesser God* became co-opted into a Hollywood formula piece. While purporting to be a sensitive exploration of the experience and culture of deaf people, it was clearly packaged for consumption by a hearing audience. Its setting and characters were given much the same treatment as those in other Hollywood films set in an 'exotic' locale or 'strange' subculture. Such films are constructed with the needs of the mainstream audience in mind, and not with the goal of accurate representation or insightful exploration of the experiences of the minority.

The trend toward realism gained some ground with *Passion Fish* (1992), in which an actress suffers an accident that paralyses her legs. Moving back to her home in the American south, she copes with a drastically changed life without a shadow of the halo that accessorizes most bio-pic heroines. Eventually, she forges two important new relationships: one with a carer and one with a beau, perhaps echoing the old equation of active heterosexuality as symbolic of a return to normalcy.

What conclusions might be drawn from the films discussed in this essay? Indeed, why are the movie representations of disabled women worth examining at all?

As a start toward answering these questions, we need to consider the process by which mainstream society members develop their ideas about disability. It is important to note, first of all, that disabled people themselves are often excluded from that process. Social scientists have known for decades that able-bodied people tend to avoid interacting with people with disabilities, in part because they are uncertain how to behave in their presence (Thompson, 1982: 108; Yamamoto, 1971: 180–89). In addition, mainstream members are often uncomfortable around disabled people because the latter remind them of their own fragility and mortality. As disability activist Nancy Mairs has observed, 'Most non-disabled people I know are so driven by their own fears of damage and death that they dread contact, let alone interaction, with anyone touched by affliction of any kind' (cited in Berube, 1997: B4). Where do the attitudes come from, then, if not typically from direct social interaction with disabled people? Social institutions such as families, schools, religious organizations, and the various levels of government certainly provide frameworks for understanding disability (however skewed those understandings may be), but it is certainly arguable that the ideas are derived to a large extent from the mass-produced popular-culture environment of which movies are an important part. It is not simply a matter of movies reflecting reality; for some people, movies are the reality on which to draw for ideas about disability. As film historian Steven Ross has argued, 'Movies play an important role in shaping the ways in which Americans think about their world—and, especially, aspects of life about which they have little first-hand knowledge' (Ross, 1999: 1).

Consider the images of disabled women we have just examined: mostly white, non-elderly, heterosexual women who conform to conventional standards of attractiveness. Such female figures, almost always inscribed as pitiable and 'good', are usually rewarded with a cure and thus restored to the privileged status of able-bodiedness (particularly in films of the World War II era and earlier) or are constructed as awe-inspiring and often economically independent overachievers. Able-bodied audiences who view films presenting such imagery might tend to believe that such qualities are normative

for disabled women, and, furthermore, that there is something terribly wrong with those women who fail to exhibit them. Such beliefs may partially account for the highly problematic treatment of disabled women in the United States and elsewhere; bluntly put, our society devalues disabled people in general and disabled women in particular who cannot be cured or who do not demonstrate a superhuman effort to 'overcome' their disabilities. According to a 1999 report prepared by Barbara Fiduccia and Leslie Wolfe of the Center for Women Policy Studies, disabled women's lives are profoundly affected by stereotyping and related social ills:

> Disabled women face a double dose of discrimination and prejudice—both as persons with disabilities and as women; women of color with disabilities are triply disadvantaged. Disabled women therefore face multiple barriers to achieving their life goals. As a consequence of the bias, discrimination and stereotyping that disabled women face, they experience low employment rates and wages, low educational levels, high rates of poverty and segregation, limited access to community services and high rates of sexual and physical violence (Fiduccia and Wolfe, 1999: 1).

It might be tempting to conclude that the experiences of disabled women are separate from the 'reality' of the Hollywood imagery, but a few movie heroines do in fact confront some of the issues suggested by Fiduccia and Wolfe: the abused Unity Blake of *Stella Maris*, the impoverished flower seller of *City Lights*, the poorly educated deaf woman raped in *Johnny Belinda*, the indigent and abused blind woman of *A Patch of Blue*, the deaf woman who works as a janitor in *Children of a Lesser God*, and, perhaps most notoriously, the woman bound to her wheelchair with a lamp cord by a psychotic (one of the few instances in which the phrase 'wheelchair-bound' might actually be appropriate) and pushed down a flight of stairs in *Kiss of Death* (1947). In general, though, the films send a message far more disturbing than these scattered images (the impact of which is often weakened by improbable 'happy endings'), and it is this: it is virtually impossible for women to be both average and disabled. In the world of Hollywood films, they either return to the ranks of the able-bodied or serve as inspirational examples of larger-than-life people. In addition, the women are almost always attractive or at least pleasant in appearance, their looks seldom disrupted by their impairments. Finally, such day-to-day concerns as prejudice, access, and transportation receive virtually no attention; in Hollywood's magical world, all social ills vanish

and all problems weigh solely on the shoulders of the individual women and the people immediately surrounding them. Such constructs do little but perpetuate the devaluation and 'invisibility' of disabled women in the United States and the many other countries where Hollywood films are shown. Often we can learn much about Hollywood film-makers' attitudes toward disabled women by noting the stories they refuse to tell. *Born on the Fourth of July*, for example, was a dramatic breakthrough in the depictions of the experiences of disabled veterans. Conspicuous by her absence, though, was a disabled woman who played a major role in the post-injury life of Ron Kovic, the movie's protagonist: Connie Panzarino, born with spinal muscular atrophy type III, who documented their emotional and sexual relationship in her 1994 autobiography, *The Me in the Mirror* (Panzarino, 1994). Though *Born on the Fourth of July* garnered critical praise for its frank dealing with Kovic's post-disability sex life, his relationship with Panzarino is nowhere to be found in the film. Such absences, ultimately, tell us as much as any presence in Hollywood film. Where is the profoundly disabled woman whose disability is congenital and deforming? Where is the disabled fat woman? Where is the disabled black woman? Where is the disabled lesbian? Everywhere in the world, but not in Hollywood film.

Notes

The authors presented a slightly different version of this essay at the 1999 conference of the University Film and Video Association (Boston, Mass.).

1. More information on the movie image of disabled veterans may be found in Norden, 2000.

2. For a sense of this perspective, see Lundberg and Farnham, 1947.

3. Only 10 of the 215 theatres exhibiting the film in late 1986 showed captioned versions, and they often did so only on early Saturday and Sunday mornings. See Norden, 1994: 288.

References

Berube, M. (1997). 'The Cultural Representation of People with Disabilities Affects Us all', *Chronicle of Higher Education*, 30 May 1997, B4–5.

Cahill, M. (1995). '"A Bad Time of it in this World": The Construction of the "Unattractive" Woman in American Film of the 1940s'. Ph.D. dissertation, University of Massachusetts-Amherst.

Chaplin, C. (1964). *My Autobiography*. New York: Simon and Schuster.

Fiduccia, B. and L. Wolfe (1999). *Fact Sheet: Violence against Disabled Women*. Cupertino, Calif.: Center for Women Policy Studies.

Freaks Pressbook (1932). Billy Rose Theatre Collection, New York Public Library at Lincoln Center, New York City.

Grealy, L. (1994). *Autobiography of a Face*. Boston: Houghton Mifflin.

Lundberg, F. and M. Farnham (1947). *Modern Woman: The Lost Sex*. New York: Grosset and Dunlap.

Mulvey, L. (1975). 'Visual Pleasure and Narrative Cinema', *Screen*, 16, 6–18.

Norden, M. (1994). *The Cinema of Isolation: A History of Physical Disability in the Movies*. New Brunswick: Rutgers University Press.

—— (2000). 'Bitterness, Rage, and Redemption: Hollywood Constructs the Disabled Vietnam Veteran', in D. Greber (ed.), *Disabled Veterans in History*, pp. 96–114. Ann Arbor: University of Michigan Press.

Norden, M. and M. Cahill (1998). 'Violence, Women, and Disability in Tod Browning's *Freaks* and *The Devil-Doll*'. *Journal of Popular Film and Television*, 23, 86–94.

Panzarino, C. (1994). *The Me in the Mirror*. Seattle: Seal Press.

Ross, S. (1999). Re: On the Waterfront [online posting]. Available from H-Film@h-net.msu.edu (25 March 1999).

Thompson, T. (1982). '"You can't Play Marbles—You have a Wooden Hand": Communication with the Handicapped', *Communication Quarterly*, 30, 108–15.

Valens, E. (1975). *The Other Side of the Mountain*. New York: Warner Books.

Yamamoto, K. (1971). 'To be Different', *Rehabilitation Counseling Bulletin*, 14, 180–89.

3

Societal Responses to Women with Disabilities in India

Meenu Bhambani

A brief review of feminist literatures reveal that women's studies in the beginning of the twenty-first century have reached a paradigmatic stage. The global issues pertaining to women have been pursued from political, social, cultural, economic, developmental, ecological and psychological perspectives. But the issues pertaining to women with disabilities have not even been approached and to think even of paradigms in the context of disabled women is a very distant dream.

It would be cliched to state that women form the 'marginal component' of society. We suggest that within this component there is another subgroup of disabled women, who are all the more marginalized. What is ironical in case of this group is that it is virtually ignored not only by their own able-bodied gender but also by disabled men.

Despite their significant numbers, women and girls with disabilities, especially in the developed countries of the ESCAP region, remain hidden and silent, their concerns unknown and their rights overlooked. Throughout the region, in urban and rural communities alike, they have to face triple discrimination because of their disabilities, gender and economic status. Prejudice prevails even within each of the three categories. Among women, disabled women are seen as inferior, and this results in their isolation and marginalization. They become the poorest of poor (Mohit, 1996: 25).

A glaring example of their marginalization and neglect is that till date there is no reliable data available with regard to the number of

disabled women. This is more so in case of disabled woman in the developing countries.

Nisar Ahmed Ganai suggests that one of the causes of female infanticide is deprivation of the malformed or deformed baby from her basic right to life. Even if she is born and survives this attempt on her life, she becomes a victim of passive abuse. Lack of care and affection result in what is called the maternal rejection syndrome or deprivational dwarfism (Ganai, 1994: 259).

Undoubtedly, several problems concerning girls and women with and without disabilities are common. Despite increasing literacy rate, the overall male female sex ratio has declined. As per the NSSO survey reports, 1991, the national sex ratio of females is 86 per 100 males. In some states like Rajasthan, it is 60 women per 100 men. In India, the dropout rate from schools is higher for girls (42.4 per cent) than boys, which stands at 35.4 per cent. Thus we find that women are usually at the receiving end of our society. They are left out of all decision-making processes and their performance is based on the three pillars—low status, low pay and low skills. This has resulted in the 'non-status of women's work' (Patel, 1995: 49).

It has often been pointed out that being a woman means being poorer than a man. For example, the Human Development Report reveals that 'poverty has a decided gender bias.' In a similar vein, the Report of the South Commission explains that 'women suffer disproportionately from poverty, illiteracy and malnutrition'. The issue is disproportionately with whom? The assumption is that the comparison is made with men (Patel, 1995: 62).

In this myriad of statistics and reports, the concerns for women with disabilities have often been ignored and have received scant attention. Women with disabilities are more vulnerable to neglect and physical, sexual and mental abuse. The media, women and organizations working for disabled persons are also indifferent to the discrimination faced by them. The issues concerning women with disabilities, thus, have to be seen in the larger and total context of society 'where large sections of the population—male and female, adults and children—suffer under the oppression of an exploitative system' (Mitra, 1997). It becomes imperative to probe the concerns, problems and discrimination faced by women with disabilities from an economic, social, cultural, political and psychological perspective. Women all over the world, in general, are victims of a discriminatory system. Why among them *women with disabilities* are conspicuously

missing? What relegates them to the periphery? In the Indian context, what societal, cultural and historical factors are responsible for their invisibility, reticence and chronic neglect?

To begin with, disabled women do not have any history. They have not set any precedence which some of the disabled men have, although like men they too have been projected in a very negative spirit. Disabled people in Indian mythology as well as history have been depicted as cruel and spiteful. A disabled woman in Indian mythology is Manthara, the one-eyed orthopaedically impaired maidservant of queen Kaikeyi in the Ramayana who was responsible for Lord Rama's exile. Another is Kubja, a hunchback *gopi* in Braj whom Lord Krishna used to address as 'sundari', meaning a beautiful woman. Lord Krishna saw the inner beauty of Kubja but the *gopis* teased him for liking an impaired woman who appeared ugly owing to her disfigurement. Similarly, there are other stories where women with disabilities are neglected by the gods. According to a *katha* (story) recited during Kartik Poornima, Goddess Lakshmi had an elder sister who could not marry because of her being dark and disfigured. When Lord Vishnu proposed to Lakshmi, she expressed her inability to marry as her elder sister was still unmarried and instead urged him to marry her sister. Lord Vishnu refused saying that there is no place for disabled people in heaven. However, he married off her elder sister to a peepul tree, which he said was another form of Vishnu.

Disabled men, on the other hand, have occupied prominent positions, such as the visually impaired Dhritarashtra or the orthopaedically impaired Shakuni, both of whom sided with evil in the Mahabharata war. However, when we enter the realm of history we find that disabled rulers are very few and far between—Taimur Lang (also Tamerlane; 1336–1405), the Mongol ruler who attacked northern India in 1398, is a rare instance of a disabled ruler. Taimur's surname, Lang, was derived from his malformed foot, which rendered him walking with a limp. Though a powerful ruler, he has been projected as an insensitive and atrocious person. These negative images have had a deep influence on the psyche of the Indian who till today perceives disabled people either as objects of pity or as evil personified.

In a patriarchal society, there are different yardsticks of perceiving and judging disabled men and women, and the treatment meted out to them is definitely discriminatory. Women are often perceived as objects of beauty and bestowers of services to their husbands and

families, their contribution seldom calculated in statistical terms. Their role as producers are overlooked and they are considered a burden on the family. It is this perception of non-disabled women as beautiful objects, delivering services free of cost, which interferes with the development of disabled women. The globalization of the economy has also played a major role in strengthening patriarchy as it has brought women to the center stage of the sex market. The testimony to this fact is the increasing number of beauty pageants held even in remote and smaller towns of India, a process that has aggravated the marginalization of disabled women as they are considered neither physically beautiful nor sexually marketable. In fact, they are considered asexual. Their disability makes them loose the quality of 'looked-at-ness' and also renders them inefficient, incapable, unwanted and undesirable.

Societal response towards disabled women is of utter neglect and total submission. One can find this negative response in the media, which acts not only as a mirror of society but also as a catalyst of change—bringing in new ideas, values, and modes of perception. In a country like India, where 50 per cent of the population is illiterate, it is the visual media, especially cinema, which makes a powerful and lasting impact on the people. Bollywood actors and actresses are not only the matinee idols but also icons and role models who are imitated and emulated by the masses. In Hindi films disabled people are often portrayed as dependent on the society. Usually confined indoors, they pity themselves and cry for escape from their dysfunctional physical state. Popular Hindi cinema has always been inspired by Hollywood and, as Madeleine Cahill and Martin Norden have observed, like their American counterparts, they reflect the discomfort of society in the company of the disabled.

In Bollywood too, one can see the difference in construction of images of disabled men and women. Let us first observe the similarities in both the genders. In both the sexes, disability is rarely congenital. It is always acquired later, making it easier for the masses to accept them. Usually the disability is cured in the climax, which brings them back into the mainstream of society. Both lead a dependent life without anyone to interact with except their immediate kinsmen. They, more or less, belong to the upper strata of society, blessed with facilities—medical, financial, educational—which help them to get integrated in the society.

As in Hollywood, in Bollywood films too, the images of men with disabilities are more prevalent. In spite of their disability, which might interfere with their male ego, they are loved and cared for by non-disabled women. But the reverse in case of women with disabilities is rare. They are objects of beauty who are desired and gazed at by mainstream males. This obsession with femininity makes the film-makers bestow them with impairments, which do not interfere with their looked-at-ness. The disabled women who have severe impairments are always placed in character roles of mother or sister and never in the lead role of the protagonist.

A brief analysis of some of the images of disabled women in Bollywood films in contrast to men with disability may be a proof of the way society responds to them. There are hardly any images worth analysing in the 1950s as the disabled had only a marginal existence until then. They are portrayed either as beggars or in other marginal roles which were totally inconsequential to the main subject of the film. These films, however, abounded in images of blind mothers who were poor, miserable and were taken care of by their only sons. Disability was simply unacceptable and this made the disabled themselves negate their existence. For example, the 1958 film *Hum Dono* had Dev Anand starring in a double role. In one of the roles he is portrayed as a disabled war veteran, a situation so unacceptable to him that he asks his own lookalike to present himself as his wife's husband.

In the 1960s there was *Aarzoo*, which had Rajendra Kumar in the lead opposite to Sadhna. When he loses one of his legs in an accident, he tries to avoid the female protagonist, as he believes his disability would make her life miserable. She, however, continues to love him and, order to convince him of her love, attempts to get one of her legs amputed. A sacrifice demanded from non-disabled women for disabled men is never reversed. If a woman becomes disabled she is left lamenting on her plight all by herself.

The 1970s were a transitional period and one finds quite a few physically impaired women in lead roles in Bollywood films. However, severe impairments were still the forte of character actresses. Thus we find Farida Jalal as the wheelchair-bound sister of Amitabh Bachchan in *Majboor* and lower-limb paralysed Naaz as Rajesh Khanna's sister in *Sachcha Jhootha*. They are, no doubt, loved by their family members but no effort is made to help them in becoming self-sufficient. Their brothers try desperately in vain to look for a suitable

match who would accept them with their disabilities and thus pass on their burden to someone else.

There were four other films on disabled women in the same decade, namely, *Kinara*, which had Hema Malini, in the role of a visually impaired dancer; *Man ki Aankhen*, which had Moushmi Chatterjee as a visually impaired orphan girl; *Koshish*, a sincere and an honest effort by writer-director Gulzar in which Jaya Bhaduri and Sanjeev Kumar played the role of a deaf-mute couple; and *Imtihaan* in which Tanuja played the part of a locomotor disabled woman. In *Kinara* and *Man ki Aankhen*, one finds the lead disabled women extremely charming, beautiful and bestowed with unusual artistic gifts. They are loved by Jitendra and Vinod Mehra, the male protagonists of these two films respectively, for reasons other than their disability. Hema Malini is shown acquiring visual impairment as a result of an accident, partially a responsibility of the male protagonist. For the first time, a mainstream commercial film like *Imtihaan* showed disability of the female protagonist which interfered with her quality of being admired, hence rendering her undesirable. In the film, Tanuja walks with a slight limp, though once again she is beauty personified. Vinod, the protagonist, pities her for her disability and loves her for her extremely good and noble nature, which is in sharp contrast to the nature of Bindoo, who plays the role of a vamp. A disabled woman, thus, cannot be average, moderate, independent or an underachiever. She is always good to look at or she has no place in the mainstream cinema.

Koshish is a pioneering, sensitive and true-to-life portrayal of a speech and hearing impaired couple leading normal lives, with their struggles, desires and interactions with the non-disabled people. The film is a deviation from the run-of-the mill stuff of commercial cinema. However, here too the disabled father is shown as imposing his will upon his non-disabled son, whom he forces to marry a girl with hearing and speech impairment suggesting that disability is acceptable only by the disabled and that they do not have any place in the world of the non-disabled. In spite of having close encounters with the disabled in their immediate family, the non-disabled refuse to develop any empathy towards them.

In the 1980s there were two remarkable films on disability, *Naache Mayuri* and *Sparsh*, one a commercial venture, the other belonging to parallel cinema. *Naache Mayuri* is based on the real-life struggle of a Bharatnatyam dancer Sudha Chandran who, having lost one leg in

an accident, achieved heights of glory in her chosen field with the help of an artificial limb, thanks to her grit and passion. She herself acted the part of Sudha. *Sparsh*, on the other hand has Nasiruddin Shah playing the character of a visually impaired principal of a blind school. He is fiercely independent, highly educated and despises any display of pity. Shabana Azmi, a non-disabled teacher working in the same school, loves him. The two films suggest a contradiction in male and female projections of disability in mainstream and parallel cinema and give a cue as to what is expected of women in society. A woman sans disability accepts disabled men without any qualms but the non-disabled men hardly have any compunction in rejecting women with impairments. The former aspect is exemplified in the 1990s films that have disabled men in abundance but disabled women a rarity. For example, *Saajan*, in which Sanjay Dutt is a polio-affected person loved by Madhuri Dixit; *Chandni*, in which Rishi Kapoor suffers from spinal cord injury but is finally cured; and *Dushman*, which portrays Sanjay Dutt as a visually impaired person. They are all desired in spite of their disability, whether congenital or acquired at some later stage in life.

The 1990s had two other films on disability, both with commercially viable starcast yet both failed to excite the masses, and the experimentation of bringing the disabled center stage ended in a fiasco. *Khamoshi* is a sensitive portrayal of a deaf-mute couple played by Nana Patekar and Seema Biswas. They are shown languishing in their own silent world and as misfits in the world of hearing people. Their only contact with the outside world is through their non-disabled daughter, Anne, played by Manisha Koirala. As in *Koshish*, they are shown imposing their will upon their daughter and creating obstacles in fulfillment of her dreams and ambitions.

Mann is a love story revolving around Dev and Priya, played by Aamir Khan and Manisha Koirala. Priya meets with an accident and loses both of her lower limbs. Like the 1960s film, *Aarzoo*, she too finds herself unfit for love or marriage and feels that she would be a liability on Dev owing to her disability. But Dev accepts her in spite of her disability. Again a male stereotypical image has been projected here. Dev would not have fallen in love with Priya had she suffered from a congenital disability as such disability would have left her on the periphery of society. However, since she was already a part of mainstream life prior to acquiring the disability it was possible to bring her back on to the centre stage again.

It is these negative images which go a long way in the formation of attitudes towards disabled women. The abilities of disabled women are never or rarely projected. Disability, in a majority of the films, is either ridiculed and made fun of in comedies or is pitied and patronized. The disabled are shown as vulnerable and at the same time undesirable, which makes their integration in the mainstream world impossible. They have never been projected as economically self-sufficient and making a positive contribution to the family income. Indeed, it is this aspect which helps in giving them a status at par with their non-disabled counterparts, who again lead a dependent life.

When women start contributing to the family income, it not only adds to their self-esteem, but also enhances their worth in the eyes of the other family members. But how can disabled women increase their self-worth when they are confined to the four walls of the house, their mobility curtailed because of their disability and limited financial resources? In a country like India marriage is a major economic burden on the parents of girls. When this is combined with disability, the expenses increase manifold resulting in neglect and deprivation of disabled women. For economic reasons primarily, they are denied access to education, vocational training, and other rehabilitative services and welfare programmes which can play a major role in their empowerment.

According to Sujata Goenka, 'Women, disabled or not, are respected if they contribute their share to the earnings of the family. Even if women do not work outside their grooves, they support a large part of world economy by "free services" in the home and the community. For reasons of bias and prejudice in statistical and conceptual analysis of much of the work women perform has been officially described as "non-economic activity" ... Women are producers of income and assets in every economy but are frequently forgotten or dropped out of developmental and or environmental strategies at all levels of national and international life' (Patel, 1995: 27).

This observation is equally applicable to disabled women whose contributions are not quantified in statistical terms, resulting in increased violence, abuse and discriminatory attitude towards them. They are supposed to be permanent workers for the family without any remuneration. Added to this is the assumption that a disabled woman is a permanent liability for the family. In this context, Komal Kamra observes that

In our country, economic status plays a very major role in deciding social acceptance. Economic rehabilitation is perhaps the most difficult to achieve for the disabled, particularly for the disabled women. Economic freedom can provide her with self-confidence, which improves her independence and therefore should be looked into with great deal of involvement by the society (Kamra, 1996: 17).

But the question here is how can economic independence be ensured for disabled women? Only by expanding the educational and rehabilitative services and empowering disabled women by providing them with vocational training, especially in the rural areas of our country. Another requirement is to change the narrow mindset of the people. This is because education, or for that matter even professional qualification, may not guarantee the disabled person a suitable economic status all other things being equal.

The economic aspect of empowerment of disabled women has to be necessarily seen from a cultural and social perspective, especially in a country like India. Our culture and society, unlike in the West, encourages dependence and subjugation instead of independence and self-sufficiency. This dependent culture is a direct result of a society dominated by patriarchal attitudes. Disabled women are permanently caught in the vicious cycle of deprivations. They are 'subjected to deliberate neglect, verbal abuse, physical assaults and sexual harassment. There seems to be a conspiracy against women, almost an underground male agenda, resulting in the marginalization and even victimization of disabled women' (Baquer and Sharma, 1997). In the rural areas at least, there exists some kind of social watch, which, however, is absent in the urban sectors. This makes the disabled women more vulnerable to sexual harassment and victimization in the cities. This vulnerability in turn compels the disabled women to look for male protection and thus seek marriage. As Baquer and Sharma opine, the society regards disabled women as non-sexual. They are not considered suitable for marriage. Even if marriage ever takes place, a number of compromises are made. Either they are married to much older men or widowers. In most cases, non-disabled men get married to disabled women, but the reverse is not true. The dowry demanded by men and offered by the families of the disabled women is exorbitant. Disabled women are considered incapable of bearing and rearing healthy children. Society undervalues women with disabilities. She is not considered an ideal child or an adult, is unfit as an employee, unsuitable as a wife, and incapable as a mother (Baquer and Sharma, 1997: 193–94).

I can confirm this out of my personal experience. In spite of my disability being less severe than the prospective groom, economic status being at par (the boy a doctor and I a lecturer), and possessing above average looks—something which Indians are obsessed with—I was rejected in favour of a non-working, less-qualified, but non-disabled girl. Indian society and culture denies women with or without disabilities the right to decide for themselves. Ours is a culture which encourages dependence, especially of women. Ironically, women are considered as service deliverers and their contribution is not economically quantified. The gender bias and discriminatory practices compounded with lack of economic status of disabled women aggravates their subjugation, segregation and misery. It is an established fact that more than 80 per cent of disabled women remain single throughout the lives. Recently, I had the opportunity of talking to a visually impaired person who is married for the past 22 years to a non-disabled woman. He disclosed three reasons for his insistence on marrying a non-disabled woman. First, he said, a disabled man should marry a non-disabled woman as that entitles one to services for a lifetime without having to pay a penny. Second, he feared the response of the society. He felt that had he married a disabled woman, the sarcastic remarks made by his acquaintances would have isolated the two. Last and most important, he confessed that although he himself had no hesitation in taking a helping hand of the opposite sex, he would not have been able to tolerate his disabled wife being touched by another male. Thus, we see that even if disabled women do get married the lasting value of marriage always remains precarious. The success rate depends on how much the bride can contribute and endure. The need to look at the ability of the disabled woman without forgetting her disability and avoid comparison with non-disabled woman is never emphasized. This attitude, together with poverty, ignorance, illiteracy, malnutrition, male attitudes, and their own indifference towards their status and situations adds to their suffering and problems.

The following two case studies of mobility impaired women from different economic and educational backgrounds would help substantiating the point. Both are urban case studies—one of Kalpana from Gwalior and another of Meera from Jaipur.

(a) Kalpana is the second of four siblings. She belongs to the higher income group of society and has access to all the facilities. A postgraduate in English with a diploma in computer applications

from NIIT, she is today a broken-hearted divorcee. In spite of being highly qualified, she lacked the right guidance and hence refused to show any inclination to empower herself with a suitable job. Like a meek cow she agreed to be married off. Her parents gave huge sums of dowry, but the alliance was annulled within three months as the degradation, alienation and abuses proved unbearable for Kalpana. She was constantly abused for her disability but at the same time was considered a milch cattle. The demands for more dowry remained unabated. She had no other alternative but to shun such life and existence. Today she is back at her parent's place, a victim of overprotection, looking for another partner on whom she could depend.

(*b*) Meera, on the other hand, is a victim of utter neglect whose dreams have been shattered to pieces. She is the only daughter of her parents, who belong to the lower middle semi-literate strata of society. She has been the sole responsibility of her mother. In fact, she owes her education up to graduation to her mother. With the death of her father, her brothers stopped all financial aid, forcing her to discontinue her studies. She has been pushed to a corner and made to do household chores all day. The search is now on for a match who would accept Meera with her average looks and her impairments so that she is got rid of once and for all.

Thus, apart from the mindset, the denial of the right to become productive members of society results in greater handicapping of women with disabilities. The problems of women with disabilities are further aggravated due to the accordance of inferior status to them within their own sex. Disabled women also lack role models and powerful advocates of their rights and problems. They are inadequately represented in the disability sector, which is largely dominated by disabled men unaware of the specific concerns of disabled women. They do not have any representation in women's organizations and NGOs fighting against violence or for social empowerment, equality, rights and opportunities. Disabled women, thus, have to fight not only with their own disability but also with an insensitive society.

The complexity of the problems highlighted above are common to both urban and rural disabled women. But rural disabled women face some peculiar problems, which prevent them from enjoying the benefits of development. Data published by the World Health Organization on women's health show that there are several blockages

in information flows in the modern circuits of many countries. Lack of access to these prevents women from having control over their bodies and learning about their bodies.

The inadequate or total lack of access to information, health care and rehabilitation services is further compounded by much higher illiteracy rates, longer distances to services and facilities, and more severe conditions of poverty than in the urban areas. Disability creates and exacerbates poverty, because of economic strain and isolation. However, because far fewer opportunities for productive work or gainful employment exist for the disabled woman than for the disabled man, she is perceived as a greater burden for the family (Mohit, 1996: 26).

The life of a disabled woman is beset with multiple challenges. But these challenges are not unsurmountable. The solution lies in shifting away from the traditional attitude of treating women as objects of worship, as this attitude makes them bestower of services and deprives them the right to procure anything for themselves. More importantly, there is a dire need for empowering women with educational and vocational skills so as to make them productive and enhance their economic and social worth. More and more vocational training centres are required to be opened especially in rural areas for this purpose. At the same time it becomes the duty of educated and privileged disabled women to adequately voice the concerns of their less privileged and unfortunate disabled sisters. The onus to be the strong advocate of gender-based disability lies on them. They must prove themselves to be the role models and try to place themselves in strategically decisive positions. Further a gender-based data of disabled people is necessary as that would help in perceiving the true extent of the problems and discriminations faced by disabled women.

Finally, women as a group must be sensitized so that the issues pertaining to disabled women are seen in a wider perspective and get the attention they deserve.

References

Baquer, Ali and Anjali Sharma (1997). *Disability: Challenges vs. Responses*. New Delhi: CAN.

Ganai, N.A. (1994). 'Child Abuse: The Etiology and Prevention'. In S. Sood and J.N. Choudhary (eds.), *Marriage, Family and Socialisation: In Developed and Developing Countries*, Jaipur: Arihant Publishing House.

Kamra, Komal (1996). 'Social and Economic Rehabilitation of Disabled Women'. In *The End of Long Silence,* p. 17. New Delhi: NAB-CBR Network.

Mitra, Jyoti (1997). *Women and Society: Equality Empowerment.* New Delhi: Kanishka Publishers.

Mohit, Anuradha (1996). 'The Problems of Discrimination'. In *The End of Long Silence,* pp. 10–30. New Delhi: NAB-CBR Network.

Patel, K.A. (1995). *Women and Sustainable Development: An International Dimension.* New Delhi: Ashish Publishing House.

4

Sexuality and Women with Sensory Disabilities

Sandhya Limaye

Learning about one's sexuality occurs both formally and informally through one's life cycle. Many learning opportunities are normally provided by one's environment. Individuals learn about their sexuality in three significant ways: (*i*) directly (from personal experiences), (*ii*) indirectly (from talking/reading about it), and (*iii*) through observation (from listening to and watching others) (Fitz-Gerald and Fitz-Gerald, 1979).

Sexuality is studied in different contexts with a wide range of concerns. The diverse nature of the growing literature on sexuality indicates that it is not a simple phenomenon. It embraces economic, social, political and genetic aspects of human existence (Horrocks, 1997). It includes not only sexual identities, sexual norms, sexual practices and behaviour but also a range of feelings, desires and experiences related to sexual awareness and sexual acts within heterosexual as well as homosexual relations. It is a combination of the physical, emotional, intellectual and social aspects of an individual's personality that expresses maleness or femaleness. It is seen and expressed in all our daily activities—work, expressions of affection, touching, sharing intimacies with other persons, behaviour, values, preferences and social scripts. Sexuality enters into our relationships in diverse ways, both consciously and unconsciously, irrespective of whether sexual satisfaction is an aim or an end (Stewart, 1979). Our ability to form and maintain relationships with other people has tremendous effect upon our sexual needs and satisfaction. There is a wide range of accepted interpersonal experiences of designating

male and female roles and of accepted sexual behaviours in cultures
that are now in existence around the world. Thus, the concept of
sexuality extends beyond the biological and psychological to encom-
pass the social and cultural dimensions of sexual identities and sexual
behaviour. Some societies encourage early sexual experiment while
others forbid and punish it. Societies also differ in their attitude to-
wards such sexual behaviours as masturbation, homosexuality and
means of sex education. Sexuality, being culturally defined and socio-
historically evolved, carries different connotations within different
communities. The understanding of sexuality may differ with age, so-
cial class and gender (Vance, 1984). In our society, we are witnessing a
growing trend towards liberal views with regard to sexuality. Yet there
is a general reluctance to discuss sexuality. Besides, there is a clear rule
about male and female roles, dress, of what is considered admirable
physique/beauty and forbidding sexual experiences before marriage.

The development of sexuality occurs in various stages of life,
spanning from infancy to adulthood. Each of these stages has unique
characteristics regarding sexuality and their behavioural patterns
concerning sexuality. One's concept of sexuality begins to develop
during infancy. A growing body of research indicates that the psy-
chosexual development that is actively initiated in infancy is the
cornerstone of future sexuality (Robmault, 1978). It continues
throughout life as each new experience, relationship and factual data
is added to the ever-expanding world of the individual. Holding
and cuddling of the infant plays an important part in a child's sub-
sequent sex development. At this stage, the infant freely explores
his/her own body and that of others as opportunity is offered. Dur-
ing this close body contact, the infant develops a strong sense of en-
joyment. Thus, the child who has felt the intimacy of a warm adult
embrace has an experience that will later be sought in self-elected
intimacies.

Interaction with particular people and things assume prevalent
patterns during the pre-school years of a child. Within this develop-
mental context, the child becomes aware of sex identity, of one's atti-
tude towards family and new relationships, and gets some idea of
where one fits into relationships. Identification behaviours are par-
ticularly strong during this period as the child attempts to emulate
the behaviour and attitude characteristics of the same gender parent
in order to gain the favour of the opposite gender parent (Freud,
1962). Most parents steer their child towards gender-appropriate

play activities, and society begins to impose patterns and stereotypes upon the child. These attitudes encourage aggressiveness and dominance in the boys while nurturing gentleness and relative timidity in the girls, thereby affecting sexual interaction and relationship.

The parents, their approval or disapproval of the child in varying circumstances, and their attitudes and relationships play an important part in the formation of a child's personality throughout the years before puberty. Many children ask questions related to physical characteristics, sexual feelings and curiosity. Their sex interest and tension become stronger and more obvious as they reach adolescence. During this period, due to hormonal and body changes, the adolescents get opportunities to learn to channel their emotions to develop independence and autonomy and to define their emerging sexuality in culturally acceptable manner. The puberty period and the years just after are the stages at which personality is more or less formed and tempered. Hormonal as well as body changes allow emotion to become mature and engender full sexuality in the individual. Children pick up much of the data on role-appropriate behaviour and gender-desirable characteristics through observation. They also gather information regarding the physical anatomy and reproduction issues, from a variety of sources, both formally and informally, including their families, peers, school, community, literature and media.

By adulthood, all these events and experiences combine into a complex concept of self, both socially and sexually. Whether this ego identity will be positive or negative depends largely on how successfully the parents have structured the environment and helped the child to become aware of the biological functioning (Schuster, 1986).

Sexuality is a complicated topic for analysis. Female sexuality is further complicated by the patriarchal emphasis in its conceptualization and operationalization. Women are socialized to have normal sexual desires and practices and accordingly demarcate their own boundaries of behaviour and expectations. Schwartz and Rutter (1998) discuss the social constructions of female sexuality and opine that the way in which we deal with any social or physical event is totally dependent on the social constructions or knowledge received through socialization. The meaning that sexual events and beliefs have for a woman is determined by her social position and cultural indoctrination. This equips her with ways of understanding and judging many aspects of sexuality.

Women's bodies are defined by men through the tradition of sexological, biological, and psychological perspectives. For example, the female body is used as the generalized object of sexual pleasure for men and this portrayal of erotic images has its influence on both men and women. Thus, a woman who has normal concerns about her body image will fear losing her feminity as a result of acquired disability. This is because women with disabilities are assumed to be asexual not only socially but also biologically and psychologically. This may lead to social withdrawal, feeling of dissatisfaction, and bitterness thereby affecting her self-identity.

A woman's sexual expression and sexual health is intimately linked to her self-image, her well being, her personal circumstances and the social contact in which she develops and lives (Schwartz and Rutter, 1998). Thus, sexuality is an outcome of totality of a healthy body, relationship with other individuals, psychosocial behaviour and learning, physical environment and a host of other factors (Fitz-Gerald and Fitz-Gerald, 1979). It is actually a life-long process of gleaning information and developing values.

Disability and Sexuality

The birth of an impaired child brings initial shock to the family. This is followed by guilt, anger, denial and rejection. Family dynamics may be disrupted because of the need for intensive treatment or care of the newcomer, and smooth patterns of family relationships may be troubled. The disabled child, from the moment disability becomes evident, is 'different' and subject to different considerations from the rest of the family (Stewart, 1979). If this child is a girl, it adds to further misfortune. More often, sex is not only forgotten, it is practically rejected in the face of unexpected deviations of the baby's make-up (Robmault, 1978). This paper focuses on women with sensory disabilities, i.e., the blind and deaf. It is needed to understand the way blindness and deafness affect sexual development.

Blindness hampers playful exploration and learning about others by observation. Seriously impaired vision can affect the interaction and emotional bond between mother and infant, thereby affecting the quality of relationship. The circle of relationship will probably be slow to grow and may be limited in intensity. A blind girl experiences frustration at each level of development in the formation of

self-concept, as the lack of vision limits both direct and indirect contact with reality formation. The difficulties in emulating behaviour patterns exhibited by a person and failure to perceive non-verbal signals in social situations—body movement, facial expressions, etc.—leads to inappropriate social skills and behaviour. Schuster (1986) points out that the socialization process may be slightly hindered as the girl gives more attention to internal rather than external stimuli as a guide to behaviour. This leads to culturally inappropriate behaviour, learning by trial and error, and feeling of insecurity. All of this can lead to devaluation of self as a person and to positive ego-identity.

Deafness is one of the most severe of all disabilities because it strikes at a basic human function—communication. For a deaf girl, the development of speech, language and verbal abstraction is a continuous struggle which affect social, psychological and educational development. This invisible handicap is not always an advantage, for it tends to foster greater misunderstanding (Fitz-Gerald and Fitz-Gerald, 1979). The limitation imposed by deafness not only restricts the acquisition of general knowledge from environment, but also hinders access to sex information. This lack of information affects not only interpersonal play but also in developing a mature and independent behaviour. It is stated that it is not difficult for deaf girls to achieve satisfying sexuality through their visual skills. This is somewhat true, but one must not forget that their hearing losses have complicated their adjustment and denied them opportunities for learning and experiences.

The issues of sexuality become more complicated for young women with sensory disabilities during adolescence and adult period. How far have women been able to exercise choice in their expressions of sexuality? The curiosity about sex is present but inadequate communication may block such experiences. Women with sensory disabilities wish to enrich their sexual identity and enjoy sexual activities. Many communities consciously regard women as inferior beings who do not have the same rights, including sexual rights, as men. Many of the women with sensory disabilities grow up in an environment which do not provide culturally valued expectation or appropriate role models. They may lack knowledge of socially acceptable behaviour which, coupled with their poor self-image, inhibits them from enjoying their sexuality in a mutually respectable manner. The ignorance regarding sexuality leads to exploitation and victimization.

Women with sensory disabilities are assumed to be asexual not only socially but also biologically and psychologically. This is because society projects the message that serious physical imperfections condemn a person to asexuality. Such stigma of negative attitudes and the social barriers that still pervade our society restrict the life space of women with sensory disabilities and often contribute to their problems of personal, social and vocational adjustment. Stewart (1979) points out that stigmatizing attitude towards women with sensory disability may create a sense of inadequacy and this self-perception becomes the actual handicap. The self that lacks confidence will experience anxiety and insecurity, and when they are unable to satisfy basic drives, it can become serious maladjustment for them.

In addition to stigmatization towards women with sensory disabilities, parental anxiety and overprotection may add to the difficulty of achieving emotional and financial independence and social experiences. This may lead to severe relationship difficulties for them due to lack of opportunity for meeting and involvement with other people and/or deficiency in the emotional and social skills that enable adequate development and maintenance of friendship (Stewart, 1979). Stewart found that many young disabled may have less ability to evaluate interpersonal relations and responses, a tendency to withdraw from social situations, few adolescents interest, less mature adjustment and greater fantasy activity.

Issues of Concerns of Women with Sensory Disabilities

Although each disability is unique, some of the most frequent areas of concerns of women with sensory disabilities are new body image, interest in opposite sex, fear of victimization, and marriage. These are discussed based on the author's experiences while working with them.

With the onset of puberty, understanding the concepts of sex, reproduction, and relationships become secondary when one has to struggle with the basic labelling of one's body parts. The deaf woman may not know of words like 'vagina', 'sex', 'development of breast'. Myklebust (1963) points out that a deaf girl is more

immature and confused from a psychosexual point of view because neither hears the innuendoes and taboos regarding sex, nor has verbal inputs about male and female development.

"What is vagina?" I don't understand what you are talking about.

—A deaf girl, 15 years old

Observation and actual experience remain the primary modes of learning about sexuality for deaf adolescent and adult women (Fitz-Gerald and Fitz-Gerald, 1979). Deaf women may be concerned about their changing bodies and occurrences of menstruation cycles but due to inadequate communication and lack of understanding, some of the deaf women prefer to keep quiet whereas others may try to share their concerns with their friends.

I don't know why menstruation has occurred to me. My mother told me that every woman has this cycle.

—A deaf girl, 18 years old

My mother always asks me to sit at a corner when I have a cycle. When asked for the reason, the reply was, "This cycle leads to pollution and it affects the whole house."

—A deaf woman, 20 years old

The above examples depict the myths and superstitions the families believe in, and naturally these women with sensory disabilities also believe it. However, due to limited vocabulary development and poor communication skills, the disabled women find it difficult to examine these beliefs.

Blind girls, since they do not understand the anatomical difference between a girl's and women's body due to our culture's dislike of extreme closeness or touch and lack of information, may become very concerned over something worse. This is clear from the following observations.

I am ashamed of the enlargement of my breasts. I don't know how it happened to me and how to hide it.

—A blind girl, 16 years old

I was informed that the vagina is located between the breasts.

—A blind woman, 22 years old

This poor knowledge of male and female anatomy may lead to insecurity in their relationship.

The importance of vision in sexual communication and stimulation is enormous. It is only through vision that one can see a man/woman to whom one is attracted. The blind girl is thus deprived of a major channel of sexual stimulus. In addition,

she is likely to be misunderstood if others are not aware of her comparative limitations. Finer elements of eye contact, ocular communication, body movement, facial expression may be missed.

> You are lucky to see and experience the company of males. You can make them your friends or boyfriends but I can't do that.
>
> —*A blind woman, 18 years old*

> I liked his voice. How does he look? A prince charming? Handsome or what?
>
> —*A blind woman, 23 years old*

> I always feel comfortable with my deaf male friends, love to chat with them. I was told that I should not do so as it is bad.
>
> —*A deaf woman, 20 years old*

It becomes clear that women with sensory disabilities have the same sex needs, drives, and interaction potentials as a sighted person. Lack of opportunity to gain experience, lack of self-confidence and sensitivity to nuances of interpersonal interaction promote the development of mature sexual relationship (Schuster, 1986).

> While attending the family function, I noticed that the men seemed uninterested in talking to me. When I tried to talk to them some of them smiled at me and walked while others made fun of me. I hate it.
>
> —*A deaf woman, 21 years old*

> My parents prefer not to take me to any family function as they feel that I am a burden to them.
>
> —*A blind woman, 24 years old*

> My parents never took me out as they did not want other people to know about my blindness.
>
> —*A blind woman, 23 years old*

Many disabled women have problems in trying to overcome the negative attitude of others. They feel that they are often mistaken to be sexless or asexual. In addition to social misconception, their own anxieties are as much an obstacle as the disability itself for forming a positive self-identity.

While enlarging one's circle of relationships, the fear of sexual abuse becomes a grave concern. The reason for abuse includes impaired judgement or knowledge, lack of assertiveness, inability to communicate, mistreatment or too much trust in others (Jurkowski, 1992).

> My uncle (father's friend) raped me when I was 18 years old. My mother asked me to keep quiet when she was informed about it. She further told me that it happens to all women, especially disabled women! It continued for four years. Now I am much better. But I still hate such sexual activity.
>
> —*A totally blind woman, 25 years old*

I don't like if somebody who claimed to be an uncle try to pat me and touch my breast.

—A deaf woman, 20 years old

If a young woman has been sexually abused, it will affect her personality, self-esteem and sexual desires and may lead to social withdrawal.

There is an attitude that marriage is not for disabled women, especially for blind women, and that they should engage in rehabilitation activities instead of thinking about sex and marriage. Many parents also feel that it would be difficult for their disabled daughter to take care of her disabled partner after marriage.

I have a dream of getting married, have a home with children, but my parents told me that marriage is not for me. I was shattered with disbelief.

—A totally blind woman, 27 years old

I told my parents that I am going to marry my boyfriend who is deaf. I was threatened to be killed as they felt that I was responsible for creating more trouble for them.

—A deaf woman, 30 years old

It is observed that a majority of women with sensory disabilities never get accurate information regarding changing roles within marriage, pregnancy, birth control and venereal diseases. It may lead to inaccurate understanding of the issues which, in turn, may lead to further problems. The disabled women often come across persons who think that sexual intercourse and orgasm are the only ways to a happy sexual life. The role one plays in marriage is partly a matter of social and personal custom and partly an expression of one's deeply ingrained view of what a husband/wife should be. Practical difficulties in playing one's role in married life can cause frustration and irritability in disabled women.

Intervention Strategies

Sexuality begins at birth and is a life-long process. It is natural that parents are a child's first and most important sex educators. Although good child sex education evolves from good parent education, it is unreasonable to expect parents of disabled children to be knowledgeable or accepting of their child's sexuality when they may not be comfortable with their own. Most parents did not receive sex education from their own parents, so they have few models to guide them.

It is necessary to guide and help the parents to cultivate in their disabled daughters a sense of healthy respect for their own body, the body of others, and interpersonal relationships. Parents have a responsibility to share their concept of sex and sexuality within a framework of religious values, cultural morals and personal ethics (Schneiders, 1968). Teachers of special schools become a valuable resource for parents. They can contribute significantly to the awareness and development which parents may need in order to provide their girl child with accurate information. Thus they can act as a buffer for misinformation and myths with both women with sensory disabilities and their families.

To teach the concepts related to sexuality to women with sensory disabilities, a sexuality and family life education programme should be undertaken through an interdisciplinary approach. These areas include the formation of meaningful relationships, promoting self-esteem and stimulating an awareness of sexuality. Women with sensory disabilities should be evaluated in terms of social history, self-perception, sexual likes and dislikes, their knowledge of sexuality, attitudes towards sexuality, and the impact of the disability on the relationship. How do women with sensory disabilities perceive their disabled partners and does this perception change the quality of relationships? This socio-sexual history can make clear the extent of the deprivation felt by women with sensory disabilities and how it might affect future relationships. The decision can be made as to whether counselling is needed to re-establish intimacy and to promote the acceptance of new limitation.

Even today, there are relatively fewer counsellors who experienced in assisting women with sensory disabilities regarding their sexuality. Awareness among professionals and the public about problems of sexuality and the need to deal with these issues must be accorded top priority in the rehabilitation programmes. The professionals must remember that women with sensory disabilities are human beings, not handicaps. Their sexual feelings and needs are similar to other non-disabled women.

To deal more effectively with the sexual problems of women with sensory disabilities, it is necessary to develop sex education programmes as a preventive measure for young women. Sex education must be aimed at integrating the phenomenon of sex into the mainstream of human relationship so as to create a mature sexual personality (Schneiders, 1968). It is important to combine the social

responsibilities as well as physical responses when discussing sex and sexuality. It is necessary to help women with sensory disabilities in obtaining sexual and social skills that may facilitate normal socio-sexual development. Schuster (1986) states that sex education is important for ego-identity formation and for effective relating and meaningful living. For women with sensory disabilities, the sources of information and formal networks to gather information about sexuality are limited because of the lack of support, lack of mobility and misconception. Consequently, the need for teaching and discussion in areas related to sexuality becomes more critical for them as compared to non-disabled women.

Sex education for deaf women requires highly visual materials. Presenting concrete visual information is an important tool to make deaf women understand the concept of sexuality, as there are communication barriers. Situational games and role-playing can be useful in developing an understanding of values and lifestyles (Fitz-Gerald and Fitz-Gerald, 1979). It is also necessary to organize workshops on sexual concerns of deaf women to find out their needs and problems.

In case of blind women, a wide variety of teaching aids including commercially produced audio tapes and records in Braille must be used. Many young blind women have a difficult time understanding basic concepts and learning details because sex education materials are often heavily visually oriented. There is a need, therefore, to describe the details of human physical variety. Tactile means can be substituted, different clay models and statues can be used in order to explore the human body by touch. The emphasis should also be laid on teaching gender-appropriate behaviour in order to develop the skill and knowledge for positive ego identity.

There is a notion that women with sensory disabilities are asexual. This attitude can affect their own sexuality. The public needs to be educated to the fact that women with sensory disabilities are sexual and that their sexuality is normal. A campaign should be launched to develop both awareness and acceptance by the public regarding the sexuality and rights of women with sensory disabilities.

Counselling programmes must be organized through schools for special children and through rehabilitation centres to assist women with sensory disabilities. Development of sexual counselling services for women with sensory disabilities requires the formulation and implementation of long-term programmes. These programmes are necessary for raising awareness, advocacy, and provision of specialized

services and training in the area of socio-sexual skills for people who work for women with sensory disabilities.

Conclusion

The more expert we become in talking about sexuality, the greater the difficulties we seem to encounter in trying to understand it. Normal development from infancy to adulthood requires sensory and motor abilities to reach out into and respond to the social environment and formulate an acceptable and satisfying sexual role. When impairment interferes with the sexual learning process, the natural opportunities for learning about sex are limited and often not available. This indicates that this is a special area, highly problematic and fraught with difficulties. Effective intervention strategies are needed in order to deal with concerns and needs of women with sensory disabilities for healthy sexual development.

References

Fitz-Gerald, D. and M. Fitz-Gerald (1979). *Sexuality and Deafness.* Washington, D.C.: Pre-College Programme.

Freud, S. (1962). *Three Essays on the Theory of Sexuality.* New York: Basic Books.

Horrocks, Roger (1997). *An Introduction to the Study of Sexuality.* London: Macmillan.

Jurkowski, E. (1992). Sensuality and Sexuality. Paper presented at the Sexuality and Disabilities Workshop, 1992.

Myklebust, H. (1963). Psychological and Psychiatric Implication of Deafness. *Arch Otolaryngology.*

Robmault, I. (1978). *Sex, Society and the Disabled.* New York: Harper & Row.

Schneiders, A. (1968). Sex Education in School: A Research Programme. Paper presented at the 219th Association for Education of Visually Handicapped, Biennial Conference, Toronto, Canada.

Schuster, C. (1986). 'Sex Education of the Visually Impaired Children: The Role of Parents.' *Journal of Visual Impairments and Blindness,* Vol. 80, No. 4, April, pp. 675–80.

Schwartz, P. and V. Rutter (1998). *The Gender of Sexuality.* London: Pine Forge Press.

Stewart, W.F.R. (1979). *The Sexual Side of Handicap.* Cambridge Mass.: Woodhead-Faulkner.

Vance, C., ed. (1984). *Pleasure and Danger: Exploring Female Sexuality.* Boston: Routledge and Kegan Paul.

▊▊
Mirroring a Reality

5
Lifelines: Learning to Live with Partial Sight

Renate Reymann

It was late autumn; the day just would not begin to dawn and big dark clouds were hanging low in the sky. I was in my late twenties then, standing in the hallway in a hospital in Berlin and was looking out into a dull morning. I had been in this hospital for almost three weeks because I had been vexed by severe migraine attacks for weeks and months, and the possible causes for this were to be explored there. That morning I was to be examined thoroughly. The eye doctor I went to see seemed to be in a great hurry, but his advanced age inspired me with the confidence I needed so badly to carry me through all these medical check-ups. The examinations were not new to me, so I did not expect anything new to arise from the evaluation on that morning. Hastily, folding up my file, the doctor informed me very briefly that I suffered from progressive macular degeneration, a disorder which would inevitably result in blindness. He then arose and dismissed me from the examination room.

I was standing by the window, looking into the park without seeing anything because of the tears that filled my eyes and blurred my vision, unable to grasp the words I had heard only a couple of minutes before. Nor was I able for the moment to keep my wits about me. Images and experiences from the past kept flooding my mind, and my head was ringing with that hurried, all too loud voice of the doctor's saying again and again that fateful verdict 'blind'. The only thing I was able to associate with this word in my mind was the colour black. I did not have any idea how anybody could live and enjoy life without

seeing anything. Panic struck me and all I wished to do was to return to my sickroom, go to bed and get my thoughts organized, and take a long and deep sleep. As soon as I was in my bed, neither worked, however. I started to cry again without restraint. I could then feel gradually that the enormous stress inside me was abating. My thoughts were going far back into my earliest childhood days. My father's vision had always been very poor, and he had even had to look for another job. Of course my parents had had their two daughters' eye conditions examined. For as long as I was able to recall I had always worn glasses. My night vision had also been very poor. So consulting the eye doctor regularly had become a routine of mine even in my early childhood. But I managed to live quite happily with this not all too important limitation. From the back of my mind the reassurance was emerging that medical science would be progressing and that nobody at the time was able to state with sufficient certainty whether my sight would really be deteriorating any further. Even some years later, when I was able to go the doctor's alone, I received this or similar kind of information.

Now, lying in my bed, I was not all that sure whether I had actually not been able to hear the entire truth earlier or had refused to do so. This brought my mind back to the present day. At home, down in Schwerin, my little daughter and my husband were waiting for me to return with some good migraine therapy as soon as possible. And once again I was overwhelmed by a number of questions. Could it possibly be that our little daughter too had congenital macular degeneration? How will my husband react? Will we have the strength to continue together as a couple and family? What's going to happen now anyway? What will the progression of my macular degeneration be like? Will there be major phases, or will the progression continue to be very slow? Who is supposed to give an answer to all these questions? Is it possible to find any answer at all? I hardly knew anything about this eye disease myself. Where could I find some information? One question after the other arose which I did not feel able to handle alone, and which again and again made my thoughts go round in circles. What was going to become of my job to which I completely committed myself and which I enjoyed so much? At the time I was working as a chief engineer in a big enterprise. My responsibilities included the planning, procurement, administration and statement of costs of all power resources used by the enterprise. To get to where I was, I had studied for many years at a university and had written a

dissertation. Actually, I was standing at the beginning of my career. To do my job, I needed my eyesight. I certainly would not be able to work just from desk. I had to control the energy systems installed in the production halls and the systems which transformed the heat energy for the various processes. My work involved a high level of responsibility and had to be performed with great reliability. What was going to happen? Would I have to give it all up now, knowing that I was going blind? But what had really changed about my eyesight during the last hours? The brief statement the doctor had made could not possibly influence the current status of my retina!

Finally I was discharged from hospital, and with mingled feelings which escape any clear definition, I flung my arms around my husband's neck as he came to pick me up. I had actually meant to discuss things with him calmly and carefully, but then I lost control and my words came gushing out in a most disordered and probably incomprehensible manner. For the moment it did me really good to just let out everything and to be relieved from carrying my heavy burden all by myself. I had got back on an even keel, and through our conversations I was able to reorganize my thoughts again. Actually nothing much had happened, except that I had been told the unvarnished truth about my eye condition in a very brutal and insensitive, but then again also the most honest, way. Maybe other eye doctors had tried before to break the prediction to me that my macular degeneration was unstoppable. But I had refused to listen, taking from the consultations only as much as I was able to bear. Now there was no running away; I had to tackle the problem. First, there were a lot of practical matters which had to be settled. My husband and I had to be sure whether Kathy, our little daughter, was also affected by the hereditary disease. So I made an appointment with the university hospital in Greifswald to have my daughter checked-up thoroughly. I also registered myself as a disabled person with the authorities and discussed with my employer my future job prospects at the enterprise. In taking all these steps I was supported by my husband. As Claus was working at the same enterprise, he helped me find new ways which would allow me to continue my work and to concentrate more on working from desk. Later, by taking on greater responsibilities in my department, it would even become possible to delegate part of my work, which required vision, to sighted colleagues. Leading a team would be a new, thrilling challenge for me. But this became a reality only after years of leading rather ordinary lives.

The time of my daughter's medical check-up was approaching, and in the summer of 1978 the whole family went down to Greifswald to go to the local eye clinic. Due to previous observations of my daughter's behaviour, for instance as to the way she moved in a dark room, results of the examination did not come to us as an unexpected surprise. By that time Kathy was seven years old, and there was one thing I wanted to ensure: my daughter was to grow up with and learn to handle her eye disease in a manner different from what had been my experiences. Although we were making great efforts, we were hardly able to obtain any information about the transmission of the disease and its likely course. We sought medical advice from various doctors, but they left us without any courage that there might be the long-hoped-for therapy capable of stopping macular degeneration, or that there might even be possibilities for transplantation. The eye doctors did not make helpful predictions as to future developments either. Even genetic counselling which we sought amounted to no better statement than that the chances of the disease being transmitted to our children were 50 per cent. And yet I was longing so much for a second child. I had always wanted to have two children, but, after my stay in hospital in Berlin, had started to strongly suppress this wish, in fact had come to consider it to be impossible and even stupid. Wasn't it irresponsible to cherish a wish for another baby with all my perfect knowledge about the hereditary disease? Again and again I caught myself thinking that my sister was not affected either. Hence the 50 per cent odds from statistics were true. Unfortunately, Kathy was affected. But why could it not be that a second child would be lucky enough to be born healthy? Or was I getting into the habit of re-interpreting all good arguments against a child? Claus, my husband, and I discussed this matter for hours and hours and still arrived at no decision balanced between reason and feeling. In fact, it was not possible to make a decision at this level at all. I realized that the only one who might have an answer was me.

How did I feel about my own life? I was quite happy with my life and found each and every day just thrilling and wonderful. Sure enough, I was aware of the limitations I had to put up with because my sight was deteriorating, but this did not make me feel depressed or angry about my condition. I was no longer able to, and simply refused to, consider and assess my life as being separate from my disability. Ages ago I had stopped asking myself why this had happened to me of all people. Claus, who supported me in the background,

inspired me through his positive attitude to life with courage and self-assurance, whenever necessary. I realized that there were largely two kinds of people around me. The first group consisted of people who were shaping life actively, while the people in the second group were being shaped by life. And I was going to ensure that I belonged to the first group at any rate. Just then an adage came up from the back of my mind, written beautifully in ornate letters on a framed board which used to hang up on the stairs in my granny's home: 'Life is a struggle. Make sure you'll be the winner.' Yes, I was definitely determined to be the winner. I could feel the strength I needed for this struggle growing stronger and stronger within me, and each time I regarded my cheerful and lively daughter I was happy that I did not have to make an either-or choice when I was expecting her. It came as a revelation to me that hit me like a bolt from the blue: By deciding against new life you endorse the view that your own life is not worth living and that if you had had to make a decision about yourself you would have preferred rather not to be alive. This idea intensely terrified me because I could see my little daughter in my mind's eye again—one who was already a schoolchild, who had so much enjoyed learning to swim, and who was a real little darling. Now it was our turn that we as parents enable Kathy to lead a self-conscious, self-determined, contented and happy life. Adopting and living this attitude ourselves, we did not find it difficult to make a choice when I was expecting my second child in 1980. Both of us were looking forward to this baby. I had become more mature and was feeling emotionally calmer and more balanced.

One year after Carsten's birth new opportunities were opening up and, with the help of a very committed eye doctor, we had Kathy's eye condition examined at the Moscow Helmholtz Institute for Eye Diseases and included her in a therapy programme for children with macular degeneration. Claus went with Kathy to Moscow for two weeks every year, and all of us were cherishing hopes that the therapy might stop or at least slow down the progressive macular deterioration. Starting in 1983, Carsten was included in the therapy programme. The children had injections of a serum and received some additional treatments to improve the retina circulation. The eye doctors were not able to predict which course the macular degeneration was likely to take, but both of us had the feeling that we had done and organized what was humanly possible. It was too late to try out such a therapy for myself, but I did not feel very sad about this.

Rather I was grateful that my children had been offered this possibility. As a study revealed some time later, the therapy experiment they had undergone had a statistical success rate of no more than 25 per cent. It would be pointless to discuss whether or not that therapy had been helpful for our two children. At any rate, consulting the Moscow Helmholtz Institute made us realize that there was no verified therapy for this genetic disorder the world over, and that parents from many parts of the world were participating in this therapy programme. Additionally, there was another piece of information which Claus brought home from these travels: In various countries, affected people had started to set up peer organizations to exchange information on inheritability, therapy programmes and the results of the latest researches.

In previous years I had tried to make contacts with the blind and partially sighted people in my hometown. I got to know some strong people, who were able to lift me up. However, I also met some people who had given themselves completely up and did not expect anything from life any longer. As such experiences made me feel sad I retired, but was even more determined to pursue the journey through life I had chosen. I felt no strong need to maintain relationships with people who did not meet my leanings and interests. Life was much too short and precious. I was longing to know people who were committed as much as I and enjoyed life.

One particular event I can still remember vividly. It was during a climb up the High Tatra Mountains in the company of my husband and friends. I put full trust in my husband and was climbing step by step, strictly following his instructions. After reaching the crest and enjoying the marvellous view, which at these heights is often barred by thick fog banks, a friend of mine who was also with the party admitted to have felt very scared during the final sections of the climb, and remarked that she dared not to gaze into the abyss. I had gone all out during the last minutes, giving full physical and mental concentration on the guiding instructions from my husband, and placing my foot where Claus had just removed his. The abyss did not scare me at all as due to my restricted visual field I did not perceive the depth. The joy one gets from the summit view was not marred in the least by frightened gazes into the terrifying depth. Even many years later this memory seemed to me like an allegory of my life. Did I not use all of my strength and resources so often in various situations to achieve the goals I had set myself? And everytime I reached a goal I

had the same feelings of satisfaction and happiness like at the time when I was in the High Tatra Mountains. The course of my lifelines was to challenge me quite often.

The year 1990 was one of those years which intervened in my life decisively. For one thing, there were those political events in my country, 'die Wende' or the turnabout, which threw people off their beaten tracks and required them day by day to take new personal decisions. Second, the doctors diagnosed cataract in my two eyes which grew so aggressively that my lenses clouded within a few weeks to the extent that reading print became impossible. At the time I consulted a self-help organization and met people who like myself suffered from progressive macular degeneration and were additionally affected by cataract. The odds for a successful operation were highly controversial both among the medical community and peers. People who were against operation argued that it was not possible to regain the same level of vision as before the onset of the clouding of lenses. Also, they said, the mental stress would be unjustifiably high because the hopes one cherishes before the operation cannot be fulfilled. There were long and learnt debates which made my consternation grow only deeper since I had resolved spontaneously to have an operation but had now found myself put in a state of great uncertainty about my choice. I was perfectly aware that the operation would not do anything about the small field of vision, and that the waning contrasts would not become any better. But at the moment my vision was blurred as if there were a piece of tissue paper before my eyes. Was I supposed to put up with this just because the operation involved some risks and perhaps would not improve my vision? I certainly was not ready to surrender without a fight. Like so many times before, I found that there was no alternative to taking a leap in the dark, i.e., to keep the appointment I had made with the hospital.

I tried to take this step with as little expectations as possible and was more than happy when I found out that when the bandage was removed from the eye one day after the operation I was able to see the tiles on the roof of the house across from the hospital. Only the day before I could perceive those tiles to be some soiled red surface. To be able to see again clearly was like a gift to me. Even if this state were not to last, I would certainly not regret undergoing the operation. Three months later I had had an operation on my second eye, which yielded, unfortunately, not the same positive results. This did not cause great sadness on my part since I was able again to use my

left eye for reading, and to see colours with both eyes. I wanted to make the maximum use of the light which had been given to me.

In the autumn of 1990 1 had, like so many other people to reorientate vocationally. The company where I was working had been reorganized, and many jobs were lost as a result of this. This radical change affected the economy, administration and the social system. It was a really thrilling time to live in, and I did not know where and how I was to come in all this restructuring. I realized that in order to stand a chance I would have to brush up my knowledge and get fit for the new era. To survive the company management cut down the workforce by 50 cent. My job, which gave me an awful pain to learn, was also among those many which were lost. However, I took advantage of some free time I had gained by orientating and acquiring new knowledge. The offers from various educational establishments kept flooding my letter box daily. It seemed as if in those days one might have learnt almost anything. First of all I wanted to do something for myself. How many times I had regretted that besides Latin and Russian I did not learn any other foreign languages at school! Now all I needed was available to me—time and enthusiasm—providing me with the opportunity to devote myself to studying a new language. Only a few days passed between the conceiving of this idea and the delivery of cassettes and books at my home. So there I was sitting in my kitchen, for one or two hours each day, books and teaching material spread across the table, wearing headphones and deeply absorbed in the lessons. Small vocabulary cards could be found all over the place and my children who were learning English at school at the time had to answer many a question patiently and repeatedly. After about six months I had completed the course for beginners and threw myself into my next educational venture. I never had had the chance to acquire computer skills—neither in my job nor privately. Unfortunately the touch-typing method I had learnt during my vocational training over 20 years before had fallen completely into oblivion. However, with my vision deteriorating further, computer literacy would become a necessary requirement for communication with sighted people more than anything else. These were reasons convincing enough in my view to register for a combined computer course and to go back to school and—unlike with my English course—to unravel each day the mysteries of computer technology in the company of fellow students. At the time I started the course I did not yet need to use electronic devices or enlargement software. My

sighted fellow students helped me to overcome any problems of orientation which occasionally arose owing to my decreasing visual field.

At this time, which was exciting anyway, I felt strongly attracted to the problems blind and partially sighted people face in society. Looking back I cannot tell exactly what my motivation was for campaigning as a candidate for the regional board in the autumn of 1990 and some weeks later even for the national board of the German Federation of the Blind—whether it was pure curiosity about founding a separate and independent regional blind organization or whether I had been sustained by the feeling that a reasonable policy for people with disabilities should be developed and implemented by the disabled people themselves. Anyway, the Regional Association of the Blind and Partially Sighted in Mecklenburg, West Pomerania—a small federal state in the north of Germany along the Baltic Sea— had been established only a few days after the two German states became united again. Busy days followed when I, carrying under the arm a copy of the constitution hot from the press, started developing, together with the other board members, a variety of interesting programmes and services for the visually impaired. Equally important was, however, the exterior impact the organization would be making on the State government, of whose policy the blind and partially sighted members had high expectations. In talks and discussions the regional blind association, supported by other welfare organizations, was fought for the social protection of people with disabilities, for the creation and retaining of jobs for blind and partially sighted workers and for the provision of funds for the programmers. This too was a new experience. In the past, programmes for people with disabilities used to be funded and—as regards content—determined by the State government. Now new ideas and expertise were much in demand in order to be able to exhaust as many funding opportunities as possible, and to carry out optimum work for peers, using at the same time whatever limited funds were available. However, not rarely did we have to recognize in the talks we were leading that the goals we had set were not achievable for the moment, and that smaller steps had to be taken. My personal role in these discussions with the State authorities' representatives reinforced my wish to become even more actively committed to and support the cause of people with disabilities and those who are socially excluded, apart from my very interesting work as a volunteer. In this latter respect, after looking for one year and a half for a job that would be both compatible with the

needs of a partially sighted individual and offer participation in decision making, an opportunity finally came up to make a completely new re-entry in the labour market.

And there was yet another fact which gave me strength and self-confidence: Despite my disability—by that time my visual field had already become so limited that I was considered legally blind—I had succeeded in finding a job. I was not a dreamer and knew that this was not common practice in the labour market. In the years to come my new job enabled me to show through my behaviour and work that people with disabilities were able to function as efficiently as their non-disabled colleagues if they were only given the appropriate equipment they need. Some months before, together with my colleagues at the board, I had started to build up the blind organization. Now I was challenged to build up, together with my colleagues at the office, the administration of the government of the State of Mecklenburg, West Pomerania. In the years to follow, many state-level regulations had to be drawn up to enable authorities to implement the federal laws in a practical manner.

As people will always need to use what they once learnt in life sooner or later, I did not hesitate a long time when I was asked whether I would be interested to serve on the commission of the European Blind Union for the Activities of the Partially Sighted and represent the interests of the German affiliate in that commission. I got to know some interesting and committed people from a variety of countries and was able to expand my horizons through sharing long discussions and talks with these people. At any case, I had to quickly enroll for an English course for intermediate students. So the good old kitchen table was once again turned into a table of learning.

At that time I read an article in a daily paper on the lookout for German host families for students from the USA. Within the framework of a parliamentary students exchange programme the young people were planned to be invited to come to Germany and stay with their host families and attend the local school for one year. My family was soon all enthusiastic about this idea. So in August 1992 we went to Hamburg to meet Nate, a young American student from Oregon, USA. Living with this new family member who came from another country made our family's life incredibly richer. It was a permanent bicultural exchange of taking and giving. We went for excursions and travelled a lot to show Nate a great deal of Germany. Nate also took part in our regular visits to the theatre,

and we discussed various cultural and political events. Through our discussions we gave each other fresh food for thought, and I very often had the opportunity to learn English together with Nate or help him with his German homework. I suppose Nate's stay in Germany gave our son Carsten a first impulse to go to Texas for one year as a guest student. Saying our goodbyes in the summer of 1993 was hard to do for everyone of the family. I felt as if I had to part from a son for an indefinite period of time. Fortunately, there were new events and impressions which made this farewell feeling fade gradually.

I moved with my family into a quiet, bright house at the outskirts of the town, far away from the noise of streets and the hustle and bustle of much-used roads. Although the location was quiet, I quickly learnt that my ability to orientate was not sufficient to reach the office safe and sound. In the morning Claus was able to give me a lift in his car, but in the afternoon I had to take the bus to get home. If I did not want to have to walk this route daily, relying on good luck alone and yet full of fears, there was only one alternative: doing a training in orientation and mobility. Sure enough, taking this hurdle was much harder than I would admit. Using the white cane enabled me to take part in traffic safely, but on the other hand this made car drivers and pedestrians perceive me as blind individual. Yet my vision was still sufficient to allow me to read a book in print or look up a bus timetable for the next bus. Wouldn't I be losing credibility with other people? Wouldn't they even brand me as a malingerer? How would the people I know react anyway if I ran across them, using my white cane as an orientation aid? Would they express their pity or would they even avoid me to hide their own insecurity? Sure enough, all my friends knew my sight was poor, but until then I could manage even without a long cane. But would fears and pressure not increase when one has to move in an unfamiliar environment? My choice to use the white cane had been influenced not least because I felt that this could be an example to my two children. One thing I had become absolutely determined about was to accept only those limitations which I could not overcome by employing technical devices. So in late autumn, on days when it was dark early, I would walk the way from my house to the bus stop and, within the city, from the bus stop to the office, accompanied by a mobility instructor. Training started with the use of the long cane, which presented only little difficulties to me. I also learnt how to make adequate use of my residual vision and hearing and was able to make entirely new experiences during

training hours. For instance, some passers-by coming up towards me suddenly changed the side of the road, although I smiled in their faces. Did this indicate people's vague reluctance to meet me or did they just mean to let me past? I did not have the courage to ask though. However, I also had some very positive reactions during my mobility training. I can recall one special occurrence when a lady addressed me when I was standing at the street corner exploring whether I should cross the road. The lady gently asked me whether she might help. I certainly would have liked to accept her assistance, but my training task was to cross the road independently and my instructor was waiting for me across the road. I explained the situation to the lady so that she would offer her assistance next time again. I had to do the last training hour entirely on my own. My instructor had gone on ahead by car and expected me to be at the bus stop in no later than 15 minutes. It was a very unpleasant autumn evening which had brought on some drizzling rain. I did not feel the drizzle because of my emotional tension; I noticed the rain only because my coat was getting wet. In only 10 minutes I reached the bus stop without any major difficulties, which made me feel happy and proud because I had been able to win back a part of mobility. Since that time the white cane has become my constant companion. On dull winter afternoons I would no longer look nervously out of the window or on my watch wondering whether I would make it home before nightfall, because my cane gave me the confidence that I was able to move independently in a familiar environment, even in the dark.

The months and years were flying. Life was filled with work and many a weekend was spent travelling alone or together with my husband in the cause of blind and partially sighted people. Without the active help of my husband I would not have been able to bear this enormous double stress during all those years. When I was away, Claus was taking care of the rest of the family, and I must admit he developed great organizational skills at this. He came to pick me up from meetings, which were not accessible by bus or train, or took me there by car. My sight had even become worse by then, so that although I was using glasses or magnifying glasses I was not any longer able to read longer texts. At first I resorted to believing that I was not able to read for longer periods because I was too tired or overstrained. But finally my eye doctor broke the news that optical devices would not be enough, considering the current status of my retina. I then found that using CCTV, which allowed varying the contrast and

magnifying the text, was really very relaxing. So once again there were some changes in my everyday life. My place of work was adapted to my needs; at home too a TV magnifier had to be acquired. Fortunately, owing to my administrative experiences, the bureaucratic hurdles were not too difficult to take. I had been able to help some other people in getting through their applications for special equipment. And with the delivery and installation of the equipment I had applied for, I finally won back again another bit of independence. At the office I did not depend any longer on the assistance of my colleagues; at home, I very soon discovered that a TV magnifier, like the one I had, was very useful both for threading a needle and for filing or painting your fingernails. I was able to read under the camera the name tape in garments or write my Christmas cards alone, or fill in a banker's order. Has any sighted individual ever thought about how important such little things can become in everyday life? I am doubtful because otherwise many products would be designed in a different manner. Life is so much geared to seeing and hearing that other important senses like the sense of touch and the sense of smell are hardly addressed. Yet I too had to find the suitable spices for cooking, had to rely on my sense of smell, because even the camera of a TV magnifier is only to a limited extent able to make print readable on a bulbous spice pot.

I had always admired my colleagues at the board because they were able to read by moving their finger tips along the Braille lines with great skill and speed. Of course, in public I too had always emphasized the importance of Braille for blind people; secretly, however, I had hoped I would be able to do without it for good or for a very long time to come. But as long as my vision allowed me to perceive the individual dots over a Braille line, all I was able to feel was a great mess of dots. I believed I would never succeed in having access to a meaningful system through touch. I spent a long time thinking about how I might solve this new problem. For instance, I might record my notes on a cassette, but how long would it take me to find a particular note, using fast forward and backward speed? And how was I to recognize my favourite CDs in future? Was I supposed to put each single CD into the machine in order for me to know who was performing? I loved reading and had changed to using audio books a long time before. Actually I would have preferred much more to unwind in my chair and read a book. This does not restrict you to one particular voice and allows your imagination free play. Were

these reasons not enough to mingle myself again among the company of students as I had done so often in the years before? But this time I would not be sitting alone at the kitchen table, struggling through the lessons. So in the spring of 1999 I enrolled for a Braille course. Registering did not require much pluck, and it was still a long time to go until autumn would be around. Unfortunately, by the time the course started I had my doubts whether I would be really able to activate my sense of touch to decipher all the individual letters within so short a span of time—after all, two weeks was not enough for learning the alphabet. But I was fortunate again to know some long-standing Braille readers who encouraged and ensured me that I would definitely be able to learn half the Braille symbols within two weeks. It was all very well for them—after all, they had been reading Braille from childhood!

On a beautiful sunny autumn afternoon Claus took me in his car to Boltenhagen by the Baltic Sea where the 'students' came dropping in one after the other. I felt as if I had been taken back to the days of my childhood when my mother used to take me to school. Saying goodbye to each other with words such as 'Be a nice and hard-working student' and 'Don't forget about me!' left me somehow sad and helpless. This mood, however, vanished very soon when all participants were getting together after dinner and were relating after a short round of introduction why they were bent on learning Braille. I was almost ashamed of my doubts. Around the table, there were some blind people quite advanced in years whose desire to be able to read independently was greater than their fears and doubts. From that day on we used to sit at tables moved closer together, spelling words like six-years olds do with the help of their primers. We encouraged each other when we made any progress and laughed heartily when somebody completely misspelled or misread a word. And most important, learning was great fun. We motivated each other and occasionally even missed the coffee break in the heat of the moment.

There were also some sighted participants in our group who wished to learn Braille for communicating with blind people. The fact that sighted people were among us did not produce, however, different levels of learning progress since they as much as we had to work hard. They used their eyes only during breaks and on our afternoon walks on the beach to bring the beautiful autumnal Baltic Sea scenery home to us through their additional descriptions. After

eight days most people in the group were actually able to identify and use the whole Braille alphabet correctly, including the punctuation marks, and were reading their first short whodunit, the contents of which, I must admit, was beyond my comprehension on my first reading. I still had to concentrate too much on the individual letters and on stringing together groups of letters. But I was happy and proud of my success. Taking the hard ascent had been worth the effort again like back in the old days in the High Tatra Mountains. I had been going as far as one possibly can so that I still had pins and needles in the tips of my index fingers when I was lying tired in my bed at night. But I had succeeded in linking meaning and contents to a script which until then had been impenetrable for me. And with this the door to independence had opened up still a bit further. Of course, I did not want to be stagnating. So very soon I made sure I got my next Braille self-teaching pack under my fingers—this time one that taught contracted Braille—and used to spell every night again, when my husband and I had made ourselves comfortable in the living room. One thing I did miss indeed was my Boltenhagen group who surely would have been able to give me a hand in mastering the tricky combinations of words. It would still be a long way for me to go before I would be able to read the first Braille books and texts fluently and without stuttering. I did not know how much time would pass until then, but I was sure I would succeed. After all, I had already brailled my first Christmas card and had received Braille letters which I was able to understand instantly.

A couple of days before the turn of the decade I had the last 25 years pass before my mind's eye. Our children were grown and not living with us any longer. Our daughter had borne her first child bestowing on us the dignified status of grandparents. Our son was doing a vocational training. So the house had become a lot calmer. Nevertheless, there was never boredom because apart from my job responsibilities I was very often away travelling and working as a volunteer committed to the needs of blind and partially sighted people in Germany and in foreign countries. The remaining time had to be allotted to careful planning to enable us to do those recreational activities we both loved so much. Claus and I did tandem tours through the wonderful Mecklenburg countryside or enjoyed the morning sun on the patio at breakfast. For 18 years we had been keen theatregoers, and the two of us had developed great skills in describing the important parts of a play or ballet being performed on stage without

disturbing the people in the neighbouring seats. But sometimes it was also nice for a change to just sit together over a cup of tea or listen to some good music and just let thoughts wander about. Yes, I was quite happy with the course my life had taken. In crucial situations, at turning points, I had been ready to fight and to determine my further life career. I was also very fortunate to have had my husband by my side at all times. This feeling of being secure within my family again and again gave me the confidence that the way I had chosen was the right one and that I was supported by my husband. Both of us had managed to teach our children with patience and carefulness that enjoying life and the pursuit of personal happiness was not dependent on my disability. I am sure that my lifelines will not be running dead straight in the new millennium. Life is much too exciting for that to happen. But if I stick to that ancient adage in my grandmother's home reading 'Life is a struggle, make sure you'll be the winner!' I will never go astray and will be able to continue to draw my lifelines by myself.

Young Women with Disabilities in Post-Secondary Education: A Personal Story

Stephanie K. Takemoto

In retrospect, entering Chapman University was both a blessing and a curse, but when the experience was new, it felt more like a blessing. I can still recall the time when the excitement swelled within me, as I hungered for independence. I learnt that I would be able to specialize in an academic area that few schools offered, not to mention being able to participate in an educational environment that could be tailored to my own personal goals. I felt privileged; I felt that I deserved it. Perhaps above all else, I felt that I was in control of my destiny. Yet the possibilities of what I have learned were beyond the scope of my imagination, for better and for worse. When I began my first semester at the university level, I learnt that being a student with multiple disabilities would serve as a roadblock that many before me had silently encountered, and that many had given up in spite of.

To begin with, I will describe the disabilities that have unfortunately come to define me in the eyes of the administration in this particular academic arena. My primary diagnosis is seronegative spondyloarthropy, which is a negative form of ankylosing spondylitis (spinal arthritis).

The Blur

At first I thought the pains were just part of the game. My particular game was volleyball, so I figured that if I wanted to be the best I would have to put my body on the line. I was selected to play on my

high school volleyball team, a dream come true. During the course of the season I suffered a variety of injuries, but that came with the game. The pain I suffered long after the season was over was what started to worry me.

All my life, I had suffered some kind of daily pain. I had a complete blood transfusion as a newborn because my bilirubin was too high. I attributed some of my pain to the fact that my heels have been sensitive ever since the transfusion. But this pain was different. It originated from deep within, relentless. Even on the few days when there wasn't pain, I wondered if my brain was just not registering it. Sometimes, the pain was so intense that I couldn't walk to the next room. Something was wrong, but my paediatrician could not put her finger on it and I could not wait anymore for a revelation.

I had a series of x-rays and blood tests done to ensure that the pains I experienced were not related to any previous injuries that I had suffered during volleyball season. Everything showed negative.

That is what we first thought. After refusing to see an orthopaedic surgeon (because I didn't like the way 'surgeon' sounded), my paediatrician decided to send me to a rheumatologist at Children's Hospital of Orange County to rule out arthritis. The tests showed that I have a negative form of arthritis. The doctor continued to explain that, specifically, I had ankylosing spondylitis and described what the disease was. I could not quite comprehend what was being told to me. I turned to my mother to try to get an explanation; nevertheless, all I can remember is seeing her in one of her 'upset' moods. Her nose and eyes were slightly pink and there was a twinkling in her eyes. My brothers had no clue what was going on; they were hungry.

Then, we were introduced to the rheumatology staff. Everything started to become a blur from here on. First, we met Vickie, a rheumatology nurse. As directed by Dr. Sanematsu, she gave me an enormous package of information to read. She began to write a letter to my high school, explaining that I had been diagnosed with arthritis and that arrangements would have to be made. Nancy, my social worker, walked in and joined the party. She explained that she was there to help me with any emotional problems. I thought, 'Yeah right, I won't be needing her.' Unfortunately, I was wrong. A few weeks later the weight of the diagnosis hit me.

When we left the hospital it was dark. People were at home with their families getting ready to settle in for the day, and my family was left to start a new life with a daughter 'labelled' with a physical disability

and all the emotional challenges to go with it. Within hours, my life changed dramatically. All within a blur, just like a car accident, life threw a curve and now the people around me and I had to cope with it.

Then if my life could not take a bigger turn for the worse, I was diagnosed with costochondritis (inflammation of the cartilage between the ribs) and fibromyalgia. Fibromyalgia? I could not even pronounce the word. I had to have my rheumatologists explain over and over to me what fibromyalgia was, because it just did not make any sense to me.

There was little documentation on fibromyalgia when I was diagnosed with it, so I was left with little information on this mysterious disease. Being the inquisitive everything there was to fibromyalgia and make the decision whether I had the disease or not. Doctors can be wrong. I had to be sure.

I was diagnosed with the disease in October 1996. Shortly following the diagnosis, I went into a deep depression for eight months. There were times when I thought that there was no way out, that my world of sports and academics was over, and then it got worse. I was diagnosed with something else, this time it was fibromyalgia syndrome, which is known to effect 2 to 4 per cent of the entire population. Over the coming months, seemingly against all odds, it got even worse. As the diagnoses piled up, I struggled to keep my sanity and felt the weight of the proverbial deck being stacked against me. All told, my number of chronic diagnoses is at 16 and counting. The latest, vasovagal syncope, leads to bouts of fainting.

Creating Friends and Relationships

As an incoming, female freshman at Chapman University I had high hopes of putting all my traumas and problems behind me. In high school I pushed men away because I felt as though they could not judge me on who I am, but would judge me on what I have been diagnosed with. Especially, because many of the guys knew what was going on in my life, many could not get past the fact that I was disabled.

At Chapman I was invisible. Very few people knew that I was disabled, but my personality still pushed men away because I was afraid of rejection. I have talked to more women in my grade levels and found that they are afraid of mentioning their disability because they do not want to be pitied. However, I have also spoken to many men

who are open with their disability and have gained more friends because of it.

I was lucky that I found a man who was willing to look past my disabilities and was willing to work on our relationship. But, I was afraid of starting a relationship with men or women because of my disabilities. I was afraid that they would see me as 'sick' and think that I am unwilling to participate in activities. I did not want to be left out of socializing like I was in high school. I feel that an attempt should be made towards getting more women with disabilities involved in their communities. I believe this because socializing with peers will not only help women gain self-esteem, but also help other women come out and become a part of life itself.

However, I found it difficult to explain my beliefs to a few members of the male disabled society on campus, who behaved as if they did not want to change how people with disabilities are treated on campus. I found that the men who are in wheelchairs are more often seen with their peers and have a wide variety of friends to help them. Perhaps that is their charismatic personality. But I have seen many women who are 'visibly' disabled (i.e., blind, in wheelchairs, etc.) with few or no friends. Maybe they have friends off campus, but part of being in college (in my mind) is to become part of the campus community. They should be just as 'popular' as the men with disabilities. But why are they not? Why are they so ready to get out of campus and not spend a few minutes conversing with a fellow student?

My theory is that women consider post-secondary education differently from men. From what I have personally seen and heard, men view post-secondary education as a time to not only learn, but socialize and make new friends. Women, on the other hand, see post-secondary education as a stepping stone to getting a better job or making a name for themselves, but nothing more than that. The university is a tool for success, not friendship.

Administration

During my first year at Chapman, my only relationships were with the faculty and administration. If the sheer number of diagnoses that I had was not enough, the fact that most of them were invisible had become an additional burden. The simple fact was invisible illnesses do not hold the same amount of weight as visible ones

when asking for reasonable accommodations at the post-secondary level of education. Since no one can 'see' my problems, I faced many walls as I was repeatedly frustrated in my attempts to secure reasonable accommodations. This is mostly due to a character issue being called in to play, as there are few tests to prove my illnesses other than my gigantic medical files, each stuffed with solid medical opinion, most of which are larger than the average single volume of an encyclopaedia.

I encountered this problem in high school, and after entering the university, I thought that my problems with an administration that could not comprehend the possibilities of invisible disabilities were over. Unfortunately, I was wrong. I commuted to the campus by car in my first year at Chapman. I had to drive an average of four hours a day to attend school. Stress being a factor that exacerbates most of my disabilities, the physical and mental stress of being on the road at seven in the morning and 11 at night became too much. By the end of my first semester at Chapman, I was attending few of my classes due to medical problems. Things got so bad that I could not walk, and I could not drive. My immune system was low, and I had become sick. Yet, it appeared, or more accurately, it did not appear, that anything was physically wrong with me.

During the end of my first year, I came to the conclusion that driving was causing the majority of the stress that made my disabilities worse than they needed to be; therefore, I decided to cut out the travel to and from school and find a room on campus. As simple as that may sound, it became my worst nightmare. I spoke with the Dean of Students, who told me that I would have to submit my application for a room on campus a month before everyone else and I would have to get several doctor's notes to describe what was exactly wrong with me. After five doctor's notes, a letter from my parents, as well as one from myself, the campus Residence Life Office and the Dean of Students accepted my application for student housing. The matter of finding me a room had effectively been turned over to the administration of Chapman University.

Housing

On the Chapman University housing application, there was a section that must be filled out if a student with disabilities wants

accommodations. Since I had arthritis and several hidden disabilities that affect my ability to walk and climb stairs, I requested for a room that was on the first or second floor and near to that of my friends. The latter was a request based on a concern from the Dean of Students. He felt that I was a danger and that there was a possibility of something happening to me because I was on medication. He claimed that he never implied calling me a 'liability' to the university, but that is contrary to what I think. Unfortunately, this particular man is known to have girls come out of his office crying, not just because of the problems that they have walking into his office but because of the attitude that he displays and the feelings of guilt that he imposes on some students. More often than not, this happened to female students as opposed to male ones.

This being true, I was subject to having my disabilities and the validity of my requests questioned. My knowledge about my disabilities was put on the line. By talking down to me, as though I knew nothing about what a disability meant to the university, I was made to feel that it was almost too much work to ask for accommodations that the university, by law, must accommodate. The Dean of Students went so far as to ask whether having my mother drive me to and from school would be a possibility? Not only is the drive from my house in traffic is about an hour and 15 minutes, I also have two younger brothers who need rides to school.

Being female, disabled, and having several problems with the university just does not hold well with this Dean of Students. During my first meeting, I was told that I should consider taking a year off because I couldn't 'handle the stresses of the university'. But it was Chapman that gave me a four-year scholarship, it would be Chapman that would withdraw that funding if I took a year off. I am not only a 'liability' but a 'complainer' too.

I nearly walked out of his office in tears because of the discrimination that I had been subjected to. All because I wanted to live on-campus the following year, I decided that something needed to be done about how Chapman University treats people with disabilities.

I was given the runaround when trying to get my room on campus. First, I had to provide sufficient documentation that I had a disability. After being given one week to provide all the paperwork, that deadline set by the Dean of Students, I thought all my worries were over because rooms on campus is something that is offered to every student. Alas, this was not true. I called everyday for two months

to make sure that my application was being processed, but after one week on vacation with my family my application got 'lost' and no room was assigned to me. Only after my mother called the school and got involved, did we get any answers from the school. Most of the information needed was due to the fact, that I would have to take out loans to pay for lodging. Not until a week before school started and I was supposed to be in, did I receive information about my future roommate and where I had been placed.

When I did find out where my room was, Chapman decided to put me as far away from the people who knew me best and knew how to treat my problems—and that too in the most expensive place on campus (which was my last choice). The former is such a big issue because the only way that the Dean would consider my application was if there were people on-campus, who were not paid by, Chapman University, who knew how to take care of me.

After a year in a residence hall at Chapman University, and the hassle that they put me through to get that room, I decided that things needed to change. By the beginning of my third year, I had met several students who were also disabled as well as a few faculty members who had confided in me that they had also undergone similar discrimination from the administration. Whether the actions were caused by personal issues or university policy, that is still being debated, but we knew that something needed to be done.

School Publicity

Recently, the school newspaper decided to write about my ordeal with the administration. Fortunately or unfortunately, there were not many reactions to it afterwards. It was disturbing, however, to read that our own Dean of Students was quoted as saying that the school makes getting a single room on campus more difficult than any other room because they do not make a profit by having one person in one room. It was also disheartening to hear that fellow students did not want to be quoted despite going through the same experiences. The article made it appear as though only one person has a problem on campus, when really it is a campus-wide problem.

In the article, neither the Dean of Students nor the Dean of Residence Life was willing to comment on my particular case. Nevertheless, the Dean of Residence Life is noted as saying that she would like

to have a discussion with me. But, as far as I saw it, she had nothing to say to me, and I had nothing to say to her. I will be moving off-campus next year because they are raising tuition and my housing costs will go up $2000. I can move into a regular apartment for less than what I am paying at Chapman University.

Another fascinating fact was that the university did not set the disabled access rooms for people with disabilities. The reporter, who wrote the story, asked how an accessible room would have helped me. At first, I tried to come up with some answers. Then it dawned on me. I had never been shown an accessible room. I do not know how one of these rooms would have benefited me. And that was the truth. The administration admitted to using the larger accessible rooms for triples that would be a bigger pay-off than having one person in the larger room.

Why are the students so afraid to say anything? Because many are on scholarship for academics or talent, and do not want to risk having their funding pulled. It is interesting to note that many of the women on campus were willing to speak about their situations, but many were not allowed to be printed either because of confidentiality clauses or because they worked for the school newspaper themselves. When men complain on campus I find that their voices are heard. But, when women make note of problems with the administration, they are not heard. Or, they are heard, but not listened to.

Why do I hear about more women taking time off from school because they cannot handle the stress from school and administration? A few students with disabilities that I know have to pay full tuition because they were not given any type of financial aid. Therefore, there is a stress on their families, who foot their bills, their medical conditions, and whatever roadblocks the administration throws in their path.

Chapman Organization for Disability Advocacy and Awareness (CODAA)

After much debate between my inner self and peers, I decided to form a group on campus that would help fight for the rights of students, particularly those with disabilities. At this point, I had already visited the Americans with Disabilities Act Committee and decided

that it was an administration-run group that was formed to find the cheapest way in dealing with accommodations for the disabled. This needed changing too. I have been told by the head of the ADA Committee that the 'committee doesn't just deal with faculty issues, but policy as well.' Nothing against policy, but I think that is the least that they can do. How about holding training for the administration so that they know how to approach sensitive issues, such as disabilities? How about holding awareness meetings for the campus?

The group that eventually took birth, the Chapman Organization for Disability Advocacy and Awareness (CODAA), is one whose future is yet to be charted. My hopes are that this organization will allow others to receive the accommodations that are required by law and that women will feel more comfortable to ask for what they need despite how a predominantly male administration imposes its restrictions.

I want to encourage the people in surrounding communities and other universities too. The existence of an organization like CODAA may make it easier for students to approach faculty and administration, whether the subject is reasonable accommodations or disability-related issues. CODAA would educate the community about disabilities, as well as furthering the overall knowledge of society.

Nevertheless, what is to become of CODAA and myself in the next few years is yet to be determined. My goals are to graduate from Chapman University and possibly start graduate school in the area of peace studies, but I always want to be involved in the area of disabilities. CODAA, I hope, will become a force on campus that everyone can be involved with, faculty, administration, students and non-students alike. The goal is to help people to understand people, regardless of race, creed, colour or even gender.

Future of Women in Post-Secondary Education

I hope to see women become more involved in their campus community because I feel that it is an integral learning experience. As the younger classes come in, more women with disabilities are welcomed into the community. Some women still feel intimidated by the university system, and rightfully so. However,

there is a greater surge of women who are willing to stand up for their rights.

We need to fight for our right to have opportunities. We need to stand together to help each other. And that is part of my goal for CODAA. That is part of my personal mission in life.

7

Women, Affectivity, Handicaps

Vanda Dignani

At this very moment, when I am trying to visualise this article, I can feel a kind of resistance building up inside me. It is as if something is warning me that it is not easy to start off with a spontaneous approach to a topic that is so delicate and engaging in nature, so rich in feelings, anxieties, emotions, psychological implications and personal experiences.

In fact, affectivity is not an abstract category around which one can build up well-structured arguments. Instead, it is more of inner realities, something which stimulates us and manifests itself in a lot of little ways, waiting to be grasped by someone who experiences it. An inner reality that accompanies and characterizes the whole course of life, from childhood to adulthood. No one at all can be said to be extraneous to affectivity or wants to suffocate it or rarefy it into a mere matter of self-expression and perception. Incidentally, I believe that for every single person the experiencing of affection, of being the object of consideration and love, constitutes an important factor and, I might say, a determinant factor in the formation of one's personality.

It is at this point, however, that in me as a woman, a woman who has been blind since birth, a question spontaneously arises. The question naturally goes beyond my own personal experience to embrace a wider and certainly more general sphere. I ask myself with concern: 'Can it truly be said that respect for every individual, regardless of the specific nature or seriousness of any handicap, proper attention to each person's real need to develop freely and relate to

others according to his or her own possibilities and limits, is always viewed as the primary goal by those close to persons in difficulties?' I also ask: 'How much is the development of little boys or girls affected by the fact that, having been born with a handicap, they have frustrated and disappointed the quite legitimate expectations of their parents who had invested so many daydreams and so much emotions in their child's birth?' Of course, if this is really the way things are, it is easy to understand that the birth of a disabled child can bring bewilderment, dismay and suffering to the parents. At that very moment, when the parents should feel only a boundless joy, there occurs a sudden, frequently traumatic break in 'the fertile, reciprocally nurturing interplay of reality and imagination' (Negri, 1991), with the consequent inevitable shock suffered by the family members quite unprepared for it. Not always are the parents helped by our frenetic and heedless society, more attentive to the appearance of things than to their essence and thus ready to marginalize those who differ from its standard models and do not comply with its abstract 'norms'. Why should we be surprised then by the behaviour of those parents who, in order to avoid a lifetime of suffering strictly linked to the handicap situation, are induced to bring up their 'unfortunate' child in a kind of unisex world in which sexual differences are practically ignored, at least until the maturing of the child's sexual organs explosively imposes its rules for the recognition of a specific gender?

These considerations give a clear idea of the state of isolation and misinformation in which parents and relatives are abandoned, and indicate equally clearly that the complexity of the problems involved and the difficulty of tackling them freely are due very largely to ignorance, taboos and inhibitions, and partly also to the scarcity of theoretical research findings on the unconscious psychological mechanisms that condition the behaviour of the handicapped and the adults who look after them. Qualitative and quantitative growth in the field of handicap knowledge is therefore indispensable to point the way to more correct approaches and more valid information. In addition, it seems to me that it would be necessary to start off by reviewing and redimensioning the actual word, so generalizing and final and so lacking in shades of meaning, that is used to label and simultaneously marginalize persons in difficulties. Certainly, a handicap is a disadvantage which must be recognised, accepted and overcome. It is not easy, I know; the process is a long one and also entails a great deal of suffering. Nonetheless, the constant presence of an

attentive educator can make it less difficult in some ways. The pupil must be stimulated and helped to communicate with and relate to others, despite his or her limits and differences. This word forces me to reflect and ask, 'differences from what?' Every single one of us is different from everyone else, and to me it seems unfair, almost absurd, that being 'different' always bears a negative connotation, since when we really think about it, 'difference' is what defines and characterizes our individuality and our very being, the way we consider and present ourselves as unique and absolutely distinctive individuals.

It is therefore wrong, and in fact harmful, to seek to negate or camouflage differences by enveloping the handicapped person in a thick, suffocating blanket of hyper-protectiveness, which does not solve the problems but only makes them worse, since the person in difficulty is not helped to grow and make an effort to communicate. The handicapped person in fact suffers a loss of identity, and this initial deprivation gives rise, first to suffering and then to the consequent need to reappropriate his or her selfhood and personality. In addition, this is the beginning of a long quest in search of one's lost identity and true liberation. As is only natural, this process is long and difficult, but it is certainly one of great growth. Unfortunately our society, with its prejudices, its abstract norms and its massive use of categories such as 'beautiful', 'ugly' and 'successful', often does not help, and in fact tends to increase the obstacles for the person in difficulty, thus making the educational process even more difficult. But this, and only this, is the route the handicapped person is obliged to follow in order to cease being just a passive sufferer and take charge of his or her own life and dignity.

It is clear that these preliminary considerations apply to both men and women, but in this case, too, there are a great many different shadings, a great many different emotions, that must be taken into account for a full understanding of the nature of womanhood, a nature which needs to be respected so that it can accomplish itself and count for something. Indeed, we need only cast our thoughts back over the history of women to realize the great number of obstacles and frustrating discriminations that pervade it. Today we still bear the full weight of a legacy that cannot easily be eliminated despite the many indubitable steps forward. There is no doubt that although the path that all women have travelled, and continue to travel today to gain recognition for their rights to equal opportunities and freedoms, the road that handicapped women must take as a challenge

to themselves and to society as a whole, is even more fraught with frustrations and difficulties. This challenge is of an extreme nature, launched to spur them towards self-acceptance so as to be able to live serenely with their 'difference' and reappropriate the right to affectivity and sexuality. For them the efforts and discomforts are even greater because they are not just 'other than man, non-man'—they are 'other' in relation to other women too. Their 'differentness' thus distinguishes them from the gender to which they belong, and even within their gender their characteristics differ from those established by social stereotypes.

It is natural that differentness interpreted in this sense immediately acquires negative connotations, ready to be stamped with the seal of inferiority. What a dreary, dismal thing is this concept of 'inferiority' ascribed to the handicapped woman by the society! Every handicapped woman, as soon as she comes into contact with her handicap, experiences deprivation. She immediately becomes aware that her state of life does not fit the parameters of the everyday material world, and for this reason she is forced to feel that she is a creature of 'pure spirit' who can be recognized to possess only what pertains to the inner life of the emotions, but is denied all qualities and consistency of a bodily nature other than those linked to mere survival. It is evident that the handicapped woman thus cancelled out virtually ceases to exist as a person and her process of growth and liberation is heavily disturbed. To this must be added the social taboo that continuously forbids her to recognize that she is by right a woman in the fullest sense as she does not fit in with the model of women as defined by society and dear to the collective imagination. So her difference in relation to other women becomes dominant. Accordingly, albeit in the context of the history of all women, I feel it is necessary to lay special emphasis on the chapter on women and handicaps. It is a tale of intense sufferings and, interwoven with realism and the everyday, contain complex problems, fears strictly linked to the nature of the handicap of those who write them, and anguished questions that arise from the bitter awareness of the continued existence of marginalizing prejudices.

This is why, I believe that the first enemy we must overcome, if we really want to achieve the high and vital goal of finally emerging from situations of embarrassment and invisibility, is the one that can do away with marginalization and prejudice. It is a well-known fact that being a woman and being handicapped means suffering them twice

over. Incidentally, we also know that whereas in the case of males some things are taken for granted, in the case of women in difficulty, on the contrary, the right to love, to sexuality, to have children is often denied. Accordingly, in the past (today some things have changed) this gave rise to a different approach to the educational process for boys and for girls, and continuing separations in the manner of presenting the world and life. Nothing could be more wrong! Reality itself, all-comprising and all-integrating, which is neither abstraction nor separation, nor an amorphous and static mass adhering to some abstract concept of imposed rules and standards, but proves instead to be dynamic and complementary, something in which all differences find their place, cannot be impoverished and mortified in this manner. Despite this, however, to educate a handicapped girl and help her to become a woman ready and able to tackle all the implications of her handicap and all the obstacles that make her entry into the circuit of life slow and difficult, it is necessary for her to be brought up in a manner in which she feels that the handicap factor 'is not lamentation, invisibility, impoverishment and tragic resignation, but instead a powerful reason for emancipation' (Ponzio, 1991). I believe that first the girl and later the woman she will become will be capable of transforming the handicap factor into emancipation and knowledge and will be able to take disdainful superiority and rightful pride as her most effective weapons when setting out on her feminine quest to conquer her handicap.

As I express these ideas, I experience a sense of dismay as I recall my own life-path, feeling once again how hard it is to achieve these longed-for goals and remembering how many bitter mouthfuls I had to swallow before I could feel I was free at last, mistress of my own life. At this point, borne up by the emotional wave of my memories and the awareness of my specific handicap, I would like to shift my attention to the process of education of a visually handicapped woman and her quest for affectivity, love and sexuality. It is true that for all girls, and for blind girls even more than others, the most difficult and delicate phase is that of the transition from childhood to adolescence, the magical age in which the world suddenly opens up with all its dreams, with all its colours and all its seductive attractions, and a powerful desire for life and freedom. However, she gradually begins to perceive the obstacles and feels that she is missing out on something. In her disappointment she would like to lean on her family for support, but at the same time she understands that her desire for

freedom conflicts with the feeling of hyper-protection that it affords her. In addition to this inner conflict, I think that the young girl begins to suffer from the absence of the unique pleasures of 'eye-contact sexuality—the most intense, seductive and luminous of all modes of communication, which can open up infinite horizons' (Barbisio, 1991). Later on, though, she may perhaps become aware that not only the eyes can communicate, but every single gesture, every expression, can and does send out messages.

In the meantime, the young girl is unhappy, and she fears that it may never be possible for her to love and be loved. At this point she could easily be in the danger of losing her balance completely in the absence of support provided by correct education and by information free of prejudices. She must, in addition, be encouraged to socialize and to pursue self-realization through work and through the establishment of sound relationships. This certainly requires much effort, but it is necessary not only because personalized answers must be provided, but because it is indispensable for adolescent girls to be helped to grow into women, and all the more so because a handicap almost constantly seems to envelope all aspects of a woman's being, blanking out all other characteristics such as age, sex and personality.

It is, incidentally, a well-known fact that a handicap makes common discrepancies even more apparent, and for a disabled woman this can tend to make such discrepancies even harder to deny. However, a blind woman who is limited by this serious but purely physical handicap and knows, nonetheless, that she has a great deal of potential, refuses to become resigned and wants to be recognized for what she is, with her own identity in which her very difference can acquire a non-negative significance. But this does not occur often or easily, and sometimes, particularly in the educational process, it was considered easier and more appropriate to try to stifle certain dreams, certain expectations, and I might say certain rights too, in the name of platitudes and frustrating stereotypes. After the difficult phase of adolescence and early youth, these problems become more acute, filled out with new emotions and new expectations that find expression in various forms and aspects. For a disabled woman, her difference from other woman becomes dominant, so for her the overcoming of marginalization means becoming the same as other women in accordance with the accepted social pattern. The process of liberation is achieved and consummated in the achievement of her traditional social role. So her highest goal, quite comprehensibly from the human

and affective standpoint, is to become a wife and mother. For her, this and only this can give real 'social status'. It means the ultimate redemption, being able to say at long last 'I'm just like other women.' Not even getting a job can have as much emancipating value. Indeed, I believe that for every woman, and for the disabled woman in particular, the experience of motherhood constitutes the moment of full self-realization. It is therefore easy to understand why, for a handicapped woman, these and these alone are the contexts in which identification and social recognition can be fully achieved. This goal is an extremely arduous one, however, and very few are able to achieve it. God alone knows at what price! Nevertheless, once she has thus achieved social integration, the disabled woman feels fulfilled. She has no desire to measure her strength disputing the specifics of womanhood. The struggle to overcome her most obvious difference and be able to meet the requirements of the norm has been so hard that she has no further desire to question anything.

In my opinion, however, it would be necessary for handicapped women to shift the conflict on to a higher plane so that all women together can work to liberate, at the very highest level, the enormous potential of this double difference. 'In the visibility of city life, in the organization of time-schedules and services, in all places specific to women or otherwise, starting off from the material circumstance, the needs and the suffering of handicapped persons means bringing about the total and substantial transformation of social relations, and of society itself as a whole' (Mattei, 1991). Of course, the road to be travelled is a long one, but I hope that a day will come in which women will be recognized as persons, who are not only subject to a series of limits and difficulties but also as persons capable of being the protagonists of their own lives, their own histories, and hence the indisputable designers and makers of their future.

References

Barbisio, Carla Gallo (1991). « Il femminile: la modulazione degli affeti» Proceedings of «Al silenzo … all'imbarazzo … all'invisibilità»—atti del convegno su identità femminile e handicap—in collaborazione con il Progetto Donna del Comune di Bologna. Published in *Rassegna Stampa Handicap*, September 1991, vol. 7, no. 40.

Mattei, Carmen (1991). «Produttività e riproduzione: due mondi, due modi di essere.» Proceedings of «Al silenzo … all'imbarazzo … all'invisibilità»—atti del convegno su identità femminile e handicap—in collaborazione con il Progetto Donna del

Comune di Bologna. Published in *Rassegna Stampa Handicap*, September 1991, vol. 7, no. 14.

Negri, Romana (1991). «La presa in carica del neonato: da «compito» della madre a coinvolgimento della famiglia.» Proceedings of «Al silenzo ... all'imbarazzo ... all'invisibilità»—atti del convegno su identità femminile e handicap—in collaborazione con il Progetto Donna del Comune di Bologna. Published in *Rassegna Stampa Handicap*, September 1991, vol. 7, no. 9, p. 7.

Ponzio, Giuliana (1991). «Dall'identità personale all'identita femminile» Proceedings of «Al silenzo ... all'imbarazzo ... all'invisibilità»—atti del convegno su identità femminile e handicap—in collaborazione con il Progetto Donna del Comune di Bologna. Published in *Rassegna Stampa Handicap*, September 1991, vol. 7, no. 9, p. 38.

8

Women with Disabilities from a Non-English-Speaking Background

Lina Pane

In our society women are frequently discriminated against just because they are women. To be a woman with a disability is then a double disadvantage, because you are a 'woman' as well as a 'disabled'. Again, if you are from a non-English-speaking background (NESB), you have a triple disadvantage: your disability, ethnicity and gender. So, you have to prove that you are capable of doing, things as good or bad as others.

Literature available on NESB women with disabilities in Australia is very limited or even non-existent. What it means to be a woman with a disability from a non-English-speaking background does not seem to interest the disability movement, feminist movement or NESB organizations. Even disability literature treats related issues like age, class, sexuality and ethnicity as though they are secondary.

Invisibility of Women with Disabilities from NESB

My argument is that both women and society need to examine the universal experience of woman, including the various aspects of gender, age, culture, sexuality and disability. The main disadvantage of women from a non-English-speaking background is the social construction of disability, and their being non-English-speaking women. In fact, the experience of being an NESB woman and of being an

NESB woman with a disability is basically the same—the difference is only the 'disability'. I plan to illustrate this through a literature review (limited as it may be), case studies, my work as a social worker in this area and my own personal experience—being a woman with a disability from a non-English-speaking-background.

Literature Review

Feminist literature refrains from discussing 'disability' as it has always been seen as one of those unspoken areas where women are seen as the carers for the 'disabled'. However, we should not forget that there are women who are disabled and yet, at the same time, feminists too. Feminist writers with disabilities, are beginning to get recognized and publishing their own works.

The Psychology and Sociology of Disability

Literature on disability has undergone many changes, from medical and rehabilitative models to a more recent one, on the interconnections of the environment and individuals with disabilities (Phillips, 1988). Human being, as Vash (1981) argues, are more alike than different, regardless of variances in their physical bodies, sensory capacities or intellectual capabilities. What makes us different is the social construction of disability. As for gender, it is the attitudes and institutions of the 'non-disabled', even more than the biological characteristics of individuals with disabilities, that turn characteristics of the disabled into handicaps (Asch and Fine, 1988; Meekosha and Pettman,1991; Vash, 1981).

Phillips' paper (1998) considers a transformational process appropriate to understanding the general experience of disability for individuals as the process of transformation is created by each individual in accordance with that person's potentials, needs and desires. However, no matter how 'individual' each person's experiences are, there are four phases of development that link her/his experience:

 (i) *Marginality:* begins with the onset of the disability; the reactions by family, peers and ethnic and religious communities to her disability
 (ii) *Retreat:* withdrawing from all expressions of the ethnic tradition

(iii) *Renegotiating:* combining elements from social reality and ideology to create an identity that suits the individual to live by

(iv) *Emergence:* a new identity emerges, a symbolic combination of parts of the individual's ethnicity with the psychological limitations that characterize an individual's disability.

Phillips' four stages in the development and experience of disability are interesting paradigms for understanding how an NESB woman interacts with the experience of disability.

Other writers such as Vash (1981) and Deloach and Greer (1981), who are themselves disabled, talk about interesting approaches to understanding the experience of disability. They focus on the notion of Maslow's definition of self-actualization (1968), a situation in which the powers of the person achieve fruition and they move towards fulfilment, actualization and enhancement. The individual seeks to fulfil his/her potential. There is a general agreement between the writers (namely, Deloach and Greer, Phillips, and Vash) that people who are able to articulate their disability-related experiences are involved in either the women's movement or the disability rights movement, have a heightened awareness of their social status, and also have a model for self-analysis. Eisenstein (1984), a well-known feminist writer, calls this 'consciousness raising', the sharing of reliable information about one's experiences.

Feminism and Disability

Feminist writing by non-disabled women have excluded women with disabilities as a group deserving attention. Eisenstein (1984) completely ignores the absence of women with disabilities from women's groups, their literature and research. Is disability seen as their primary identity? Writers like Boylan (1991) seem to point out that neither the disability movement nor the feminist movement fully addresses the issue of women with disabilities. In the disability movement, a woman faces sexism and in the feminist movement, there are women who do not understand her disability-based concerns.

Literature on NESB Women

Historically, Judaic and Christian ideology concentrated on the belief that disability was a punishment by God for sins, corrupt morals and evil conduct. Bickenbach (1993) suggests that the main issues

for NESB women with disabilities are isolation and exclusion. In many cultures, people are members of an extended family who offer support. However, this may not be the case when a member of a family has a disability. This isolation is not only limited to the person with a disability, as it can have an impression on the immediate and extended family.

Westbrook et al. (1993) investigated the attitudes towards disabilities within six Australian communities including NESB Australians and Anglo-Saxon Australians. The study basically illustrated that the discrimination against people with disabilities remains unchanged and, not surprisingly, few theorists have attempted to link the relationship between culture and disability. Another interesting point that Westbrook et al. (1993) illustrate is the difficulty of the parents of women with disabilities in coming to terms with their daughter's disability. The mother is reported to feel more ashamed than others. It basically comes down to the lack of resources and education that the medical profession and other service providers are not passing on to the parents with disabilities.

The structures of society also produce medical and personal tragedy models of disability which go with the powerlessness experienced by people with a disability, for example, films such as *My Left Foot* or *Forrest Gump*. Westbrook et al. (1993: 3) argue that 'negative community attitudes towards people with disabilities are expressed primarily in terms of exclusion from, or lack of access to, social roles, activities and facilities'.

For people from an NESB with a disability, cultural factors such as questions of blame, honour, shame, status, marriageability and religious belief can result in feelings of guilt and, in particular, expectations of family responsibility rather than gathering support from other support agencies. Often, as Mullaly (1997) illustrates, people from an NESB find themselves in minority groups where oppression occurs due to the barriers and boundaries of class, gender, disability, culture and issues of injustice. However, as there is limited or lack of literature and research on them, it can only illustrate the 'invisible' experience. What seems to be happening is that the experience is separated into categories. A woman with a disability from an NESB needs to be integrated into the mainstream which includes both disability and NESB issues for women.

Disability has become the commonality of all these people, without the recognition of differences such as NESB, class, gender and

sexuality. People with disabilities are also seen as separate, not as part of the human race, simply because disability is affected by the degree and stigma of discrimination imposed on individuals by society. In other words, society makes disability more of a handicap than it actually is for the person considered disabled.

A Study on NESB Women with Disabilities

In my first report on women with disabilities from a non-English-speaking background (Pane, 1994), I illustrated that the experience of women with disabilities, no matter what background they come from, is not recognized. The 10 women with disabilities from NESB interviewed in the study came from various backgrounds and ages. There was also a thread that linked them together—they were women with disabilities who worked as social workers, as teachers, or as community development workers. It was an interesting pattern, as all of them were in a position to help others and change 'negative' attitudes towards disabilities. Four women were between the ages of 25 and 30, and six were between the ages of 40 and 45. Four women came from an Italian background while the rest were from Maltese, Polish, Chinese, Greek, Afghan and Bulgarian backgrounds. Five of the women were born overseas while five were born in Australia. The disabilities were polio, cerebral palsy, visual impairment, paraplegia and double amputee. Most of the disabilities were acquired after birth from seven months to the age of 39, either through sickness, accident or deterioration. Four of the women were born with the disability.

Overall, the women shared a similar experience in matters pertaining to family relationships, as their parents' attitude towards them ranged from being loving and supportive to being over-protective. The parents also seemed to have difficulty in coming to terms with their daughters having a disability, both at the time of disablement and even at a later stage. The siblings of the women seemed to accept their sister more easily and are still more supportive than the parents. There were times in the relationship when siblings felt embarrassed at the condition of their sister but this disappeared with maturity.

Several observations made by these women are recorded below:

> Mum always wished that I were normal and more like my brothers. But now I'm older, she knows in her heart I'm not going to change and she is satisfied ... but deep down she will never accept the fact that I'm disabled.

A person with no expectation of self, and realizing that others also had no expectation of myself, what I was capable of achieving or doing, left me dependent upon the attitudes and societal values of others.

Even though women have very individual experiences, their cultural background does not seem to accept disability. If the individual is a woman with a disability, this negative attitude is deeper, as the expectations of being a woman getting married and having children is not perceived as an opportunity or choice for the woman with the disability. These attitudes, even though not verbal, underlie people's actions and responses to the woman with a disability.

In the study, five non-disabled NESB women were interviewed as well to find out their attitudes towards NESB women with disabilities. The NESB women represented a range of ages and cultural backgrounds. Overall, the responses from the women were quite positive, as they seemed to understand the issues of NESB women with disabilities. One of them demanded that women should be empowered 'to take charge of their own lives' while another suggested that 'there should be more ethno-sensitive and multicultural organizations in the welfare and disability fields to work with group of women.' A third remarked that 'more women from NESB with disabilities need to be encouraged and resourced to actually being in the position to be able to undertake such an analysis and study.'

Another similarity in the response of the NESB women with disabilities is that they recognize that a woman with a disability has a double disadvantage, and if you are from an NESB, then you have a triple disability. Personally, I was quite impressed as an NESB woman with a disability by the overall positive attitude and practice that the women illustrated in the response to my questions in the study. Nevertheless, the NESB women with disabilities felt that there were still misconceptions and a lack of understanding of what the issues are for women with disabilities.

Practical Experience as a Social Worker

In 1995–97, I worked as an Employment Advisor at a disability service centre called Disability Employment Action Center (DEAC), where I was associated with the programme, Women's Employment Support Service (WESS). The service was quite specific and very unique, as it was the first of its kind. It was about working with

women with disability from an NESB to obtain successful employment opportunities. I enjoyed working at WESS because I saw how the programme had changed the lives of women in achieving amazing goals and giving them a sense of empowerment.

It was also rewarding to set in place a service that provided ideas and letters of support. It also supported my previous work on disabled NESB women, where I highlighted the service needed to work with NESB women with disabilities as a 'whole' and not separated into parts, i.e., NESB, disability or women's issues. DEAC decided to set up a service and then invited me to apply for a position as Employment Advisor.

During my association with WESS, I was able to demonstrate to my colleagues as to how to work with NESB women with disabilities and provide cross-cultural training. I also set up a women's peer mentoring group for the women who used the service so that a network is built for them and that they may develop positive self-images, self-esteem, confidence and motivation which will lead to more positive outcomes in seeking employment.

Personal Experience as a Disabled NESB Woman

My personal experience is similar to many of the women I wrote about in my first report on disabled women (Pane, 1994). I was born in Australia in 1966 of Italian parents, I am a middle child and quite balanced. I never really understood what it meant to be an NESB woman with a disability until my mid-twenties when I found it difficult getting a job because of my disability. To compound my problems, my parents had this high expectation that I would achieve beyond their dreams, and yet often did not expect me to do as well as I have.

My Italian background is very important to me because of its caring, sharing, giving nature. I still cherish the extended family where I have grown up. I recently got married, which in itself should have been a very normal part of life, but not for me. First, I married a man with a disability and, second, he wasn't Italian but an Australian. Our courtship, if anything was a challenge. I am not sure even today if it was the disability that caused the inconceivable differences or the different cultures.

At first there was no acceptance from my parents of our relationship, and this made it difficult and close to breaking point. However, with sheer persistence and help from other family members, who wanted peace again, our relationship was accepted. My husband's side was quite the opposite in their response. They accepted me immediately and could not understand what all the fuss was about. Neither my sister nor brother experienced this situation. Expectations placed on women were one of marriage and children and this was true for my sister, the oldest one. My brother was male; he could not do anything wrong, as he carried the family name. Such expectation, however, was not placed on me, and relationships of any sort was considered a taboo as far as I was concerned.

However, today there is complete acceptance of our relationship and my husband is treated like a family member. My parents have helped us in setting up the house and my dad, a great handy man, has done so much to make our home physically accessible. My mum even tells me that she thinks I have done better than my brother and sister because of the equal relationship we have and there is no 'cultural expectation' of what we are supposed to be like. My sister, as she was the first born, was brought up the old way while my brother was not expected to help with household duties of any sort.

There is one subject though that Mum disapproves of, that is, the idea of having children. Although neither of our disability is genetic, and the chances of having a 'disabled' child for us is the same as it is for anyone else, Mum has this underlying fear that if I get pregnant, our child would also have a disability.

Conclusion

Women with disabilities from NESB are like any other women with disabilities but they experience disadvantage on a larger scale. Their relationship with their family is supportive, over-protective or non-accepting, and this has an effect on the women's self-esteem and overall perception of self. Even though NESB women have very individual experiences, their communities do not seem to accept 'disability' due to the lack of understanding, which again results in negative attitudes towards women with disabilities.

The need of the hour is to empower and support women with disabilities, in particular NESB women with disabilities, to achieve their

rights in all aspects of 'being'. Empowerment to me means raising people's consciousness by changing the way people view themselves and the way they view society. It is also about creating a place or space for women with disabilities, to exchange views with other women about life and what it means to be a woman with a disability.

The issues faced by disabled NESB women affect their self-esteem, confidence and perceptions of themselves. It is important to ensure that these perceptions are not tied up with the negative attitudes and misconceptions of disability held by society at large. The answer lies in making women visible, questioning the dominant culture and questioning the language we speak and the categories in which we think. It is about changing the way the world thinks about women, disability and culture.

References

Asch, A. and **M. Fine,** (1988). *Women with Disabilities: Essays in Psychology, Culture and Politics.* Philadelphia: Temple University Press.

Bickenbach, J.E. (1993). *Physical Disabilities and Social Policy.* Toronto: University of Toronto.

Boylan, E. (1991). *Women with Disability.* London: Zed Books.

Deloach, C. and **B.G. Greer** (1981). *Adjustment to Severe Physical Disability: A Metamorphosis.* New York Mc Graw-Hill.

Eisenstein, H. (1984). *Contemporary Feminist Thought.* Sydney: Allen & Unwin.

Maslow, A.H. (1968). *Toward a Psychology of Being.* New York: Van Nostrand Reinhold.

Meekosha, H. and **J. Pettman** (1991). 'Beyond Category Politics'. Paper presented at TASA, Melbourne, 1989.

Mullaly, B. (1997). *Structural Social Work.* Toronto: Oxford University Press.

Pane, L. (1994). 'Triple (dis)Advantage: Women with Disabilities from Non-English Speaking Backgrounds, Living in Australia'. *Australian Disability Review,* pp. 57–65.

Phillips, M.J. (1988). 'Disability and Ethnicity in Conflict: A Study in Transformation'. *Women with Disabilities: Essays in Psychology, Culture & Politics,* chap 7.

Vash, C. L. (1981). *The Psychology of Disability.* New York: Springer.

Westbrook, M., V. Legge and **M. Pennay** (1993). 'Attitudes Towards Disabilities in a Multicultural Society'. *Social Science Medicine,* vol. 36, no. 5, pp. 615–23.

III

Locating Women's Agencies in Differing Spheres and Systems

Locating Women's Agencies
in Differing Spheres and
Systems

9

Disabled Women in Society: A Personal Overview

Ann Darnbrough

We the people of the United Nations determined to save succeeding
generations from the scourge of war, which twice in our lifetime has
brought untold sorrow to mankind, and to reaffirm faith in fundamen-
tal human rights, in the dignity and worth of the human person, in the
equal rights of men and women and of nations large and small
—*from the Preamble to the United Nations Charter, 1945*

Before discussing the particular problems of disabled women in soci-
ety, I should say at the outset that it is necessary to acknowledge dis-
ability as a human rights issue. Women, according to a recent report,
constitute half of the human race, contribute two-thirds of the entire
work, yet control only one-tenth of the world's resources and enjoy
the status of subordinate or second-rate citizens (National Confer-
ence of Disabled Women, undated).

The message that resonates through both the United Nations
Charter and the Universal Declaration of Human Rights is that the
quest for justice, equality, peace, security, people's participation and
the sustained improvements in the quality of life of every individual,
whether man or woman, are inseparable human pursuits. UNICEF
has recently concluded that there is now 'broad agreement that the
realization of children's and women's rights is a fundamental condi-
tion for sustained improvement in human development' (United Na-
tions Children's Fund, 1999).

The persistence of grossly unequal gender relations and wide
gender gaps in social, economic, political, civic and cultural areas of

life constitutes not only a denial of those rights, but a threat to the health and well being of both women and their children. Constructive and engaged approaches to these disparities are of central importance to the realization of universal human rights.

I am not arguing that everyone is of equal ability. Clearly, some men in some contexts are more able than some women. Conversely, some women in some contexts are more able than some men. When I speak of equality for women, I do not mean uniformity. What I assert is the right to be accorded equal worth, opportunity, respect, dignity, protection, benefit, and status before and under the law without unfair discrimination.

This has not yet been achieved—in some countries more so than others. Women and girl children commonly remain underprivileged, undervalued and underpaid. Seldom do women command respect beyond a limited role as wives and mothers. They are rated as inherently inferior to men and, therefore, considered unfit to take any serious decisions. Poor rural women, in particular, are among the most deprived people in the world. They generally have poorer health than men and suffer very high rates of illiteracy.

This downgrading is not only unfair to the individuals concerned, but also collectively in terms of the prodigal squandering of the contribution that women can make to society at every level. The brains, initiative, imagination and distinctive feminine qualities of half the world's population is being lost just when these abilities are needed more than ever.

Marcella Ballara is one of many writers to emphasise this point. She argues that for the better future of humankind, it is both economically unsound and morally unacceptable to ignore the potential contribution that women can make in the wider society outside their homes. It is no longer acceptable to exclude women from the decision-making process and from consultation. This is all the more so at a time when the progress of development is faltering in countries around the world, particularly in those with the poorest economics. Ballara accepts that progress towards ensuring gender equality is being achieved in some countries, but she notices that in many instances women's position is still far from satisfactory: their lower status in both industrialized and developing countries is rooted in economic inequalities and denial of access to power. Society is reluctant to change attitudes and to abandon sexually discriminatory practices, customs and habits that negatively affect the education of women

and girls, while among women there is widespread ignorance of legal rights (Ballara, 1992).

As we shall see, disabled women, besides facing discrimination because of their disabilities, are also caught up in a pervasive climate of sexual injustice.

Cultural and Religious Discrimination

It is usually said that it is not fair to criticize deeply held faiths and cultural traditions. But why? While the culture and religion of any group of people can in some respects be wonderfully distinctive and treasurable, rigid doctrines, antipathetic to women and honoured only by time, should no longer be accepted as a justification for the continuance of discriminatory practices. Many of the world's outdated belief systems bear a heavy responsibility for perpetuating shibboleths which keep women in inferior positions. They have a lot to answer for.

The world's religions are bastions of male dominance. For too long, men have maintained a stranglehold on all the leading positions: from popes, bishops, rabbis and imams to local leaders of worship. If disabled women come in for any attention at all, it is as objects of pity. From this demeaning position they command little respect and certainly cannot expect to be taken seriously. In the Christian religion, for example, a great deal of emphasis has been given, as if demonstrating virtue, to the performance of miracles to cure disabled people, whereas what is really needed is a solid endorsement of disabled people as human beings of worth, and to give them a proper place in our society.

In some traditions, it is a common experience for women to receive a lesser share of resources, including food. A picture of twins (a girl and a boy) published in Esther Boylan's powerful book (Boylan, 1991) graphically illustrates how girls suffer lack of nourishment whereas the healthy boy is about twice the size of his emaciated twin sister. The boy was nursed and fed first, and his sister had what was left over. The health needs of women and girls are seen as of lesser importance to those of men. Sex bias in health care has been well documented in Asia, Africa and the Middle East. These studies show that more male children are immunized and treated by hospitals than girl children, and the girl child has a higher rate of

death from diseases like measles, diarrhoea and respiratory infections (Aidoo, 1991).

Worse still, in the name of culture and religion in certain countries, the horrific practice of female genital mutilation—an operation which often leaves women disabled for life—is still practised. UNICEF, with rather more tact than I can muster, has called attention to these cultural abuses:

> In all parts of the world, customary laws, social practices and cultural values exert major influences on the degree to which children and women exercise their rights. Development partners need to understand these factors prior to designing programme approaches and to work closely with national and local organizations to address those practices that may either be harmful to women and children or represent strengths on which to build. In dealing with female genital mutilation, for example, approaches need to combine legislative measures with advocacy, communication and other strategies to bring about changes in established attitudes and practices (United Nations Children's Fund, 1999).

Exclusion from Employment

It is ironic that while women are usually over-worked (in many countries they rise before the men and go on working till they drop in the evening), they earn very little from these activities. Disabled women rarely feature in employment debates and initiatives and they are on average at least twice as unlikely as disabled men to get a job.

Exclusion from Government

Few women have a realistic prospect of advancement in society and, therefore, of the opportunity to contribute to the transformation of the way in which legislation is couched and the manner in which their countries are run. According to a survey by the Inter-Parliamentary Union, fewer than 12 per cent of the world's parliamentarians are women. The Scandinavian countries have the best record. Sweden has 40 per cent women MPs; Norway, Finland and Denmark follow closely behind. Following the Labour Party's election victory on 1 May 1997, the UK now has 120 women (18 per cent) in Parliament. In the United States, only 11.7 per cent of legislators

are women. However, these figures are outstanding compared to the average of 3.3 per cent in Arab countries. Ten nations, including Kuwait, Papua New Guinea, Tonga and the United Arab Emirates, have no women parliamentarians. Even fewer disabled women can aspire to parliamentary membership. Examples are notable as exceptions: Uganda, which assures disabled people parliamentary seats; the UK, which has a wheelchair-using woman MP; and South Africa, which includes a disabled woman MP in the new administration (Disability Awareness in Action, 1997).

Exclusion from Education

Girls and women the world over have had to struggle to take part in the educational opportunities available in their areas. Education gives women the opportunities for social and economic integration, and are a stepping stone to independence. But such opportunities are frequently denied. When there are a number of children in a family and money is tight, it is usually the girls who lose out. Education is simply not seen as a priority for girls and women. Their life-chances are restricted by a vicious circle of negative perceptions which restrict or preclude educational opportunities (Abu-Habib, 1997).

Similarly, in many countries, disabled people have a poor record of access to education. A survey of five areas of Lebanon revealed that of 1,870 people, 80 per cent were totally illiterate. Of these 82 per cent were women. In Kenya, the chief inspector schools reported that only 4 per cent of disabled children attended school, as compared to 85 per cent of the non-disabled population (Disability Awareness in Action, 1997).

Marcella Ballara writes:

The traditional or new roles that women fill rarely leave them with enough free time to devote to full-time or even part-time educational activities Some religious traditions may restrict women's activities to domestic tasks, stressing their role as mothers, which limits their access to education. Lack of self-confidence, timidity, submissiveness to male authority, as well as isolation and age differences between participants, are also limiting factors for women's participation in education (Ballara, 1992).

Blatant Ill-Treatment of Disabled Women

Space allows for only two examples, both from Lebanon. Nevertheless, they reveal how invidious gender inequity can be.

In one case, the Lebanese Sitting Handicapped Association (LSHA) was approached to investigate the situation of a teenage girl who had not been seen by neighbours since her house had been directly hit by a mortar shell and the rest of her family had fled without her. On entering the half-destroyed house, LSHA volunteers discovered the girl inside, injured and in a pitiable state. An investigation revealed that her father had refused to take her with the rest of the family—perhaps hoping that she would be killed, and this would be 'God's wish'. He told LSHA volunteers that he had preferred to save their cow because it was more useful to them than their disabled daughter. When LSHA wanted to take the girl to a nearby hospital for her wound to be treated, her father categorically refused. 'What for?' he asked. 'So that I start paying for her?' LSHA had to ask for the assistance of the local police to take the girl to hospital (Disability Awareness in Action, 1997).

The second case of gender differentiation is illustrated by the experience of Zeinab, the victim herself from Lebanon:

> I had polio when I was very young. My parents were told that I would never be able to walk normally again. My mother had to struggle so that I could have as many surgical operations as possible, but she never let me go to school. In the institutions where I was staying, all the other girls were going to school except me. My mother said it was not important for me to learn. I am now 26 years old, and totally illiterate. I learnt to sew, and I have been working in sewing factories for 10 years. My mother and father do not work, and my brother is unemployed. My father gave him his shop to start his own business, but somehow he managed to lose everything. He only comes home to ask for money, which he spends on alcohol and other things. Despite all this, my parents love and respect him and dare not confront him. I, on the other hand, am not allowed to go out except to go to work. They have forbidden me to participate in a summer camp for disabled people. They have even stopped me from marrying a man that I was in love with. They said that even if I eloped, they'd find me and kill me. They could do that! I got scared and left the man I was involved with. My parents say that I am disabled and cannot marry. But that is not true. They do not want me to leave home because my salary is their only income. Sometimes I wonder why they can't love me the same way they love my

brother. After all, he only brings them trouble. I am the one who looks after them (Disability Awareness in Action, 1997).

Equal Rights for Women on the International Agenda

A succession of global conferences has stressed the importance of issues related to the improvement of the status of women. Each of them has contributed to a clearer recognition of the crucial role of women in sustainable development and protecting the environment; of the human rights of women as an inalienable, integral and indivisible part of universal human rights; of violence against women as an intolerable violation of these rights; of the importance of health, maternal care and family planning facilities; and of access to education and information, as prerequisites to the exercise by women of their fundamental rights.

Nothing, however, has yet equalled the powerful assertion of the rights and growing solidarity of women throughout the world which emerged from the United Nations Conference on Women held in Beijing in September 1995. The fact that it was hosted by a country scarcely renowned for upholding human rights gave it a special impetus. It attracted some 6,000 delegates from 189 countries and over 4,000 representatives of accredited non-governmental organizations. Gertrude Mongelia, the Secretary-General of the conference, observed in her introductory address:

> The Beijing Conference will be another milestone for women. The conference will take place 50 years after the United Nations set its global objectives, one of which was to obtain the equal rights of men and women. It will also be an opportunity to see how far we have travelled towards achieving the objectives for the advancement of women 20 years after the UN Mexico City conference (1975) which launched the United Nations Decade for Women, and defined a first World Plan for Action to promote the equality of women and their contribution to development and peace.

> The conference should create the impetus in society for women to move forward, well equipped to meet the challenges and demands of the twenty-first century for scientific, technological, economic and political development (*ICOD News*, 1995).

This expectation has not yet been fully realized. But the proceedings were also remarkable in a new and perhaps unexpected way. It was the first time there had ever been an organized representation of disabled women at an international women's conference, with disability organizations coming together to press the specific rights of disabled women.

The conference was also unique in many other ways. The earlier U.N. conferences in Mexico City, Copenhagen and Nairobi had succeeded in placing women's issues high on the agenda of the United Nations and national governments, but they had neither put emphasis on disability nor integrated the views of disabled women into the conference proceedings and results.

The Beijing Conference was to rectify this omission. One report described it as a landmark for disabled women, who had refused to be relegated to the category of 'women with special needs'. Their struggle to be heard as individuals in their own right, and on equal terms with able-bodied women, was reminiscent of the earlier days of the women's movement where women were fighting for the equal rights and the right to be heard (Kiwanuka, 1995).

Disabled women had organized themselves in groups with a clear agenda in the Beijing Conference. Despite the difficulties nearly 200 disabled women attended the conference. Whilst in practical respects the conference managers were ill-prepared to receive disabled women or to communicate with them effectively, disabled women themselves were well organized, and demanded that their voice be heard. This was a major step forward, gained through the support of a number of organizations and coalitions of women with disabilities formed in the previous decade.

The initial impetus for this participation can be traced to the NGO Forum at Huairou. There, a number of disabled people's organizations, including Disabled People International (DPI), the Federation for the Deaf and the women's committee of the World Blind Union, formed a women and disability network. The network organized an international symposium of women with disabilities, attended mostly by the 200 disabled women who participated at the conference. This event provided an opportunity for disabled women to meet, share experiences on issues of common concerns, discuss the Beijing draft Platform for Action, and agree on a common strategy for the participation of disabled women in the Beijing Conference.

DPI, a Canadian-based international coalition of disabled people, prepared for the conference for almost three years, attending all five regional preparatory meetings and contributing to debates which determined the 10 points of critical concern to women highlighted in the Beijing Platform for Action.

At the conference, disabled women successfully lobbied official delegations to take on board the Standard Rules of the Equalization for Persons with Disabilities, to abolish 'negative stereotyping of women with disabilities by the media', and to adopt measures, to ensure 'commitment to promote employment of women with disabilities'. A round-table meeting was organized, which, among other things, aimed to produce recommendations to ensure that subsequent U.N. conferences on women would be more friendly and accessible to women with disabilities.

The conference marked a watershed in the movement for securing equality, development and peace for all women everywhere in the world. It resulted in the unanimous adoption of the Beijing Declaration (United Nations, undated), which unreservedly dedicated the participating governments to addressing the constraints and obstacles which had impeded the advancement and empowerment of women all over the world. The declaration stands today as a core document establishing principles which underlie the need for urgent action:

> Women's empowerment and their full participation on the basis of equality in all spheres of society, including participation in the decision-making process and access to power, are fundamental for the advancement of equality, development and peace.

The conference also unanimously agreed on a platform for action (United Nations, undated). This has 361 inspirational paragraphs which provide an agenda for the empowerment of women to take full part in all aspects of life at local, national and international levels. The mission statement asserts that its key aim is to remove 'all the obstacles to women's active participation in all spheres of public and private life through a full and equal share in economic, social, cultural and political decision-making.' The mission statement goes on to reaffirm the fundamental principle that the human rights of women and of the girl child are an inalienable, integral and indivisible part of universal human rights. It also

emphasises that 'women share common concerns that can be addressed only by working together and in partnership with men towards the common goal of gender equality around the world. It respects and values the full diversity of women's situations and conditions and recognizes that some women face particular barriers to their empowerment' (United Nations, undated).

Disabled Women: The Need for a Dedicated Platform for Action

While disabled women share common cause with all women in their struggle for equal rights, the Beijing Platform for Action carried a special message that they also face specific barriers to full equality and advancement because of their disability. It did not, however, spell out what those barriers are. This is not unusual. There is a tendency to see discrimination on grounds of disability in generalized, non-gender terms: disempowering 'persons' rather than men and women. While it is true that many barriers to full participation bear equally upon both sexes, the discrimination which women experience by reason of their gender is compounded by disability, and there are many forms of oppression which fall more heavily upon women and girls. As Esther Boylan has remarked, 'this double prejudice is the root cause of the inferior status of women with disabilities, making them the world's most disadvantaged group' (Boylan, 1991).

Among the problems faced by disabled women is that they have not yet been fully integrated into either the disability movement or the women's movement. Even ardent campaigners for disabled people's rights are not always alive to gender issues. In the Middle East, for example, while general literature on disability in the region abounds, disabled women remain strangely invisible. I am told that most of the literature dealing with the experience of disability makes little differentiation between men and women. Yet there is now ample proof that disability is experienced differently according to gender. Physical. social, psychological and other disadvantages caused by disability have a strong gender dimension. Coping mechanisms developed by disabled persons and their family are also gender differentiated (Abu-Habib, 1997).

The opposite case, no less unhelpful to disabled women, is that those who most fervently champion women's rights are not necessarily concerned about disability issues. A case in point is the experience of feminist Canadian film-maker Bonnie Sherr. In a well-known statement, after suffering a stroke, she said that she felt abandoned by feminism.

When either disabled people are oblivious of gender issues, or women do not concern themselves with disability issues, they are failing to make the links between gender and disability as two aspects of social identity. These are distinctions which need first to be recognized and then to be acted upon.

Disabled women are commonly devalued for two basic reasons: the emphasis on physical appearance found in every society, and the importance placed on strength to carry out household duties as well as work outside the home. On these grounds, disabled women are made to feel less worthy than even their non-disabled peers, and may even be denied the option to marry.

I believe that it is vital to call attention to the particular burdens suffered by disabled women. Unfairness to any individuals in a society reflects on the moral health of that society and detracts from any progress that an otherwise benign community might have pursued to improve the lives of its citizens. Stereotypical and negative attitudes towards women in general and disabled women in particular devalue man's claim of having achieved a state of true civilization.

Empowerment of Disabled Women

It would be a mistake to conclude that men are entirely responsible for the inequalities faced by women. Surprisingly, women themselves frequently collaborate in sustaining male dominance and their own inferior, submissive status. This has to change.

In many parts of the world, women are gaining strength to challenge pervasive discrimination by joining together and supporting each other. Such empowerment derives from the point at which disabled women reach an understanding of their right to full citizenship and are given the tools for equality and participation. It is achieved principally through disabled women coming together to share their experiences to gain strength from one another and to provide positive role models. It means breaking away from an

identity of grateful passivity in favour of discovering the will and the power to change one's own circumstances. This is neither an easy nor a comfortable process for disabled women or for the wider community of which they are part. But it is an essential component in the struggle for full participation and equality of opportunity.

The movement to assert disabled people's rights is spreading and growing throughout the world. It is profoundly influencing attitudes towards disabled people and pressurizing authorities to give heed to their demands. However, even within this movement, disabled women have had to make it clear to disabled men that they have the right to play a full part in the decision-making process and in the formation of organizations of disabled people. They have had to insist on a fair share of the benefits that disabled people are wresting from an able-bodied society. This has led to the creation of a sense of solidarity among women. Also some very strong women's groups within the disability movement have emerged.

Women's Potential to Contribute to Society

It would be foolish to ascribe all of humanity's evil traits to the male population singularly while endowing all women with supposedly angelic characteristics. Humans of both genders are much more complicated than that. Many women, having gained power, have proved to be as ruthless as their male counterparts. It is nevertheless generally true that women have personal gifts which, given the opportunity to flower, would hugely benefit humankind.

Women are excellent at working in teams. They consult and work together for a wider benefit. They are much less likely to be struggling for power with the aim of bossing their colleagues around. These gentler attributes are vital if the world's population is to enjoy a peaceful twenty-first century fit for our children and future generations.

A Peaceful Revolution for the Future

After more than half a century, the intent of the United Nations Charter of 1945 still remains a dream, not least in its aim to save succeeding generations from the scourge of war. We still live in a

macho culture where old-fashioned male ideas of domination and of solving problems with violence still hold sway. Bombing people into submission, sending troops to kill and destroy communities to prove the authority of the strongest power, has become a strategy of legitimate governments. Statesmen have put on the apparel of terrorism. A few women, of course, have emulated these aggressive characteristics, but they are exceptions. As a general rule, women know better than most that resourcefulness, kindness, gentleness, shrewdness, consideration, reconciliation and community spirit are preferable to brute strength. An ability to negotiate is far more valuable than sabre rattling.

It is my case that the twin failure to achieve peace and to emancipate women are inextricably linked. There is another way. Women are at last beginning to make a significant mark in the world. This can only be for the better for all people. It would be easy to dismiss the U.N. covenants, declarations, and conferences as nothing great. However, they are providing women with the opportunity to have their say, to be seen as leaders and planners and, most importantly, to demand the rights enshrined in these documents.

Women are increasingly establishing themselves in central roles in a variety of capacities in the movement of humanity for peace. Their full participation in decision making, conflict prevention and resolution, and all other peace initiatives is essential to the realization of lasting peace.

In this article, I have emphasized the importance of empowering women, largely because they have a lot of catching up to do if they are to take up the opportunities slowly being made available to work alongside men in every area of life. To ensure the stability of a peaceful world women and men need to be able to work together in a truly equal partnership. To do this men must learn to give up much of the power to which they have clung so tenaciously.

As the Beijing Platform for Action pointed out: 'Empowerment of women and equality between women and men are prerequisites for achieving political, social, economic, cultural and environmental security among all peoples' (United Nations, undated).

A women's revolution is building up. This revolution will be entirely different from previous upheavals, which have been more or less characterized by violence and the pursuit of power by the strongest men.

In this peaceful revolution, it is important that disabled girls and women are not left behind. They must be accorded the same human rights to which every human being is entitled. The women's movement and the disability movement must ensure the backing and support which has all too often been lacking.

References

Abu-Habib, Lina (1997). *Gender and Disability: Women's Experiences in the Middle East.* Oxford: Oxfam.

Aidoo, Agnes Akosua (1991). *The Girl Child: An Investment in the Future.* New York: United Nations Children's Fund.

Ballara, Marcella (compiled) (1992). *Women and Literacy.* Women and World Development Series. London: Zed Books.

Boylan, Esther R. (1991). *Women and Disability.* Women and World Development Series. London: Zed Books.

Disability Awareness in Action (1997). *Disabled Women: A Resource Kit.* London: Disability Awareness in Action.

ICOD News **(1995).** no. 4, August.

Kiwanuka, Justin (1995). A Report on the Beijing Conference.

National Conference of Disabled Women (undated). A Report. New Delhi: NAB-CBR Network.

United Nations Children's Fund (1999). Cooperation for Children and Women from a Human Rights Perspective.

United Nations (undated). *Platform for Action and the Beijing Declaration.* New York: United Nations.

10

Loud, Proud and Passionate: Including Women with Disabilities in International Development Programmes

Mobility International USA

In 1995, more than 300 women with disabilities and allies from around the world made history at the Fourth U.N. World Conference on Women and the parallel Non-Governmental Organization Forum. In spite of nearly overwhelming barriers, they joined forces to form the largest ever international coalition of women with disabilities and make a powerful statement to the world's women: 'Disabled women's rights are women's rights are human rights!' Their actions in Beijing, reported by international media, resulted in heightened awareness by non-disabled women's groups around the world about the situation and accomplishments of women with disabilities.

In Beijing, for the first time, the voices of women with disabilities were significantly reflected in an official, international agreement. The Platform for Action, the blueprint agreed upon for action over the next decade to improve the status of women, and the mandates of governmental and non-governmental organizations to include girls and women with disabilities in areas of economic development, education, leadership training, health, violence prevention and decision making attempts to 'mobilize all parties involved in the

development process, including academic institutions, non-governmental organizations and grass-roots and women's groups, to improve the effectiveness of anti-poverty programs directed towards the poorest and most disadvantaged groups of women, such as ... women with disabilities' (United Nations, 1995).

Women with Disabilities and Development: Making the Link

Around the world women with disabilities are challenging old stereotypes by becoming involved in politics, leading organizations, entering labour market, and participating in community life. They are taking remarkable steps to fight systemic discrimination based on gender and disability that results in poverty, inadequate health care, lack of education, violence and abuse of disabled women and girls. By working cohesively across borders, they are developing networks of support and a culture of shared pride in their strengths and accomplishments

Disabled women are an untapped resource for international development, as partners, staff and beneficiaries. Women and girls with disabilities are under-represented and under-served in every aspect of the international development field. In spite of the fact that women and girls with disabilities are estimated to represent up to 20 per cent of the world's female population, the majority living in less economically developed countries, they are denied significant participation in community projects, human rights organizations and international development programmes.

International development and women's organizations must combat—not contribute to—marginalization, oppression and segregation of women with disabilities. Human rights organizations must apply their well-developed understanding of the oppression of women and poor people to the situation of women who are also disabled, and take proactive steps to counteract the many levels of oppression faced by disabled women.

Mobility International USA (MIUSA) has collaborated with women with disabilities from every region of the world since 1981, through international exchange programmes emphasizing leadership training and disability rights. Since 1995, MIUSA has also coordinated a series of international leadership and networking

projects for disabled women, beginning with the International Symposium on Issues of Women with Disabilities in Beijing, China. Here, the disabled women from around the world examined common issues and set the agenda for the NGO Forum and the Fourth U.N. World Conference on Women. MIUSA research fellows, Laura Hershey and Robin Stephens, conducted interviews with 30 disabled women leaders at the conference, which resulted in the 1995 report, Leadership Development Strategies for Women with Disabilities: A Cross-cultural Survey.

Following recommendations from the Beijing research, MIUSA set up the International Women's Institute on Leadership and Disability (WILD), 1997 and organized the International Symposium on Microcredit for Women with Disabilities, 1998. In 1997, MIUSA published *Loud, Proud, and Passionate: Including Women with Disabilities in International Development Programs* as a bridge between development organizations and women with disabilities who are working locally and internationally. In these pages, women with disabilities around the world describe their work, organizations, challenges and progress. They make specific recommendations as to what steps international development programmes, women's groups, disability rights organizations, and women with disabilities themselves need to take to address the situation of women with disabilities.

Naming the Problems

Development policy makers and workers need to listen to women with disabilities as they identify the barriers that impact their ability to participate in the development of the community and achievement of their rights. Among the important problems articulated by women with disabilities are:

- Women and girls with disabilities are denied access to education and vocational training, employment, transportation and housing.
- Women and girls with disabilities receive inadequate—if any—rehabilitation services because the very limited available resources are directed toward adult men with disabilities.
- They are less likely than non-disabled women to marry, but more likely to be abandoned with children, facing social stigma, loneliness and poverty.

- Protection against violence is not available to women and girls with disabilities.
- Although women and girls with disabilities are more likely than non-disabled women to be physically, sexually, and emotionally abused, most battered women's shelters and rape crisis centres are not accessible to them.
- Involuntary sterilization, contraceptives, and abortion continue to be forced upon them.
- They are denied access to reproductive health services by cultural attitudes, physical barriers, financial constraints and un-enlightened medical personnel and health-care providers.
- In most countries, women and girls with disabilities have a higher mortality rate than disabled males. They are also more likely to be malnourished than their male counterparts.
- Restricted to their homes by inaccessible environments, lack of mobility aids or transportation, and family overprotection and shame caused by cultural biases, women with disabilities are often isolated and unaware of either rights or options.

Critical Issues and Strategies

With an understanding of the critical issues facing women with disabilities, development assistance programmes can facilitate coalition building between disabled women and other marginalized women. In 1999, MIUSA conducted a new survey of grass-roots organizations and development efforts by women with disabilities from Eastern and Central Europe, Africa, Asia and the Pacific, North America and the Caribbean. The women cited lack of opportunities for employment (42 per cent), education (38 per cent) and resulting poverty (25 per cent) as the most pressing issues for them. Respondents also cited access to health care, opportunities for leadership and participation in decision making, and legal protection for women with disabilities as urgent issues.

The international development field needs to support effective strategies which disabled women have taken to improve their situation. Seventy-five per cent of the organizations surveyed offer leadership development opportunities to them; most offer targeted training through seminars and workshops. Seventy-five per cent conduct some form of public campaign to raise community awareness of the

issues, rights and potential of women with disabilities. Seventy-three per cent offer training programmes and support women with disabilities to participate in business or income-generation activities, and 29 per cent offer some kind of micro-credit programme for women with disabilities. More than half of the organizations conduct advocacy activities for improved rights of disabled women, many at national and regional policy levels. Nearly half of the organizations address educational and health needs of disabled women, and 44 per cent offer programmes for young women and girls with disabilities.

Respondents credit these strategies as they have resulted in improvement in the situation of women with disabilities over the last few years. Most significantly, 60 per cent of respondents reported both increased opportunities for disabled women in leadership and increased inclusion of them in their communities (although many describe the improvements as gradual or slow). Half reported improved educational and training opportunities for women with disabilities, and nearly half (42 per cent) noted increased programmes for girls with disabilities. Less frequently reported improvements are in legal rights (33 per cent), health care (27 per cent) and economic opportunities (27 per cent). Improvement was noted by less than 20 per cent in reproductive and parenting rights. In the area of violence against women with disabilities, 19 per cent noted some improvement in awareness of the problem, but many cited apparent worsening of the actual incidence of violence. Three respondents stated that no improvement at all had been made in the situation of women with disabilities in the past five years.

Tools for Empowerment

Disabled women leaders in the MIUSA survey address the difficulties of reaching and mobilizing a constituency, which, due to a history of oppression and abuse, is largely impoverished, illiterate, isolated and affected by low self-esteem. They credit the training and support by NGOs in the formation of successful disabled women groups and in giving them the courage and motivation to participate in non-disabled as well as disabled women's groups. Lack of office equipment and meeting facilities, lack of access to telephone, Internet and fax and limited transportation options are significant logistical obstacles

which local and international development organizations may have to experience.

The recommendations made by disabled women to international development programmes, human rights, women's and other non-governmental organizations have been included in MIUSA's publication (MIUSA, 1997). Some of these are

- Leadership training and community development projects must conduct specific outreach efforts to include women with disabilities.
- Women with disabilities must be involved in all policy and decision-making processes, and at every level of the projects: as staff, consultants, participants, and evaluators.
- Advice and expertise of women with disabilities must be utilized in designing programmes and policies, research, conferences, and documentation of major social issues that affect women.
- Education, vocational training and rehabilitation programmes must include disabled women to prepare women and girls for careers and gainful employment.
- Rehabilitation and adaptive technology must be available for women with disabilities and they must be involved in the development and production of adaptive devices.
- Health service personnel must be trained to offer informed and sensitive service and education addressing the health needs of girls and women with disabilities.
- Governments and non-governmental organizations must be pressured to effectively implement the many important recommendations which have been made over the years by various U.N. bodies and non-governmental organizations, particularly at the Fourth World Conference on Women in Beijing in 1995.
- Governments and non-governmental organizations in host countries must be educated to prioritize issues of women with disabilities in development efforts.

Resource for Development

The fact that people with disabilities, particularly women, are under-represented and under-served in the international development field is widely acknowledged by leaders of development assistance programmes as well as by international disability rights movements and

grass-roots organizations. Scarcity of data on the participation of disabled women in development activities is only one indication of how little attention has been given by the development assistance community to their issues and perspectives.

The few studies on inclusion of people with disabilities in development assistance substantiate the reports, but do not aggregate data by gender. In 1994, economists Robert L. Metts and Nansea Metts surveyed international donor agencies working in Ghana, Kenya and South Africa and found only two, UNHCR and Peace Corps, which had policies addressing the inclusion of people with disabilities. Overseas development assistance support for disability-related activities was less than 1 per cent of the overall assistance budget: 0.171 per cent in 1994 and 0.194 per cent in 1995 (Metts and Metts, 1998a). The U.S. National Council on Disability (NCD) concluded that 'those responsible for creating and implementing U.S. overseas policies and programs generally lack awareness of disability issues, cannot articulate our national policies with respect to people with disabilities, do not incorporate the interests of people with disabilities into U.S. foreign policy objectives and do not see the importance of U.S. disability advances and achievements for people with disabilities in other countries.' NCD recommended 'training US foreign affairs agencies and their contractors to plan for programmatic accessibility' (National Council on Disability, 1996).

Anecdotal evidence is consistent: disabled women around the world report they are denied significant participation in community projects, human rights organizations and international development programmes in spite of extreme need. Women and girls with disabilities are, across the globe, the 'poorest of the poor'. Unemployment, lack of education and training, and inadequate health services result in poverty, vulnerability to violence and illness—in short, denial of basic human rights. With little chance to achieve economic security through employment, marriage or inheritance of property, disabled women in most societies face economic hardship and even threats to survival. Yet these women have traditionally not had access to economic development initiatives, even those targeting women. Disabled girls and their mothers have difficulty participating in maternal and child health programmes. Young women with disabilities do not have access to vital health information, particularly HIV/AIDS prevention. The Uganda Disabled Women's Union states this in strong terms:

It is quite absurd that international development programs rarely address the needs of disabled women. Women with disabilities are harassed sexually, exploited by men, suffer abject poverty and social disrespect, malnutrition, disease and ignorance (MIUSA, 1997).

Strategies for Inclusion

Many recommendations have been made to develop effective strategies to increase inclusion of people with disabilities in international programmes. In addition, a number of strategies recommended for integrating gender perspectives into development organizations, for example, by the U.S. Agency on International Development (USAID) Office on Women and Development and InterAction's Commission on the Advancement of Women (CAW), a coalition of leading U.S.-based development and relief organizations, may be useful for integrating perspectives of women with disabilities. Strategies and interventions range from low-cost, practical adaptations in methods and facilities to training and education to broad policy changes. Discussed here are a number of themes, which run consistently through the variety of recommendations.

Comprehensive Inclusion of Disabled Women

The inclusion of women and girls with disabilities must be comprehensive and take place at all levels of the development process. USAID, in its First Annual Report on Implementation of the USAID Disability Policy, declares: 'To be effective, programs must be constructed to include people with disabilities at all stages of implementation' (USAID, 1998).

Full inclusion of women with disabilities in the development process must go beyond the limited approaches which mark most of the programmes meant for them—often charity-based, focused on prevention, medical intervention, physical rehabilitation and custodial care. While women with disabilities may benefit from appropriate targeted interventions, which enable them to maximize their skills and abilities, development assistance programmes must support them to access the full range of options available to all members of the communities. USAID's Disability Policy suggests that all

programmes should be accessible to people with disabilities, noting, 'people with disabilities have the same needs as others for nutrition, family planning, health care, training and employment' (USAID, 1997).

Regarding similar efforts towards gender integration, InterAction's CAW however cautions while women-specific projects are appropriate under certain conditions and can bring significant benefits to women, they are 'often ineffective in achieving a longterm change in the balance of power ... since they often lead to further marginalization of women' (InterAction CAW, 1998).

In his recommendations to the World Bank, Robert L. Metts notes that 'international strategies to increase the economic and social contributions of people with disabilities must [employ] integrated and multifaceted combinations of rehabilitation, inclusion and empowerment strategies' (Metts, 1998). In addition, the USAID Disability Policy acknowledges that 'the response to [factors limiting participation of people with disabilities] must be a balanced combination of prevention, rehabilitation and measures for the equalization of opportunities' (USAID, 1997).

Involving Disabled Women as Implementers and Recipients

In order to achieve full inclusion, women with disabilities must participate not only as beneficiaries, but also as administrators, consultants, partners and field staff. USAID's Disability Policy promotes participation of individuals with disabilities in country and sector strategies, activity designs and implementation, and observes, 'One of the best means of raising awareness in programs is to actively pursue [USAID] personnel procedures so that of Agency staffing patterns reflect the intention of Agency programs.' Metts and Metts also note, 'Within the context of a development assistance agency like USAID, the tasks, associated with providing equal access and opportunities to people with disabilities may be divided into two components: inclusion of people with disabilities as providers of services and recipients of services' (Metts and Metts, 1998b).

Increasing the involvement of women with disabilities as programme planners, implementers and participants will require dedicated outreach efforts and changes in attitudes, assumptions and gender and disability awareness by both government and local staff.

InterAction's CAW advises that 'agencies must provide staff with necessary gender training and tools required to operationalize gender equity in their program.' USAID's Disability Policy encourages grantees and contractors to provide training to people with disabilities. Its 1998 report states that 'training on disability and sensitivity to disability will be part of the regular training program for leaders and for leadership development' (USAID, 1998).

Making Projects Accessible to Disabled Women

Inclusive programmes must incorporate adaptive strategies and perspectives of women with disabilities in every phase of the development process, beginning with programme design and continuing through implementation and evaluation of projects and policies. USAID's Disability Policy suggests, 'Many mainstream programmes, with minor modification at the design stage, help address [needs of people with disabilities]' (USAID, 1997). InterAction's CAW seconds this approach to inclusion in their recommendations for gender integration: 'Integrating gender considerations fully into programming requires that gender roles and relations are taken into account in all stages of programming from project design and implementation to monitoring and evaluation' (InterAction CAW, 1998).

Loud, Proud and Prosperous, an international coalition on microcredit and economic development for women with disabilities, formed at the 1998 MIUSA International Symposium on Microcredit for Women with Disabilities, elaborated on specific considerations that should be included in project design: 'In order for women with disabilities to enter microenterprise ventures on an equal basis with non-disabled women, microcredit and economic development programs must build strategies and costs of equipment and services for disability related accommodations into all project and funding plans' (MIUSA, 1998). The USAID Office of Human Capacity Development has taken a proactive step towards implementing inclusive policy by stating that missions are allowed to pay for accommodations that make participation by people with disabilities possible (USAID, 1998).

CAW emphasizes the importance of seeking expertise from women in order to successfully incorporate gender perspectives into programme planning: 'Consultation with local women's organ-

izations and involving women participants in program planning is perhaps the best way to ensure a gender perspective in program design.' In the same way, women with disabilities must be involved in programme planning to ensure that practical and effective adaptations are built in projects to facilitate full participation of women with disabilities. 'Women leaders with disabilities are the best resource for technical assistance and problem solving for inclusion of women with disabilities. All development organizations, micro-credit programme and lenders must consult with women leaders who have disabilities for strategies to make all information, programs and services accessible for women with disabilities' (MIUSA, 1998).

Working with Organizations Led by Disabled

Grass-roots organizations led by disabled women offer resources to development assistance programmes seeking to expand the participation of women with disabilities. USAID's Disability Policy recommends that U.S. private voluntary organizations (PVOs) support indigenous NGOs interested in issues concerning disabled people and advises:

> Missions with programs that are largely NGO-driven already include the participation of organizations that represent people with disabilities. These organizations exist and are growing. Support of these organizations fits easily within the USAID goal of strengthening civil society. As a rule, people with disabilities are the last to receive education and other services in developing countries. Because of this historic discrimination, many organizations of people with disabilities need support in organizational development.

Metts and Metts (1998b) also support this in their recommendations to USAID activities in Ghana: 'We also strongly suggest targeted interventions to support the emerging organizations of people with disabilities in Ghana, for it is through these types of grass-roots organizations that people with disabilities in Ghana can begin to organize to represent their own interests'.

Adopting Organizational Policies for Disabled Women

Systematic practices to include women and girls with disabilities require coherent policy and strategic objectives for implementation.

In their survey of gender integration by InterAction member organizations, CAW identifies organizational gender policy statements as the first key issue, explaining, 'Developing a policy statement on gender and development is an important step in promoting gender equity in programs and within an organization's structure' (InterAction CAW, 1998). USAID recognized the importance of using policy to address inclusion of people with disabilities in USAID through the enactment of the Disability Policy and Plan of Action. Metts and Metts emphasize the importance of disability policy in their recommendations to USAID in Ghana: 'Positive outcomes will also be realized as all of the entities that do business with USAID in Ghana begin to implement their own new inclusionary policies and strategies in response to the new USAID mandate' (Metts and Metts, 1998b).

Data Collection on Disabled Women

Data collection is essential in order to accurately assess the extent of inclusion of women and girls with disabilities in the development assistance process, and design and evaluate effective strategies to remedy inequalities. Strategists for gender integration recognize the importance of data collection to serve as baseline and for evaluation of interventions. In the Gender/Woman in Development (G/WID) Strategic Plan of 1995, the USAID Office of Women in Development states the importance of collecting information: 'Knowledge regarding women's roles is often limited ... with data and findings that are not comparable and that do not support the derivation of broad implications useful in program and policy development to benefit women Improving this information base will be important for the achievement of [G/WID objectives]' (USAID, 1995). In their report on InterAction membership organizations, the CAW states: 'Collecting gender disaggregated data ... is critical in order to design programs to promote equal participation and benefits for men and women' (InterAction CAW, 1998). Metts and Metts (1998b) recommended that 'identification and recruitment strategies must be supported by data-collection processes rigorous enough to facilitate proper evaluation.'

If information about women's roles is limited, accurate data about the roles of women with disabilities in development is even more so. The United Nations (1995) recognized the egregious lack

of data regarding women with disabilities and declared that governments and NGOs must 'improve concepts and methods of data collections on the participation of women with disabilities, including their access to resources'. A similar sentiment was voiced by grass-roots women leaders with disabilities from Africa, Latin America and Asia in their resolution inaugurating MIUSA's Loud, Proud, Prosperous Coalition: 'Research must be conducted to collect accurate statistical information about the economic situation and strategies of women with disabilities around the world' (MIUSA, 1997).

Development for All Women: A New Paradigm

The international community can no longer afford to overlook the immense resources that women with disabilities offer. Disabled women have knowledge, skills and expertise, and with access to appropriate resources can provide leadership and make important contributions to our own lives and our communities, regions, countries and the world. It is time to bring the perspectives of women with disabilities and to include them in international efforts to achieve economic justice, human rights and a peaceful world.

Human rights, women's and development organizations must support women with disabilities to achieve the full range of options available to them: to be workers, leaders, activists, mothers, partners, citizens. Development programmes and women's organizations must support them to meet and work side by side with other disabled women and non-disabled women. Through exchange of experiences and strategies, women with disabilities can reframe individual struggles in political and social contexts, develop skills and pride, and join the development process as potent agents of change.

References

InterAction Commission on the Advancement of Women (1998). *Best Practices for Gender Integration in Organizations and Programs from the InterAction Community: Findings from a Survey of Member Agencies.*

Metts, Robert L. and **Nansea Metts (1998a).** *Overseas Development Assistance to People with Disabilities in Ghana, Kenya and South Africa.* Eleventh Annual Meeting of the Society for Disability Studies, Oakland, CA.

——— **(1998b).** 'USAID, Disability and Development in Ghana: Analysis and Recommendations.' *Journal of Disability Policy Studies,* 9(1).

Metts, Robert L. (24 August 1998). Suggested World Bank Approach to Disability: Discussion Points for Meeting of the International Working Group on Disability and Development, 24–25 September 1998.

Mobility International USA (1997). *Loud, Proud, and Passionate: Including Women with Disabilities in International Development Programs.* Eugene, Oregon: MIUSA.

——— **(1998).** Resolution and Recommendations: Loud, Proud and Prosperous: An International Coalition on Microcredit and Economic Development for Women with Disabilities.

National Council on Disability (1996). Report on Foreign Policy and Disability.

United Nations (1995). UN Platform for Action from the Fourth World Conference on Women, Beijing, China. United Nations, Department of Public Information.

U.S. Agency for International Development (1995). Strategic Plan: Office of Women in Development, Bureau for Global Programs, Field Support and Research, FY 1995–2003.

——— **(1997).** USAID Disability Policy Paper: US Agency for International Development: Policy Guidance.

——— **(1998).** First Annual Report on Implementation of the USAID Disability Policy. Report by USAID Disability Team Coordinator.

11

Understanding the Experiences of and Advocating for the Service and Resource Needs of Abused, Disabled Women

Elizabeth Depoy, Stephen French Gilson and Elizabeth P. Cramer

Defining Disability: Multiple Perspectives

Many perspectives on the meaning of disability have been advanced, each founded on diverse and sometimes competing values and theoretical propositions. Here we briefly review the medical, social, political and cultural definitions of disability, each of which is critical to an understanding of the marginal status of disabled women in the present cultural context.

Medical Model of Disability

The medical approach defines disability as a permanent biological impediment and positions individuals with disabilities as less able than those who are non-disabled. As a form of biological determinism, the focus of disability is on physical, behavioural, psychological, cognitive and sensory tragedy and thus the problem to be addressed by disability services is situated within the disabled individual (Mackelprang and Salsgiver, 1999; Shakespeare and Watson, 1997).

Not unexpectedly, the medical model of disability does not bode well for those who are permanently disabled with conditions that cannot be cured. Thus their condition cannot be modified or changed by professional intervention (Quinn, 1998: xix). In this view, the

individual who cannot be 'fixed' by professional intervention remains deficient. This view of disability has resulted in providers viewing the needs of persons with disabilities as related to their disabling condition. Thus services and supports for individuals with disabilities within this paradigm are aimed at medical intervention and obfuscate social issues such as abuse that may be experienced by disabled women.

Social Model of Disability

In the social model, while an internal condition is acknowledged, it is not necessarily undesirable or in need of remediation (Shakespeare and Watson, 1997; Quinn, 1998). The incapacity to function to a large extent is related to a disability-hostile environment in which barriers clash against personal choice (Gleeson, 1997). Negative attitudes, limited physical access, limited access to communication and/or resources and to the rights and privileges of a social group are considered as some of the barriers that interfere with the disabled individual's potential to actualize his/her desired roles (Barnes and Mercer, 1997). Thus disability is seen as diversity of the human condition and not an undesirable trait to be cured or fixed.

A social model of disability, thus, is one that is socially constructed. It views the locus of the 'problem' to be addressed by services and supports within the social context in which individuals interact. Rather than attempting to change or fix the person with the disability, a social model of disability sets service goals as removal of social and environmental barriers to full social, physical, career and spiritual participation (French in as cited in Quinn, 1998: xx). The emergence of the social model has therefore, made room for considering issues such as abuse in the lives of disabled women by shifting the focus of disability away from the disabling condition to the environment as the disabling element. Abusive environments are no exception and are thus open for examination in this model.

Political Model of Disability

Closely aligned with the social model of disability, but moving disability into the domain of power and resources, is the political model. In this view, disability is seen as a condition which interferes with one's capacity to work and make economic contributions to a social group. Thus the privileges afforded to those who do contribute are withheld

in part or in total from disabled individuals because they have nothing to exchange. Curiously, despite claims by policy makers that disability is an objective category, history and current definitions reveal that it is a value-based, changing determination shaped by the opinions of human worth held by dominant social groups. According to Oliver (1996), the political definition of disability, while not equivalent to policy, legislation or social change, does provide direction for future political action. This view of disability advances an even stronger rationale and foundation than the social model for the development of theory, research, services, supports and policy related to protection from and prevention of abuse perpetrated against women with disabilities.

Cultural Definition of Disability

Defining 'disability' as culture transcends internal determinants of disability, subsumes social and political definitions, and creates a cultural discourse that characterizes the collective of disabled persons. Cultural views of disability suggest that all individuals who define themselves as disabled belong to a unique group which shares experiences, tacit rules, language, and discourse. In this view, the notion of disability is about group belongingness and distinction from other groups who do not share the disability identity (Mackelprang and Salsgiver, 1999).

Within this definition, issues of race, class, gender, and power differential are important determinants of the shared experiences that bind disabled people together in a single, identifiable community of concern (Charlton, 1998). Linton (1998: 4) notes that 'we [disabled people] are bound together, not by ... [a] list of our collective symptoms but by the social and political circumstances that have forged us as a group. We have found one another and found a voice to express not despair at out fate but outrage at our social positioning.' This outrage is tied not only to the political position of disabled people, but from a materialist analysis which identifies the financial constraints that further disable individuals with disabilities (Rioux, 1994). The political view of disability provides the context for analysis of power and action strategies to address abuse.

As is evident, each definition of disability brings an important perspective to bear on understanding the current prevalence of abuse among disabled women and the response of service, support and policy to this phenomenon. We now turn to a discussion of

prevalence of abuse among disabled women to identify the scope of the problem.

Prevalence of Abuse

In excess of three million women are physically abused by intimate partners each year and nearly one third (31 per cent) of women in the United States have been physically or sexually abused by a husband or boyfriend at some point in their lives. These statistics increase when abuse is expanded to include emotional battering and other forms of non-physical abuse. Although men are more likely than women to experience a violent crime, women are five to eight times more likely to encounter violent crime at the hands of an intimate partner, are seven to 14 times more likely to endure severe physical assaults from an intimate partner, and are significantly more likely to be stalked by former and current partners compared to men (Family Violence Prevention Fund, 1999).

Domestic violence perpetrated against disabled women has revealed that they are at disproportionately high risk for multiple forms of abuse in diverse settings including homes, in hospitals, and in institutions (Nosek et al., undated; Sobsey, 1994).

A national study comparing disabled and non-disabled women demonstrated that the rate of abuse experienced by disabled women and non-disabled women is similar. In both groups of women, 62 per cent had experienced emotional, physical or sexual abuse at some point in their lives with husbands or live-in partners as the most common perpetrators of physical or emotional abuse. However, differences were noted in the length and diversity of abuse and perpetrators thereof. Women with disabilities experienced the abuse for a longer duration, were more likely to be abused by a greater number of perpetrators, reported a higher number of health care workers and attendants as the perpetrators, and noted fewer options for escaping or resolving the abuse than their non-disabled counterparts (Young et al., 1997).

An issue that is closely related to the abuse of disabled women is the disablement of non-disabled women through physical battering. Common injuries due to domestic violence treated at emergency rooms include fractures, dislocations, dental injuries, muscular/skeletal injuries, head injuries, and gunshot wounds (Bureau

of Justice Statistics, 1997). The staff of the Domestic Violence Initiative for Women with Disabilities in Denver, Colorado has collected service statistics showing that an alarming rate of 40 per cent acquired a disability as a result of the abusive relationship. Of those seeking services, 60 per cent were already disabled (National Coalition Against Domestic Violence, 1996).

Consistent with the prevalence statistics, disabled women themselves have identified abuse as a serious personal concern. In a study of the service needs of 100 disabled women, prevention of and intervention for abuse and violence was ranked as the topmost priority (Berkeley Planning Associates, 1992).

Let us now look at some of barriers to the development of efficacious services and supports for disabled women.

Barriers to Protection of Women with Disabilities

As discussed above, the service and resource needs of abused, disabled women have just begun to be studied and addressed. However, due to the dearth of empirical evidence about disability and abuse, there are major barriers to the development and implementation of services and supports that can enhance inclusion, productivity, safety and quality of life for this population. Three particular areas, namely, inaccessibility, negative attitudes towards disabled women and incapacity to identify the unique abuse encountered by disabled women have been noted as service barriers, to a large extent due to the absence of sound knowledge with which to counter these barriers. Such barriers can be conceptualized through social and cultural models of disability.

Inaccessibility

Inaccessibility is both a cultural and social phenomenon. Looking at the domestic violence services as social agencies, many shelter and non-shelter community services are characterized by physically inaccessible settings, lack of, immaterial that women with sight and/or cognitive impairments can read, shortage of staff proficient in the use of American Sign Language to communicate with women with hearing impairments, and lack of training to provide services on multiple cognitive, receptive and expressive levels. These barriers

are listed by Barnes and Mercer (1997) as social limitations in that the social context provides inadequate support for a segment of the population that is clearly in need. An additional example of social incapacity is transportation. Transport services for persons with disabilities operate on too limited a schedule (daytime and weekdays) and require advanced notice of request. Women with disabilities who may require transportation support are seriously limited in their access to crisis and/or after-hours safety and support services. Thus the locus of the 'problem', as seen through the social lens of disability, is limitation in environmental support and accessibility. Similarly, for women needing personal care assistance, domestic violence programmes may be unable to provide or coordinate such assistance so that she is able to leave her home (National Coalition Against Domestic Violence, 1996). Without a clear identification of the access and daily assistance needs of disabled women, rehabilitation services and supports cannot respond appropriately.

Negative Attitudes

Negative attitudes fall within the realm of social, political and cultural understandings of disability. Based on a medicalized stereotype that women with disabilities are asexual and are unlikely to be in a relationship, or, that they would not be abused because others would take pity on their condition (Calvey, 1998), it is not unusual for women with disabilities not to be believed when they disclose the abuse to service providers. Chenoweth (1996), Gilson et al. (2001), and Sobsey (1994) note that when disabled women are taught to comply with the requests and instructions of others, tacit cultural understandings silence these women from expressing their lived experiences and perceived needs. Moreover, Gilson et al. noted the difficulty of women in communicating with service providers, including hotline staff, health care providers and police, partly due to dual service system that separates 'disability (medical model) issues' and 'domestic violence issues' (social, political phenomena); for example, the abused women reported that once they were identified as having a disability they were immediately referred to the disability services agency, which directs attention away from social issues to the treatment of individual disorders. As has been indicated in our discussion of the medical view of disability, the women reported that health care providers are trained to view disability, rather than abuse, as the issue for treatment.

Incapacity to Identify Abuse

A third barrier to service is the non-recognition of the unique forms of abuse that disabled women experience. Narrow cultural and political definitions and conceptualizations of physical abuse (such as a criminal justice definition of physical assault or those that emerge from the power and control framework) may exclude those disabled women who are being abused by control and restraint mechanisms that may appear to service providers to be less harmful in the non-disabled population than direct assault. Examples of these situations include withholding access to medications, controlling assistive devices, and refusing to communicate using assistive devices or with sign language (Gilson et al., 2001). Provider and community failure to understand and characterize abuse among the disabled culture may serve to isolate women from services and supports that could potentially decrease or eliminate the abuse and provide a supportive environment in which women with disabilities can live safely and productively. Furthermore, disabled women have noted that standard abuse assessments fail to identify the types and extent of abuse occurring in their relationships, and thus, providers using such instruments do not identify many situations as domains for intervention (Gilson et al., 2001).

The limited knowledge about forms of abuse unique to women with disabilities may thus inadvertently place this population deeper into a world of limitation and isolation. Thus, viewing non-recognition of abuse of disabled women as a cultural phenomenon highlights the isolation of these women from the social services and supports that could potentially decrease or eliminate the abuse and provide a supportive environment in which women with disabilities can live safely and productively.

An Important Study

Literature related to the need for innovative community-based methodology clearly highlights the limitations of traditional research paradigms in illuminating the experience of diverse individuals with disabilities (Gill et al., 1994; Gilson et al., 2001). Disability researchers have been calling for methodologies, in concert with socio-cultural definitions of disability, which are capable of revealing person-centred, contextually embedded insights as a basis for programme and support development (Barnes and Mercer, 1997; Seelman and Sweeney,

1997). Expanding beyond medical understandings of disability requires the implementation of research designs which are both theory generating and theory testing. These diverse methods are critical to the development of knowledge that is necessary to underpin services and supports promoting community inclusion, productivity and quality of life for diverse populations.

Here, we review the findings of a study conducted by Gilson et al. (2001), in which the researchers used a naturalistic method relying on focus group data collection strategies. Consistent with social, political and cultural views of disability, these methods gave voice to disabled women who have experienced abuse and, thus, the findings emerge from the women's own understandings and experience of their abuse.

According to the participants in this study, while there are forms of abuse common to all women, some types of abuse are unique to disabled women in particular because of the limitations that the disability itself presents. What may not be abusive for non-disabled women may be extremely harmful for disabled women. For example, causing harm by moving a mobility impaired individual against her wishes is not a form of abuse that can occur when one is independent in mobility. Of particular note was the additive effect of demeaning or dismissive comments to women with disabilities who already belong to a population that is devalued and marginalized by mainstream culture.

Moreover, because disabled women are frequently dependent on providers for daily care, perpetrators can be 'of many faces' in the lives of disabled women. Providers who are often seen as 'helpers' may, in fact, be the very individuals whose behaviour is intentionally or indirectly abusive to women with disabilities.

From the women's voices, the researchers have suggested that the cultural construct of limitation, and thus cultural isolation, seems to amplify seemingly benign situations into harmful ones, placing disabled, abused women in cycles of poverty or isolation, or both. This further serves to increase their vulnerability to even more abuse and limitation.

Not unexpectedly, because of the current conceptualizations of abuse for non-disabled women, providers and other community members may not recognize extremely harmful abuse that is unique to women with disabilities. Therefore, realizing that women with disabilities experience unique forms of abuse is crucial to efforts to include

them in services and supports for abused women and to advance preventive efforts for this population in the future.

Considerations for the Future

Considerations for the future fall into several arenas, including (*a*) current service revisions and (*b*) direction for future research.

First, the application of traditional criminal justice models of abuse to identify disabled women who have been or are being abused is not sufficient, thereby neglecting disabled women in the service system. To rectify and alter this immediate and severe social problem, participants suggested the following questions as probes to identify abuse that might not be identified with traditional assessment techniques:

1. Has someone ever withheld something from you such as medication or an assistive device that you needed?
2. Has someone ever said you cannot do something, say, get a job or find housing?
3. Has someone ever walked out of the room when you requested them you need to use the restroom, or left you in your chair knowing there is no other way for you to transfer without any kind of assistance?
4. What level of respect do you feel you get from people?
5. Do you feel that you are in control of your life?
6. Who controls your activities? Your medication? Your health? Have you ever experienced anything that made you uncomfortable?

Second, although spouses or live-in partners have been found to be the most frequent perpetrators among samples of disabled and non-disabled women (Young et al., 1997), the participants reinforced that there is a greater likelihood for health care workers and attendants to be the perpetrators of disabled women than for non-disabled women. Therefore, when asking questions about the perpetrator, service providers should not assume that the relationship between victim and perpetrator is a romantic or familial one.

Further research to test, advance and apply socially and culturally sensitive theory to the development and implementation of services, supports, and policies that will prevent abuse among disabled women and provide necessary supports for this type of population is essential. Regarding future inquiry, participants suggested that service providers

examine the issue of abuse of women with disabilities by type and on-set of disability in that the population of abused disabled women is not homogenous. Another participant suggested that the factors responsible for perpetration on the part of health providers is specifically related to the stress the job. A more complete understanding of individual, medical, social, and cultural diversity of both individuals who are abused and of perpetrators, and the identification of correlates and predictors of abuse of disabled women, can serve to inform prevention programmes. It can also provide the much-needed and relevant knowledge on which responsive programmes and policies can be developed and implemented.

Finally, the role of multiple and sometimes competing views of disability must be taken into account to inform the development, implementation and evaluation of efforts at various system levels to protect those who are abused and to include women with disabilities into abuse and violence protection and prevention services, supports, policies and legislation.

References

Barnes, C. and G. Mercer (1997). 'Breaking the Mould? An Introduction to doing Disability Research', in C. Barnes and G. Mercer, eds., *Doing Disability Research*, pp. 1–14. Leeds: The Disability Press.

Berkeley Planning Associates (1992). *Meeting the Needs of Women with Disabilities: A Blueprint for Change*. Berkeley, Calif.: Author.

Bureau of Justice Statistics (1997). 1.4 Million People Treated in Hospital Emergency Rooms for Violence-Related Injuries [online]. Available at http://www.usdoj.gov/bjs/ (24 August 1997).

Calvey, P. (1998). The Invisible Woman: Women with Disabilities and Abuse. Paper presented at the Eighth National Conference and 20-Year Anniversary, National Coalition Against Domestic Violence, Denver, Colo.

Charlton, J.I. (1998). *Nothing About Us Without Us: Disability Oppression and Empowerment*. Berkeley: University of California Press.

Chenoweth, L. (1996). 'Violence and Women with Disabilities', *Violence Against Women*, 2(4), 39–411.

Family Violence Prevention Fund (1999). *Domestic Violence is a Serious, Widespread Social Problem in America: The Facts*. San Francisco, Calif.: Author.

Gill, C.J., K.L. Kirschner and J. Panko Reis (1994). 'Health Services for Women with Disabilities: Barriers and Portals', in A. Dun, ed., *Referring Women's Health: Multidisciplinary Research and Practice*, pp. 357–66. Thousand Oaks, Calif.: Sage Publications.

Gilson, S.F., E.P. Cramer and E. DePoy (2001). '(Re)Defining Abuse of Women with Disabilities: A Paradox of Limitation and Expansion'. *Affilia: Journal of Women and Social Work*.

Gleeson, B.J. (1997). Disability Studies: A Historical Materialist View.' *Disability and Society*, 12(2), 179–202.

Linton, S. (1998). *Claiming Disability: Knowledge and Identity.* New York: New York University Press.

Mackelprang, R.W. and **R.O. Salsgiver (1999).** *Disability: A Diversity Model Approach in Human Service Practice.* Pacific Grove, Calif.: Brooks Cole.

National Coalition Against Domestic Violence (1996). *Open Minds, Open Doors.* Denver, Colo.: Author.

Nosek, M.A., D.H. Rintala, M.E. Young, C.C. Foley, C. Howland, G.F. Chanpong, D. Rossi, J. Bennett and **K. Meroney (undated).** *National Study of Women and Physical Disabilities: Special Summary.* Houston, Tex.: Center for Research on Women with Disabilities.

Oliver, M. (1996). 'Defining Impairment and Disability: Issues at Stake', in G. Barnes and G. Mercer, eds., *Exploring the Divide: Illness and Disability*, pp. 39–54. Leeds: The Disability Press.

Quinn, P. (1998). *Understanding Disability: A Lifespan Approach.* Thousand Oaks, Calif.: Sage Publications.

Rioux, M.H. (1994). New Research Directions and Paradigms: Disability is not Measles', in M.H. Rioux and M. Bach, eds., *Disability is not Measles: New Research Paradigms in Disability*, pp. 1–7. North York, Ontario: Roeher Institute.

Seelman, K.D. and **S.M. Sweeney (1997).** 'Empowerment Advocacy, and Self-Determination: Initiatives of the National Institute on Disability and Rehabilitation Research. *Journal of Vocational Rehabilitation*, 9: 65–71.

Shakespeare, T. and **N. Watson (1997).** 'Defending the Social Model', *Disability and Society*, 12(2): 293–300.

Sobsey, R. (1994). *Violence in the Lives of People with Disabilities: The End of Silent Acceptance?* Baltimore, Md.: Paul H. Brookes.

Young, M.E., M.A. Nosek, C. Howland, G. Chanpong, and **D.H. Rintala (1997).** 'Prevalence of Abuse of Women with Physical Disabilities', *Archives of Physical Medicine and Rehabilitation*, 78, suppl. 5, S34–S38.

12

The Situation of Disabled Women in South Asia

Salma Maqbool

Geographically, the land mass commonly known as South Asia is made up of seven countries, i.e., Pakistan, India, Bangladesh, Nepal, Bhutan, Sri Lanka and Maldives. This part of the world has been the home to several ancient civilizations that were the torch-bearers of wisdom and enlightenment for humanity. Sages and reformers taught people to take care of others and share their earthly possessions with those who were not bestowed with spiritual and material holdings.

Presently, there are more than a billion people living in the South Asian region. This is about one-fifth of the world's population. Out of this, about 100 million or more are people with disabilities. Approximately, 50 per cent of this population are girls and women. This is the largest population of disabled people in any region of the world. Moreover, 72 to 80 per cent of the South Asian people live in rural areas. Consequently, people with disabilities in the rural areas is much higher than in the urban areas.

Disabled people in the South Asian countries face the same socio-economic problems to a large extent. Most of them are poor and are subject to oppressive discriminatory practices, myths and taboos fostered by the ignorance of the people over centuries. They suffer from malnutrition, lack of health care, education, training and employment opportunities.

The situation of girls and women with disabilities in South Asia has to be studied in the context of the status of women in general. Traditionally, women occupy second-degree citizenship and are taken as living tools for performing certain duties at home and outside. At times, they are treated as useless and sub-human beings and looked as 'burdens' on the family.

The status of disabled people started improving towards the latter part of the eighteenth century. Men and women with missionary zeal, sometimes belonging to religious groups, were charged with the spirit of working for people with disabilities in the South Asian countries. They set up schools and pursued many rehabilitation programmes for children with disabilities, mostly in the major cities. Customarily, affluent citizens ran charity homes for people with disabilities. But, unfortunately, such attempts overlooked their basic human rights, such as education.

The prevailing sociocultural pattern encouraged the admission of male children and youth with disabilities to such specialized institutions. Culturally, South Asian societies have always been male dominated. The head of the family—father, uncle or brother—disallowed their disabled female ward to leave home, as this would bring shame to the family. Rarely, the perseverance and persuasion of the missionary succeeded and there were few females who received formal education and training during this period. However, a majority of the girls and women with disabilities continued to lead a life of silent misery.

Surveys conducted to evaluate the difference in the status of boys and girls with disabilities have often indicated that the latter are more prone to risks of life and early death resulting from common childhood diseases because parents generally neglect the health problems of the girl child to a large extent.

The concept of establishing service-oriented institutions to improve the quality of life for people with disabilities gained strength and started taking roots in the early nineteenth century. Groups of like-minded people, particularly those who had a person with disability in the family, came together to work in an organized manner. Service organizations/agencies sprung up in many of the big cities in South Asian countries. The larger and more developed among such organizations recognized the desperate situation of girls and women with disabilities and established separate educational and vocational facilities for them. Usually these city-based centres were

residential and thus encouraged the admission of girls and women with disabilities from rural areas as well.

Service organizations/agencies of this era played a major role in educating and rehabilitating people with disabilities, raising their self-image and self-confidence on one hand and social awareness about their 'abilities' on the other.

As the nineteenth century advanced, the world was swept by the reactionary, self-help movements of people with disabilities. The salient feature of this movement was the rejection of the custodial attitudes of society towards people with disabilities, and the demand for 'full participation and equality in all spheres of life'. This period saw the birth of international organization such as the International Federation of the Blind (IFB) which had many affiliates in the South Asian region. The self-help organizations made extraordinary efforts to give impetus to the progress of girls and women with disabilities and launched special programmes for them. The first Leadership Training Seminar for Blind Women in Asia was held in March 1981 in Kuala Lumpur, Malaysia under the joint auspices of IFB and the World Council for the Welfare of the Blind (WCWB), followed by similar programmes in Africa and Latin America. Coincidentally, two great blind women, Fatima Shah of Pakistan and Dorina de Govia Nowell of Brazil, headed the IFB and the WCWB at that time. During this period, specific measures such as formation of disabled women's committees were formed to impart leadership qualities to girls and women with disabilities. The moulding and empowering of girls and women to become agents of change drew the attention of people and organizations across the world.

The United Nations declared 1981 as the International Year of Disabled Persons (IYDP). The main objectives of this declaration were

(i) awareness creation about disability issues,
(ii) prevention and early detection of disabling diseases, and
(iii) rehabilitation of people with disabilities.

Member states launched pragmatic policies to improve the quality and standard of life of people with disabilities. The South Asian countries participated with great enthusiasm to achieve the goals of IYDP and thus the momentum of work for disabled persons increased significantly. Emphasis was also laid on developing plans and programmes that can provide disabled girls and women with

opportunities to have access to education, vocational training and other measures.

In 1981, the Disabled People's International (DPI), the cross-disability umbrella organization, came into existence in Singapore. One of the goals of DPI was to increase the participation of girls and women with disabilities in the organizations at the local, national and international levels. The constitution of DPI placed special emphasis on the development of the status of girls and women with disabilities. In IFB, accordingly, a number of leadership-training and capacity-building programmes were initiated for disabled women and girls.

The U.N. Decade of Disabled Persons (1983–92) carried forward the work for the improvement of the condition of people with disabilities. The 'World Programme of Action for Disabled Persons' contained guidelines on improving the condition of girls and women with disabilities who were lagging behind in comparison to their male peers.

The South Asian Association of Regional Cooperation (SAARC), the primary regional body comprising Pakistan, India, Sri Lanka, Bangladesh, Maldives, Bhutan and Nepal, observed 1993 as the Year of Disabled Persons in the SAARC Region. It proved to be a milestone in the activities of this intergovernmental organization. The historic Islamabad Resolution on Disabled Persons and the Plan of Action were adopted by the SAARC countries to provide welfare services to persons with disability. However, such approaches had always been very general and nothing specific was ever undertaken to improve the plight of women with disability. In November 1998, national self-help organizations of women with visual disability gathered in New Delhi and launched the Forum of Visually Impaired Women in SAARC Countries with the aim of bringing together the visually impaired women of the region for better networking and also for taking a collective approach to the overall development of girls and women with such handicaps in the society. The author has been honoured to lead this forum as its chairperson.

Though the initial efforts at creating awareness among disabled people and rehabilitating and integrating them into mainstream society came from local NGOs, international self-help organization of people with disabilities also entered the scene later on. Furthermore, several U.N. conventions and resolutions urged the member states to plan and implement pragmatic policies for their disabled

citizens. There were also special resolutions adopted in favour of girls and women with disabilities on the occasions of U.N. women's conferences in 1975, 1985 and 1995.

We have discussed the gradual though slow progress in the improvement of the quality of life of girls and women with disabilities of the South Asian region. Let us now examine the status of girls and women with disabilities in the societies of these countries more closely. Despite the fact that the governments of the South Asian countries have ratified important U.N. human rights instruments for women and girls with disabilities such as the Convention on the Elimination of All Forms of Discrimination Against Women (CEDAW), the U.N. Declaration on Human Rights, the Convention on the Rights of the Child, and the Standard Rules on the Equalization of Opportunities for Persons with Disabilities, these documents have not yet been implemented.

The responsiveness and commitment of most governments in creating equal opportunities for women with disabilities is minimal. National development efforts that target women and women's rights movements in nearly every country continue to exclude disabled women. A large number of women with disabilities, particularly those in rural areas of South Asia, still suffer from deprivation of basic human rights, domestic and sexual violence, lack of access to education, health care facilities and rehabilitation programmes. The media portrays negative images of women with disabilities, focusing only on their physical disfigurement. The cosmetic industry has further isolated disabled women by presenting only healthy and beautiful women as objects of admiration and attention.

Girls and women with disabilities are thus subject to many types of discrimination in society. In some cultures, the birth of a disabled child is considered the result of the sins of the parents. The birth of such a child may be hidden from the community because of the fear of being outcasted. The growth period of the girl child with disability is engulfed in either over-protection or sheer neglect, thus hampering their balanced physical and psychological development. Girls with visual impairment are usually considered incapable of taking charge of the normal physiological changes at puberty. Often visually impaired girls are not trained like their normal siblings to perform household chores as no such responsibility is envisaged for them in future life. Marriages of visually impaired young women are not a

common practice because family life and child-bearing and rearing is deemed to be beyond their capacity. Non-disabled young women attain a degree of status in the community after marriage. Unfortunately, girls with disabilities are deprived of their right of marriage and normal sexual and family life.

The plight of girls with hearing and speech loss is somewhat better than the others as this disability is invisible and their physical growth and activities are closer to the norms, thus enhancing their acceptability in the community. Mild locomotor disabilities in girls and women provoke lesser level of discrimination because such individuals can undertake usual domestic responsibilities. However, those with severe conditions are doomed to a life of dependence like their grossly mentally impaired sisters. Slightly mentally impaired girls are taken as stupid creatures not worthy of training in any form.

The lack of educational facilities for girls and women with disabilities especially for those residing in rural areas may be considered as the main reason for their backwardness. Even in the urbanized centres, access of disabled women to education is very limited. This is because of the fact that the integrated system of education has not taken off properly and the special education centres are fewer in number.

Similarly, vocational training opportunities are not available to the large majority of women with disabilities. Community-based rehabilitation programmes are being pursued in some parts of South Asia. However, they are again insufficient as compared to the population of disabled persons.

The employment of girls and women with disabilities is also extremely restricted because of the lack of education and vocational skills. Moreover, only a few openings are available for them, such as in the educational system and low-grade menial jobs.

Girls and women with disabilities often suffer from acts of domestic violence and sexual assault. Such acts are not spoken of by the person concerned because of oppression and lack of access to any form of consultation and legal aid.

Another area of violation of the human rights of girls and women with disabilities is their exclusion from inheritance of family properties. In this case, the guardians of the disabled girl issue statements to the concerned authorities that their ward is not in the right mind

to manage her own affairs and also that she is well provided for by the family.

At a time when the National Plans of Action for Women are being launched in some countries of South Asia as the follow-up of the Fourth U.N. Women Conference, the rights of women are being recognized as human rights. Groups of empowered women with disabilities have worked with other women in the, formation of the National Plans of Action and together they are pushing forward for the improvement of the quality and standard of lives of girls and women with disabilities.

The participation of women with disabilities at national and international conferences is still very low. Even at the Fourth U.N. Women's World Conference, there were only seven participants with disabilities in the governmental delegation from the whole world. The author was the only woman with disability from South Asia representing the national delegation of Pakistan at the conference. Fortunately, about 200 women with disabilities from many countries including from the South Asian region were able to participate in the NGO's Forum which was held concurrently with the Beijing Conference.

The ranks of empowered women with disabilities of South Asia, through the gradual process of development, are now raising their voices to be heard in the chambers of the governments as well as the various strata of society. They are speaking for the millions of their deprived peers who are still suffering in silent misery. They are asking for their rights and equalization of opportunities in the mainstream. Their demands reflect the provisions of the Beijing Platform for Action. They are demanding that

(a) Seats should be reserved for women with disabilities in the national, provincial and local legislating bodies.

(b) Women with disabilities must participate in all decision- and policy-making levels that are concerned with their lives. Furthermore, they should be directors and administrators of projects that are launched for their development.

(c) Women with disabilities should have easy and full access to health and medical care throughout their span of lives.

(d) Girls and women with disabilities must have full access to education (inclusive of professional and high-tech training).

Primary education must the made compulsory for girls with disabilities.

(e) All agencies (including U.N. specialized agencies) and international non-governmental organizations (INGOs), which give financial assistance to national governments for women development programmes, must have a component for, and insist on, including the development of girls with disabilities in their terms of references.

(f) Financial institutions should provide interest-free/soft loans to girls and women with disabilities who wish to establish self-employment units.

(g) Home and peer counselling should be provided to girls and women with disabilities through governmental and non-governmental agencies to create awareness about the rights and needs of disabled persons in general and women in particular.

(h) Training facilities to educate girls and women with disabilities in self-development, health and family care, vocational training, business management and entrepreneurship should be offered through governmental and non-governmental programmes.

(i) Employable girls and women with disabilities should be provided with jobs commensurate with their abilities and training.

(j) Work environment and schedules should be accessible to girls and women with disabilities.

(k) Assistive devices for mobility, domestic chores, education and workplace requirements should be provided to girls and women with disabilities.

(l) Incentives such as scholarships and special transport facilities should be provided to girls and women with disabilities to encourage them to participate in educational and training activities.

(m) Government must impose restrictions on media channels to refrain from portraying negative and stereotype images of girls and women with disabilities.

(n) Free legal aid should be available to girls and women with disabilities who have been subjected to any form of exploitation, domestic violence and sexual abuse.

(*o*) Women NGOs should develop close network with groups of girls and women with disabilities to strengthen their struggle for equalization of opportunities.

Women with disabilities in South Asia are possessed by the sheer determination to achieve equal of opportunities in all walks of life and overcome barriers that seem insurmountable now. However, their goals may come closer if their counterparts in other regions of the world share their experiences and show them the path that they have already treaded to achieve their rightful place in the society.

IV
Facilitating Strategies and Entitlements

13

The Status of Women with Disabilities in Trinidad and Tobago

Jacqueline Huggins

Introduction

The World Health Organization has postulated that 10 per cent of any given population is disabled. The Ministry of Social Development's 'Policy on Persons with Disabilities' (1994) refers to a sample survey conducted in 1991 which indicated that in Trinidad and Tobago, 6.8 per cent of the population, which was 1.2 million, had either a mental, a physical or a sensory disability. A more precise number of disabled persons is not available and this can be attributed to a lack of research on this population.

Different sociological perspectives have identified different factors as being responsible for the status or positioning of an individual in any given society. According to Roucek and Warren (1963), status can be ascribed, that is, acquired by birth or achieved depending on what a person has accomplished or is believed capable of achieving. In this light, this article operationalizes the status of women with disabilities by using variables such as education level, employment and income, relationships, marital/union status, access to resources and mobility and rehabilitation which are important to physically disabled persons. The article focuses on women with physical disabilities including visual impairment, arthritis, and amputation of limbs, poliomyelitis and cerebral palsy.

The Disability Movement in Trinidad and Tobago: A Women's Perspective

According to Driedger (1996), the worldwide view before the 1950s was that persons with disabilities were sick people. This perspective dictated the type of treatment that was given to those who were disabled, and this included being locked away in asylums and family attics. In other words, persons with disabilities were shut out of the mainstream of society. Before the work of the disabled and civil rights movement, women's issues were not considered important. Moreover, they were marginalized by society because of being disabled and being women at once.

In the early twentieth century, most of the efforts made towards improving the situation of the disabled were concentrated around different groups establishing their own associations. These associations, with the help of government's subventions and contributions from non-governmental organizations (NGOs), for example the churches, sought to meet the needs of their members, which included education through the building of special schools, residential care, housing, social services and other social needs. The period from 1914 to the early 1970s saw the establishing of organizations for the blind, deaf, and physically and mentally handicapped.

By 1988, the movement was considering independent living as an alternative for persons with disabilities. In 1990, the Independent Living Center of Trinidad and Tobago was established which provided training programmes in 'training for trainers', peer counselling and advocacy expected to develop the knowledge base, skills, confidence and assistance that the disabled needed to participate more fully in society.

In 1992, the formation of the Disabled Women's Network of Trinidad and Tobago (DAWN), which is the only known group mainly for disabled women, heralded a new lease on life for women with disabilities within the movement. The group grew out of the Independent Living Center, when the women realized that the issues faced by disabled women were different from those faced by disabled men. They decided that the need of the hour was a programme initiated by women for women. Emphasis was placed on independent living and training, which included educational enhancement, and there has been a begrudging acceptance by some of the disabled men.

Driedger and Guy (1996) feel that education about gender and disability issues have led some women to become more self-assured and focused on the areas that are of particular importance to their development. The level of the impact made on the lives of women with disabilities is yet to be fully evaluated, but for DAWN, making a positive contribution to the life of even one woman with a disability is an achievement.

In the early 1990s, women openly discussed the barriers to their integration into society; for example, uncooperative families, husbands who kept them shut up in their homes, and lack of transportation (Driedger and Guy, 1996). Since its establishment in 1992, DAWN has worked with the Caribbean Association for Feminist Research and Action (CAFRA) which continues to provide training services and advice about access to women's services and legal issues. The aim of this group is to foster a sense of empowerment in women with disabilities. Both the issues of disability and gender were brought to the fore in a seemingly new way. Driedger and Guy (1996), agree that the process of disabled women coming together as a group was not a smooth one. Most of the resistance came from disabled women themselves while there has been a begrudging acceptance by some of the disabled men.

Conceptualizing 'Disability'

Defining disability is a complex process. This complexity has been witnessed in the analyses of the subject as postulated by various writers. A review of the literature shows a development through stages, from merely looking at individuals with disabilities and their responsibility for their position in society to a consideration of the part that the environment plays in the positioning of these individuals. Some of the recent issues between individuals and across cultures, hidden disabilities and the question of whether the frailties of old age should be classified as disabilities.

According to Oliver (1989), the theoretical approach of the individual perspective places emphasis on the adjustment of the individual through rehabilitation programmes which are paramount for returning him or her to normalcy. In addition, it gives importance to the psychological adjustment by which the individual comes to terms with his or her physical limitations. This perspective on

individual adjustment does not allow the individual to look outside of himself/herself for an analysis of his/her situation. A fundamental question is whether the individual perspective is in the best interest of persons with disabilities.

Several writers argue that the individual perspective is not in the best interest of disabled persons and there is a need for a newer way of conceptualizing or defining disability. The social model or handicapism perspective advocates that the focus should be on the ways that physical and social environments impose limitations upon certain groups or categories of people and as a consequence exclude them from mainstream society. Wendell (1996), while agreeing with Oliver (1989) that defining disability is complex, adds another dimension to the discourse, that is, on the question of who to incorporate and where to draw the line. The writer presents a unique way of putting herself within her discussion by incorporating her experiences and so brings out the issues in a way that no other writer has. The feminist way of doing research, that is, essentially giving the subjective situation of women greater priority over taken-for-granted sociological accounts of their lives, seems to have been successfully put to the test.

Wendell (1996) agrees with Ron Amundson's definition of disability as 'the absence of basic personal abilities' (Amundson, 1992: 108). In addition, she accepts his definition of a handicap as 'an opportunity loss sustained by an individual resulting from the interaction between the individual's (biomedical) disability and the specific environment in which the individual's opportunities exist' (Amundson, 1992: 111). This paper utilizes both the definitions to analyse the subject matter under discussion.

Women, Differences and Disabilities

Disability studies have moved beyond the economic and social disadvantages of women with disabilities. Instead, the focus is more on providing a political analysis based on the common experiences of women who may differ, for example, by culture, race/ethnicity and class.

Throughout the disability literature, 'double jeopardy' is the commonest phrase used to describe the status of disabled women. This is because, first, they are women and second, they are disabled. The issues focused on are those that are considered important for women

as a whole but emphasis is placed on the concerns of women with disabilities, for example, disabled women in relationships, sexuality, reproductive rights and decision making.

Most of the literature on disability subscribes to the fact that the disabled are different from the non-disabled. However, a distinction is made in terms of how this difference is perceived—whether positively or negatively. Begum (1992: 70) acknowledges that in many respects oppression of the disabled woman is similar to that encountered by non-disabled women. In the final analysis, the differences among disabled women and the impact of their disability on their experiences show the usefulness of the concept of difference in understanding disability and the community being researched. This concept emerged in feminist theorizing as a result of challenges to the generalized conception of women's oppression by women of colour and lesbians in North America. The success of these groups in getting attention to their experiences (however limited they may be) showed the virtue of such a concept.

In Trinidad and Tobago, most of the research done on women does not reflect the reality of women with disabilities. There has been no acknowledgement of the differences between women with disabilities and non-disabled women. In 1991, for example, when Patricia Mohammed reflected on the women's movement in Trinidad and the gains of women since 1962, she compared women versus men (Mohammed, 1991: 36–38). The term 'women' is used in a general sense. The gains, which she identified, for example, women's entry into the male-dominated labour force, are real but do not represent the reality for women with disabilities. She, however, acknowledged the difference between women from Trinidad and their counterparts in Tobago and limited her study to Trinidad.

Mohammed states that 'education and economic opportunities were taken up avidly by women during the oil boom years' and that 'there are no real obstacles to female entry into male-dominated professions except those caused by poverty or cultural restrictions' although she is silent on the number of disabled women included in her study. The writer rightly mentions the existing anomalies which primarily affect 'women who, because of their poverty or lack of education, may be unable to fully exploit their privileges', but the deep meaning this holds for women with disabilities is minimized since they were not identified. It must be noted that Mohammed is not singular in this practice.

Another important issue found within the literature is that of the assessment of the positioning of women with disabilities within both the disability movement and the feminist movement. What was the role played by disabled women within these movements? How were their issues dealt with? The issues of gender and the concept of difference ring out glaringly as the writers seek to come to terms with the problem.

Stuart and Ellerington (1990) suggested that there is tension between the feminist movement and disabled women to the extent that the movement's agenda seems to be almost worlds apart from the disability movement's and the position of disabled women. Two women's movement has a long history of organizing politically to effect social change, and one may need to ask the pertinent question of why certain groups of women have not benefited from the hard-fought battles of the feminist movement. Is it that there is the need to look at theory? If theory is seen as a means to an end (that is, policy formulation and implementation) then one must agree with Stuart and Ellerington when they posit the need for the use of subjective and qualitative methods of doing feminist research.

Stuart and Ellerington substantiate this point in the literature and inform that the mainstream disabled consumer movement is one that was traditionally gendered, to the extent that men held power and women's issues were invisible. A look at 'mainstream' sociological thought and research would necessarily show the same situation. The two writers have added though that disabled women's plights are gendered in a two-dimensional way, that is, they have to struggle for equal status as disabled persons as well as struggle for equal status as women. However, it is only recently that attention is being paid to women's issues and further development or exploration of this fact would necessitate the questioning of the relevance of the work of the feminist movement as opposed to the work of the disabled women's movement.

The Study

The study has focused mainly on women with physical disabilities, inclusive of visual impairment, poliomyelitis, cerebral palsy and amputation of limbs. The research instruments included in-depth interviews with organizations for persons with disabilities, life histories and a survey questionnaire and participant observation.

The sample was chosen by a stratified, two-stage design with cluster sampling in the second stage. An initial study sample of 46 respondents was selected from two organizations for persons with physical disabilities with whom in-depth interviews were conducted. Disabled Peoples International (North) and DAWN were chosen because their membership comprised both women and men with a range of physical disabilities. The sample comprised both women and men, the latter being included in an effort to make a comparison of disabled women and disabled men with the hope of bringing to the fore the gender issues which may have been existing. However, problems in the sampling process resulted in a very small number of men making up the final sample.

Initially a random sample was taken where every second woman from the list of 37 women was selected and every second man was selected from the list of five men who were members of DAWN. Due to the problems of locating the respondents of the initial sample, a random sample of the remaining persons on the membership list was again taken, resulting in a final sample of 12 women and two men.

The membership of Disabled Peoples International (DPI) consisted of more men than women and since the research was primarily on women with disabilities, the random sample selected consisted of every second woman from a list of 29 women and every tenth man from a list of 61 men. As in the case of DAWN, there was a second random sampling of the members of DPI because of wrong addresses and problems of locating several respondents, resulting in a final sample of 11 women and two men. The variables, which included education level, employment and income, relationships, marital/union status, access to resources, mobility and rehabilitation, were chosen after discussions with persons with disabilities about their perceived situation and positioning in the society and the issues that were important to them.

In the first instance, a pilot study was done with the objective of testing the questionnaire for any problems in its content and form and its subsequent improvement. Despite using the life-history method, there were times when I questioned whether this study needed a more qualitative input since many respondents were eager to share their life experiences in detail which the questionnaire was unable to capture. I was familiar with several of the respondents because of my work with the groups. However, I was able to form new friendships as I compared notes about migraine headaches and

pinched nerves, discussed favourite pastimes and life in general. I am aware that my work has not ended with this research paper.

The qualitative approach to social analysis, in this case the life-history method, proved very fruitful in gathering 'from the heart' information on three persons with disabilities. These individuals were chosen at random although willingness to share was a variable, which influenced the choices that were made. It was remarkable how some of the preconceived notions about the effects of a disability on someone's life were contradicted. The issues brought to the fore were no different from those that were raised through the survey questionnaire; there was, however, a richness to the information which was lacking in the survey data.

Survey Results

The total number of persons interviewed in the survey was 27, 23 women and four men. All respondents were physically disabled persons. The precise number of disabled women is not yet known in Trinidad and Tobago and therefore the sample used in this study is not representative of all women with physical disabilities including visually impaired and blind women. The use of a small sample of women and a still smaller sample of men is a limitation in terms of the precision of the results of the study. The findings therefore need to be taken with caution and seen as trends for further examination. However, it is still hoped that the issues brought out in this study will add intimate and detailed information to the small but growing database on persons with disabilities. It is also hoped that this information will not only lay the groundwork for future studies but also be a catalyst for change in the status of women with disabilities in Trinidad and Tobago.

Age and Sex

Fourteen female respondents were between the ages of 25 and 45 years; five were between the ages of 51 and 60 and four were 61 and over. Of the male respondents two were between the ages of 51 and 60 years; and one each between 25 and 45 years and 61 years and over. None of the respondents was below the age of 25 and this may be attributed to the fact that the sample was taken from two organizations for persons with disabilities which do not have a large number of

younger persons. In addition, the programmes and services of DAWN and DPI may not be incentives for young disabled persons to join these two groups.

Education

The primary school level was the highest level attained by seven of the women. Similarly, seven attained secondary level but graduated with less than five Caribbean Examination Council (CXC) passes. Of his figure, 10 per cent of the women who were older than 51 years did not sit CXC but took the Senior Cambridge examination, which was the examination for that era. None of the women graduated with more than five CXC subjects despite the number going to secondary school. Women who did not go to the mainstream schools totalled six. These women attended special schools including the School for the Blind and Princess Elizabeth Center for Physically Handicapped Children. Technical education in the secretarial and garment construction fields was attained by two of the women. One woman was able to attain university-level education, which was the highest level attained in the sample. One-half of the male respondents attained the level of tertiary/university level and the other half attained the primary school level of education.

The age at which a woman became disabled had some influence on the level of education attained. Four women who became disabled between birth and five years of age went to special schools. It is only recently that the process of mainstreaming is being done in a more serious manner, especially at the secondary school level. This has it own problems, since inaccessibility and lack of aids prevent disabled students from completing their education. On the other hand, four of those who became disabled between the age of 26 and 45 had only attained primary school level. This may be attributed to a certain extent to the limited opportunities for secondary education for all women in the past.

Marital/Union Status

Nine women were no longer in a relationship while seven were married and living with their partner. One female respondent was never married nor had a partner. One woman was married but no longer living with her partner, three were widowed, and one was divorced.

Type of Disability

History shows that poliomyelitis (polio) affected many children in Trinidad and Tobago in the 1950s and this could be one of the reasons why polio was the commonest type of disability for seven of the women. Only three were visually impaired and two had cerebral palsy. The remaining 52.3 per cent was made up of a variety of disabilities such as spinal cord injury, multiple sclerosis, varicose vein, spastic and amputation of limbs due to diabetes. One woman who was visually impaired was unsure of the age at which she became disabled. A little less than half of all women (47.8 per cent) were disabled during the age group of birth to five years and just over one-third (34.8 per cent) of them became disabled after the age of 25. The majority (65.2 per cent) were disabled between birth and 25 years. Among the four male respondents, one each had cerebral palsy, visual impairment, quadriplegia and ankylosing spondylitis. Two male respondents were disabled between birth and five years, one after the age of 25 and one was unsure about it.

Problems due to Disabilities

The respondents were asked to identify all the problems they feel they face because of their disability. The problems identified are the same as those that may be faced by any non-disabled person in this society. The problem of transportation was considered a major problem by 17 of the women. Economic, health and unemployment problems were identified by 15, 12 and 12 of the women respectively. Seven women considered social relationships and five considered housing as problems. One woman felt that none of her problems were due to her disability.

The men in the sample also considered the same problem as the women. Two men identified economic, social relationship, transportation and unemployment problems being a result of their disability. One person identified, health, housing and disrespect from others as problems faced because he was disabled. Although the questionnaire did not give the details of why the problems were chosen, respondents felt that there is some level of discrimination in terms of access to opportunities which are normally open to non-disabled persons. The economic problem is the major problem which affects all other problems.

Dwelling

Most of the respondents resided in a single dwelling house. More than half of the women (61 per cent) lived in a single house, 34.7 per cent lived in an apartment and one lived in an institution. Three of the men lived in a single house and one lived in an apartment. There were no homeless persons or persons who lived in town houses or condominiums. Although most women lived in single houses, only four of them owned those houses; three co-owned the house with spouse or children; four lived in a house which was owned by their parents; and one lived in a house which was solely owned by her spouse.

Most of the respondents were generally more dissatisfied with the building construction than with the furnishings (furniture and appliances) of their homes. The ones who were mainly affected were those who did not have ownership of the building and hence had no control over what was done to it, for example, renovations. The lack of mobility aids and accessible infrastructure was the main reason why six of the women were dissatisfied with where they lived. Additionally, inadequate living space, lack of utilities and the need for major and expensive repairs were each problematic for five of the female respondents. The additional cost to bring to a level that is sensitive to the needs of the disabled is usually a form of contention for the disabled and their families. This situation is carried to another level as the infrastructure of public areas is examined, Incidentally, the high cost of rent or mortgage was a problem for only one of the women. Two male respondents also had a problem with a lack of mobility aids and accessible infrastructure while one had a problem with inadequate living space and the high cost of rent/mortgage.

Mobility

The frequency with which respondents leave home is very instrumental in measuring mobility. Eight of the women in the sample leave home between 2 and 5 days per week; six leave home once a month; five left once per day; three left once per fortnight; and one never left home. The persons who left home most often, that is, at least once per day, may be those who are employed. Leaving home may be dependent on availability of transportation or on whether the respondent has something important to do.

The number of activities that a respondent engaged in 'often', 'seldom' or 'never' also measured mobility. The activities are considered to be 'normal' everyday activities. The respondents were asked to tick as many activities as necessary. In general, all respondents tended to frequently engage in activities, which can be done at home or indoors. Engaging in a hobby (14), listening to the radio (18), reading newspapers, magazines and books (14), attending religious services (12), receiving visitors (13) and watching television (17) were activities which were often performed by most of the women. The women seldom went to the movie (9), on outings or informal gathering (12), for shopping (10), to visit friends or relatives (11) and to attend social groups or community meeting (9).

During the study it was found that many respondents were on the organization's membership listing but did not attend meetings or any of the activities of the group. There were several restrictions that were responsible for this. The activities in which many did not engage were outdoor activities. Most of the women never took part in sporting events (15), go to parties (15), and go to the movies (12). One woman cited going to her doctor, which was an important activity for her and which she seldom did, under the 'other' category.

On average, the male respondents followed the same pattern as the females. Of significance is the fact that half of them seldom went shopping and three quarters of them were never engaged in a hobby. This behaviour may not be any different from that of non-disabled men. However, one of the male respondents was bedridden and hence his level of activity was very low.

Both physical impairment and a lack of transportation placed restriction on the women in the sample. More than half of the women (12) had these two problems. The inaccessibility of the environment was also a deterrent for 11 of the women in the sample. Women totalling nine for each category stated that lack of accompaniment, cost of the activity and lack of proper facilities at the place restricted them from going out. Lack of motivation was not a big problem except for six women. Although five women did not experience any restrictions in carrying out activities, the problem of mobility both in terms of the individual's capability to move her body as well as the obstacles and lack of proper infrastructure in the environment and transportation cause restrictions for the disabled woman. Notable also is the fact that since many of these women are single and they have problems getting someone to accompany them

on their trips from home. The men also have the same problems as the women but lack of proper facilities and cost are not as big a prob-lem as it is with the women since only one man had this problem. Half of the male respondents experienced all of the other problems.

Employment

Six of the female respondents were employed while 17 were unem-ployed. The jobs that are done by women are the ones that are nor-mally considered women's work; for example, seamstress, receptio-nist/telephone operator, store attendant and garment factory worker.

Two of the males were employed and two were unemployed. What is significant is that many of the respondents are of working age. Of the female respondents who were employed, one was self-employed, one employed in private sector, two employed in an NGO/charitable organization and two were employed in a family business. None of the women was employed in the public sector, which is state con-trolled and there may be the need probably for the government to ei-ther look at the qualifications needed for entry into the service or to look at its employment practices. All the men who were employed were at an NGO/charitable organization.

More than three-quarters of the women who were unemployed had worked before and 23.5 per cent had not worked before. The major reason why they stopped working was because they became disabled (38.5 per cent); 15.4 per cent were medically unfit, 15.4 per cent had resigned and 30.7 per cent left their jobs for various reasons including loss of business, bad working conditions and domestic rea-sons. Half of the men stopped working because of disability and half of them had stopped because of closure of the workplace. Some of the persons who became unemployed because of disability felt that if proper facilities were in place they could still have been employed since their level of disability is classified as impaired.

Income

The base figure of TT$5,000.00 was used this since it represents the amount by which an individual is considered eligible for receiving fi-nancial assistance from programmes of the Ministry of Social and Com-munity Development. This figure is lower than the poverty line figure cited by the 1996 Report of the Ministry of Social and Community De-velopment (previously called Ministry of Social Development). The

annual income for 10 of the women interviewed is under TT$5,000.00 per year. Seven receive between TT$5,000.00 and TT$10,000.00, three receive between TT$10,001.00 and TT$20,000.00 while one receives between TT$20,001.00 and TT$30,000.00. Of those that receive under TT$5,000.00, one is employed in a family business and nine are unemployed. One woman who works in the private sector receives between TT$10,001.00 and TT$20,001.00 annually. Women who work in NGOs have an annual income between TT$5,000.00 and TT$20,000.00. Two of the male respondents receive under TT$5,000.00 annually, one receives between TT$10,001.00 and TT$20,000.00 and one man receives between TT$20,001.00 and TT$30,000.00. Men who receive more than TT$10,000.00 annually work in NGOs/charitable organizations.

When compared with men, it is found that women receive less than TT$5,000.00 per month at a ratio of 5:1. Female respondents who fall within the income bracket of TT$10,001.00 and TT$20,000.00 have a ratio of 3:1 to men. Within the highest salary bracket, the ratio of women to men is 1:1.

The main source of income for 11 of the female respondents was public welfare, and this is inclusive of a disability grant. Seven women received money from other relatives, six received money from their children, employment or pensions (NIS and old age). Male spouses give money to four of the women, which is less than the percentage of women who were married and living with spouse. There was a low level of money received from investments, which perhaps suggests that since the respondents received low levels of income there is not enough to save or invest. Income was received from investments by two of the women and five received money from non-relatives, for example, friends. The respondents stated that these amounts are not substantial and this is confirmed by the large number of persons who receive under TT$5,000.00 per year. One respondent reported that she did not receive money on a regular basis but rather had to depend on others to buy things for her.

Two male respondents (50 per cent) received income from employment and two (50 per cent) from pensions. One of them was able to receive income from investments he had made. None of the men received public welfare grants.

Respondents were asked to identify how many persons including them share their income. Most of the respondents did not share their income with anyone. Eleven of the female respondents used their income for themselves; nine shared it with 2–5 persons; two

shared with six or more persons and one did not have any income. One hundred per cent of the male respondents used their income for themselves. Many women had children as dependents and hence had to share their income with them. In addition more women lived with their parents and assisted in the running of the home.

A greater percentage of females than male respondents depended on the social services grant for their daily living. The public assistance grant was received by seven of the females while three received the disability grant and one received old-age pension or national insurance grants (NIS). More than half of the women did not benefit from the social welfare or NIS grants. Several respondents were impaired and not necessarily unable to work, and this could be the reason why some of them do not qualify for these benefits. One person was not aware of the criteria for applying for the public assistance. Only one male received a grant from the NIS.

Relationships

The most common relationship change for women who became disabled was with their siblings. This was followed by children, friends and other relatives (3). Only two women experienced changes in relationships with their parents, spouses and co-workers. One woman reported that her husband became more supportive and loving while another reported changes with neighbours. The male respondents experienced more changes with their friends (2), followed by children, co-workers, other relatives, siblings and spouses/partners (1).

Respondents considered changes with their children, friends, and other relatives as main relationship changes in their lives. One woman found that her children could not accept her disability and four other women found that relatives became unsupportive and some stopped visiting. One man spoke of the staying away of his friends as a major relationship change. Disability renders many people immobile in the absence of aids. Hence many people depend on others to visit or do things for them, but this may not be always forthcoming. Ignorance about disability may sometimes keep friends and family away.

Abuse

Generally there was a low incidence of abuse. Verbal and emotional abuses were the ones most experienced by the female respondents and the spouse/partner was most often the perpetrator. In the 'other'

category, the respondent refers to the carers at the Port of Spain General Hospital where she was warded for a long time. She was subjected to physical, emotional and verbal abuse. This is an area where more attention must be placed since in many cases persons with physical disabilities frequent health facilities or institutions where they have to stay for long periods. Although the incidences are small, it is clear that perpetrators are those who are close to the victims, for example, parents, siblings and spouses/partners. Only one male respondent was a victim of verbal abuse and this was at the hand of a vagrant on the street.

Society's View of Women with Disabilities

Driedger and Guy (1996) look at the issue of gendered relations of disabled people in Trinidad and Tobago in 1996 and contend that disabled women in society experience the same discrimination as other women worldwide. The writers report that the disabled community in Trinidad was working on this issue four years prior to 1996 when their paper was written. Reference is made to the vulnerability of women with disability to acts of physical, sexual and emotional violence, which are mainly committed by male family members. They inform us that these women have few choices since in most cases they lack the financial and emotional support to leave an abusive situation.

Driedger and Guy (1996) continue their discourse by reviewing the development of the Disabled Women's Network, which is seen as the women's arm of the Disabled People's International. Disabled women organized themselves as they became aware that they experience life differently than men. At the advent of DAWN, the women in DPI were not in positions to effect change or make decisions. For example, the male-dominated executive was responsible for approving the funding of the women's programme. It is only after 1990 that the women in DPI seemed to take up leadership roles and made conscious efforts to address specific women's issues and problems. These issues were never given any importance earlier within the movement. Unfortunately, the writers skirt the issue of gender rather than give an in-depth analysis of the issue.

Begum (1992), in her discourse about disabled women and the feminist agenda, explores ways in which some women are excluded

on the basis of both gender and disability. She suggests that 'although disability may be the predominant characteristic by which a disabled person is labelled, it is essential to recognize that gender influences play an important role in determining how that person's disability is perceived and reacted to' (Begum, 1992: 62).

Esther Boylan (1991) explores the ways in which disability is gendered. The qualitative method of research using the life experiences of women forms a major part of her work. The author has been very general with the term 'disabled women', such that the essence of the differences that exist among disabled women is lacking. All aspects of life, for example, employment, education, human sexuality, and human rights, are seen as being influenced by gender. The concept of difference is also shown to be very relevant within the 'disabled women's group', in terms of the type and degree of disability they have. Its relevance is also seen in the circumstances in which they live and in the degree of independence that they have been able to achieve. These factors are important notwithstanding the fact that several gendered issues commonly affect disabled women. In general, Boylan (1991) reveals that the opportunities and support afforded to disabled men, by which they are encouraged to become integrated into the mainstream of society, are either not available to disabled women or available only with tremendous difficulty.

Within the disability literature, social issues like rehabilitation, education and employment are portrayed as elusive goals for disabled women. These issues have been identified as affecting women with disabilities in an exceptional way. Notwithstanding the reality of this statement, care must be taken that generalization does not make us forget those disabled women who have 'made it' in the society.

Rehabilitation

Discussions on rehabilitation in the literature on disability focus on the restoration of the person who has become disabled to a level of usefulness or to a condition of good health. This rehabilitation process is different for different groups of disabled persons. Reference to rehabilitation for persons who are physically disabled describes the provision of services, which include special educational and vocational training, occupational training, counseling and therapy. In the literature, pertinent questions are posed about the applicability of rehabilitation programmes, the concept of independent living, the

opportunities that are available for disabled people and the benefici-
aries of the rehabilitation programmes.

Smyke (1991) reveals that a disabled woman's chances of being
taken for treatment or rehabilitation are reduced in some traditional
societies because of isolation or abandonment. She further adds that
although it is assumed that a disabled male should learn some skill or
profession that will enable him to earn a living (male as provider),
the same assumption is not made about disabled women. As a result,
vocational rehabilitation programmes are generally male oriented.
According to Boylan (1991), though there have been strides in terms
of women's involvement in community-based rehabilitation pro-
grammes, the negative attitudes that fuel gender-bias towards males
are still entrenched in society.

Education

Driedger and D'Aubin (1991) look at literacy and purport that it
is both a gender issue and a disability issue. They both agree with
Boylan (1991) that there is a high rate of illiteracy among women
in general in developing countries as opposed to men and dis-
abled women are even more likely to be illiterate. It must be
noted that in some developing societies, for example, in the an-
glophone Caribbean in the late twentieth century, this may no
longer be the case.

The experiences shared by women with different degrees of dis-
ability, in both the sources, reveal that access to educational oppor-
tunities and facilities is less for disabled women than men (and able
women). This is so because parents may be reluctant to pay the fees
or feel that they must keep their disabled daughter at home to pro-
tect her. In addition, there may be problems of mobility such as lack
of transportation to and from school or the unavailability of an aid
such as a pair of crutches or a wheelchair.

Driedger and D'Aubin (1991) use women's life experiences to
substantiate their discussions; for example, in the cases of Trinidadi-
ans, Joyce Joseph and Korisha Mohammed were both disabled by
polio in childhood. In Joseph's case, her education ended when she
outgrew the go-cart used as a means of transportation for taking her
to and from school. The situation was made worse as there was no
wheelchair or crutches available. Joyce's family did not have a car and
the bus seldom travelled into the area where she lived.

Mohammed received schooling in a residential institution but when she left her education was curtailed since there was a transportation problem and her parents were not able to afford a private tutor. Mohammed, however, was able to overcome the odds (no details on how it was facilitated) to gain secretarial training and, in 1991, was studying for her A level (university entrance) in English literature. Kathleen Guy (1998), coordinator of Disabled Women's Network of Trinidad and Tobago, stated that most women with disabilities have not graduated from high school because of the inaccessibility of schools, lack of accessible transportation and societal attitude that disabled women do not need an education.

Employment

Added to the lack of educational opportunities is the lack of employment opportunities. This is due to a narrow view or assumption that women who are disabled do not need to work since their families will care for them. Boylan (1991) also states that the labour market policies being more male oriented ignore the fact that many women are responsible for the financial security of their family. This includes women with disabilities who sometimes take on family commitments or women with families who become disabled and/or, more often than not, are divorced or deserted by their husbands or partners.

Though special aids and adaptations have been introduced to make it easier for disabled people to become part of the workforce, employment programmes for disabled people are male oriented or biased towards employing disabled males. Boylan (1991) concludes that a woman with disability still needs to convince an employer to look beyond both her gender and disability.

Quinn (1994) suggests that social roles have a dramatic impact on the ability of women with disabilities to pursue employment. According to the writer, women with disabilities experience discrimination in many areas of work. Even when they have skills and aptitudes that are equivalent to disabled men's, they are more likely to be channelled into occupations that have been traditionally regarded as female (Fine and Asch, 1988). Fine and Asch contend that because women are 'different', they are viewed in a negative light or as lacking the essential qualities and abilities required to perform jobs. In Trinidad and Tobago, it was reported that a small percentage of disabled women are employed in jobs in the open market, for

example, as receptionists and telephone operators, while some are in sheltered workshops.

Violence against Disabled Women

One of the major problems facing women with disabilities worldwide is that of abuse. Literature on disability has hardly placed any emphasis on the issue of abuse of women. However, there is a consensus among researchers that women with disabilities, regardless of age, race/ethnicity, sexual orientation or class, are assaulted, raped and abused at a rate two times greater than non-disabled women (Sobsey, 1988; Simpson and Best, 1991; Cusitar, 1994). Researchers state that the more disabled a woman is, the greater the risk of her being assaulted (Sobsey, 1994).

One may be tempted to ask whether non-disabled women are subjected to any kind of abuse. What is significant is that in the challenge to violence against women, women with disabilities do not fit 'nicely' into the paradigm set up by feminist researchers. Many of them are assaulted, raped and abused by carers and service providers, that is, those who have positions of power and control over their lives and on whom they may be dependent, in addition, to their intimate partners.

Guy (1998) stated that since most of the women with disabilities stay at home a lot, there is a high potential for abuse—sexual, emotional and physical. Sexual abuse against girls and women with disabilities is not uncommon, but it is seldom reported since they are advised to keep quiet. Guy feels that this is so because there is the fear that the society will probably 'cry shame' on the family and the authorities that allow these atrocities to go unreported. The truth of this statement is however debatable. She also adds that many of these women remain quiet because the perpetrators of the abuse are family members who sometimes threaten to withhold help and assistance if their actions become public knowledge. For Guy, this denial of assistance to the physically disabled woman who needs help with toilet and grooming is in itself a form of abuse since this causes the woman to be stressed out and neglect her appearance.

Another area that pose a challenge for disabled women, but which non-disabled women do not have to face, is of access to services for victims of violence. For many women with disabilities who are survivors/victims of violence, mainstream services are often not physically and attitudinally accessible. There is a lack of ramps, rails, attendant services and attitudinal barriers of staff, for example, in the case of

shelters. In additions, there are barriers related to sexual orientation. In these shelters, support for women who are victims of partner (male) abuse and not for those who are abused by carers, neighbours and service providers are apparent. There may also be insensitivity to issues related to disability and women with disabilities may be turned away from shelters.

Driedger and Guy (1996) also agree that the abuse of women with disabilities often occurs within the family itself and it is quite common for the perpetrator to be a male family member, that is, husband, father or sibling. The authors look at the important issue of the woman being financially dependent on others and hence the choices that may be available to her. This dependency relates back to the lack of opportunities for rehabilitation, education and, by extension, employment of disabled women.

A study conducted on abuse among 44 women with disabilities in Trinidad revealed that the types of abuse ranged from neglect, abandonment, financial abuse, physical, emotional and sexual abuse (Francis et al., 1995). In addition, 32 per cent of the women indicated that their abuser took advantage of their disabled situation, and that the most common perpetrator was their husband followed by their parents. Although it revealed that immediate treatment for injuries received from physical abuse was not sought, the study did not reveal whether the abuse was reported or not.

Human Rights

Another gendered issue explored by Boylan (1991), Lakoff (1989) and also Begum (1992) is that of human rights—such as the right to marriage, to motherhood and right to personal fulfilment. The common thread seen in all the literature reviewed is that while disabled men are more likely to marry and enjoy family life, society tends to treat women with disabilities as asexual. This has serious implication for self-esteem and self-image of disabled women. Despite changes occurring in the society where disabled women as sexual beings (heterosexual or lesbians) are breaking the silence, in the main disabled women are not considered desirable by men and are discouraged from marrying or having children. Most of the discouragement comes from parents and carers in institutions.

A primary issue is society's perception of the 'perfect' and 'beautiful' body which many women spend their lives trying to achieve. This

puts pressure more severely on women with disabilities, since the beautiful body is seen primarily through physical appearance and does not incorporate the diverse and individual characteristics of women.

The discourse on conceptualizing disability shows that the status of women with disabilities can never be truly understood until we understand the complexity, that is, disability. It is not possible to deny how important the ideological, economic and social structures of the society are when defining the term and in effect demarcating the position of those who are so defined. The dilemma of whether the problem lies within the individual or the environment will perhaps be clarified only when research is conducted and the experiences of persons with disabilities are analysed.

Conclusion

This article sought to study the status of women with disabilities in Trinidad and Tobago and identify the factors that have contributed to this status. An analysis of the collected data has shown that women with disabilities are positioned at the lowest levels in this society based on the variables, which were used to measure status. The lack or the inadequacy of existing policies and laws have contributed to the underdevelopment of persons with disabilities, especially women with disabilities.

The impact of disability is such that it affects mobility, relationships, human rights, and limits access to opportunities for development and for leading 'normal' lives. For too long, disabled students who are successful at the common entrance examination face a major problem of accessibility and lack of support staff. In the main, the lack of education or opportunities for higher education has a spiralling effect on employment and income. Many women with disabilities face serious economic situations, which ultimately have dire effects on the other areas of their lives. Transportation poses a major problem for the disabled because of high costs of the service and inaccessibility of vehicles. In many instances employers are sceptical of employing persons who are disabled, especially women, although they may be qualified for the job. Not much effort is also made to train them if they are unemployable. Again, persons who become disabled are forced to leave the job because of the lack of proper

facilities to facilitate their continued working life. Ignorance about disability results in the insensitivity of able-bodied persons toward persons with disabilities.

In addition the non-inclusion of disabled women in the mainstream of society has led to the society being the poorer in terms of skills and experiences. Many efforts are now being made by the government and disabled persons themselves to improve the situation. However, it is imperative that the government takes forward the policy governing the employment, rehabilitation, and the integration of persons with disabilities into the mainstream education system. There is also the need for attention to be paid to the existing laws which govern public buildings, the structure and delivery system of all financial and economic facilities of the relevant government ministry which cater to the needs of persons with disabilities. It is also hoped that women with disabilities will seek to become proactive and find creative ways of using the media to promote the work they do as well as lobby the necessary interest groups for changes in legislation that would positively affect their lives. These groups should work collaboratively with the government to educate the general public about disability and disabled persons. Finally, the government, organizations working for persons with disabilities and disabled persons themselves should work unitedly to ensure that there is improvement in the status of people with disabilities in general and women with disabilities in particular.

References

Amundson, R. (1992). 'Disability, Handicap and the Environment', *Journal of Social Philosophy*, 23(1): 105–18.

Begum, N. (1992). 'Disabled Women and the Feminist Agenda', in Hilary Hinds, Ann Phoenix and Jackie Stacey, eds., *Working Out: New Directions for Women Studies*, pp. 61–71. London: Falmer Press.

Boylan, Esther R. (1991). *Women and Disability.* Women and World Development Series. London: Zed Books.

Cusitar, L. (1994). 'Strengthening the Links: Stopping the Violence', in *Disability Cool: Barriers to Accessing Services by Victims of Violence.* Toronto: Disabled Women's Network.

Driedger, D. (1996). 'Emerging from the shadows: Women with Disabilities Organize', in D. Driedger, Irene Feika and Eileen Giron Batres, eds., *Across Borders: Women with Disabilities Working Together*, pp. 10–25. Canada: Gnergy Books.

—— **(1997).** 'Trinidadian Women Plant Seeds of Independence', *Horizons Women's News and Feminist Views*, summer, 11(3).

222 Jacqueline Huggins

Driedger, D. and **April D'Aubin (1991)**. 'Literacy for Whom? Women with Disabilities Marginalized', in *Women and Disability*. Canada: Disabled People in International Development.

Driedger, D. and **Kathleen Guy (1996)**. 'Begrudging Acceptance: Gender Relations in the Trinidad and Tobago Chapter of Disabled People's International', in D. Driedger, Irene Feika and Eileen Giron Batres, eds., *Across Borders: Women with Disabilities Working Together*, pp. 71–81. Canada: Gnergy Books.

Fine, M and **A. Asch (1988)**. *Women with Disabilities: Essays on Psychology, Culture and Politics*. Philadelphia: Temple University Press.

Francis, Y., A. Sealey and **F. Bornn (1995)**. Study on Abuse of Women with Disabilities in Trinidad and Tobago. Paper submitted as a requirement of the CAFRA T&T International Women's Exchange Program.

Guy, K. (1998). 'Abuse and Women with Disability: Wake up Miss Lady!', *Trinidad Guardian*, 19 January 1998, p. 9.

Lakoff, R.T. (1989). 'Women and Disability', *Feminist Studies*, summer, 15(2).

Ministry of Social Development (1994). 'Policy on Persons with Disabilities', June 1994. Trinidad and Tobago: Ministry of Social Development.

Mohammed, P. (1991). 'Reflections on the Women's Movement in Trinidad Calypsos: Changes and Sexual Violence', *Feminist Review*, summer, no. 38, pp. 36–37.

Oliver, M. (1989). *Social Work with Disabled People*. London: Macmillan.

Quinn, P. (1994). 'America's Disability Policy: Another Double Standard?' *Affilia*, spring, 9(1): 45–57.

Roucek, J.S. and **R.L. Warren (1963)**. *Sociology: An Introduction*. Paterson, N.J.: Littlefield, Adams and Co.

Simpson, L. and **E. Best (1991)**. 'Courage Above All: Sexual Assault and Women with Disabilities'. Disabled Women's Network, Toronto.

Smyke, P. (1991). *Women and Health*. London: Zed Books.

Sobsey, D. (1994). *Violence and Abuse in the Lives of People with Disabilities*, Baltimore, Md.: Paul H. Brookes.

——— **(1998)**. 'Sexual Offenses and Disabled Victims: Research and Practical Implications', *Vis-à-vis*, 6(4).

Stuart, Meryn and **Glynis Ellerington (1990)**. 'Unequal Access: Disabled Women's Exclusion from the Mainstream Women's Movement', *Women and Environments*, spring, 12(2): 16–19.

Wendell, Susan (1996). *The Rejected Body: Feminist Philosophical Reflections on Disability*. New York and London: Routledge.

14

Challenges to Empowerment and Independent Living: A Case Study of Young Adult Mexican Women with Disabilities

José Azoh Barry

Introduction

Scholarly as well as non-scholarly contributions on women's subordination and asymmetric presence in the domain of public life have been numerous since the first United Nations decade for women in the 1970s. Concerns for more integration of women into the development process, particularly in developing countries, boosted the emergence of the concept of empowerment.

Mothered by women's movements and Third-World feminists, empowerment, a process which results in generating positive changes, is 'held to be a panacea for social ills' (Batliwala, 1994: 127). Among them is the low status of women, which is persistent and not specific to isolated areas of our planet (Tiffany, 1979) where women represent half of the population.

However, within 'this half of the sky', some live with diverse forms of disabilities exposing them to the experiences of a double social marginality (Hanna and Rogosvsky, 1993; Lonsdale, 1990; Morris, 1993). Disability and gender—the latter being a concept contrasting social with biological determinism—are historical and cultural constructions known for generating discrimination. In a context of persistent poverty and marked social inequalities, women with disabilities

are triply or multiply challenged and concerns for their empowerment justified. In addition, research in this regard is incipient.

With the aim of addressing the issue of empowerment as it applies to women with disabilities in Mexico, this contribution is limited to a specific aspect of power, that is, control over intellectual resources which actually relates to the control over material assets and ideology.

Since intellectual resources include knowledge, information and ideas (Batliwala, 1994: 129), their access is key to entering the process of empowerment. But in the case of women with disabilities, such access, although not denied on the basis of ideology and laws, remains jeopardized by external forces such as poverty, hardship and mental predisposition of their families. Decisions made by the family on the basis of their material conditions of existence, their beliefs, feelings and attitudes towards people with disabilities result in repelling their margin of control, thus power.

In accordance with this thesis and acknowledging the clear distinction between condition and position of women (Young, 1988), the focus in this chapter is more on these 'oppressive' forces rather than the patriarchal ideology (Caldwell and Caldwell, 1994; Mason, 1984). I begin with a brief overview of disability demographics and other issues in Mexico and then present the main methodological aspects of the research carried out in the state of Nuevo León. I arrive at the findings putting an emphasis on formal education and training opportunities as means of gaining intellectual resources and part of the external forces supposed to induce empowerment. Finally, the intersections of circumstances that impact progress in empowerment are discussed.

Disabilities in Context: An Overview

Though improvements made for a wider integration of people with disabilities do not follow the same pace and proportions worldwide, there is consistent evidence that change for better is underway. In Mexico, a plural society, the national political Constitution recognizes people with disabilities as full citizens with the same rights and obligations like the others and acknowledges diversity (Convive, 1996). By laws, they are allowed to attend regular schools regardless of sex, type of disability or any other considerations since 1993. In this frame, a reform was made at the Department of Special Education

(Departamento de education especial) in order to get closer to the regular school system, and share the path towards an integration where teaching is possible while respecting diversity. The national plan of development as a master scheme for social policy includes them and expresses the importance of their social participation along with the other components of the population.

An innovation in the last census (1995) by the National Institute of Statistics, Geography and Information (INEGI, Instituto nacional de estadística, geografía e informática) consisted of adding a set of questions about the presence of people with disabilities in the household, which suggests that they are more and more taken into account in the plans of development of the country. However, specific data by gender are not yet available. The statistics provided about their proportion in the population are informally criticized for privileging some disabilities as a result of the definition of disabilities that was applied.

Another joint effort bringing together three governmental institutions, namely, the National System of Family Integration (DIF, Desarrollo integral de la familia), the Department of Public Education (SEP, Secretaría de educación pública) and INEGI, provided statistics on juveniles with disabilities. Just to give an idea, there is a little more than 2.7 million children from both sex with disabilities, 78 per cent of whom attend school at the basic or primary level (DIF, 1997: 27).

As far as spatial dispositions are concerned, the presence of wheelchair ramps is undeniable. Access to public as well as private space is part of the rights stated by the Commission of Human Rights in the state of Nuevo León.[1] Yet, it remains insufficient and the inadequacy of the infrastructure in regular schools is denounced for limiting an access which is no longer denied officially. Discriminations in employment and neglect in both public and private spheres regardless of gender are alleged.

An issue now under investigation, and linking children with disabilities and women, is the fact that some mothers are abandoned for having given birth to an 'abnormal' being (Guajardo, 1999). So women face a situation where the existing delicate line between a deviant body and biological normality incriminate them, which is likely to increase the number of females head of household. Given that there are more women than men in the general population of 97.4 million inhabitants as reflected in the masculinity index of 94.69 (INEGI, 2000), it could be speculated that the proportion of women

with disabilities is greater than that of men. In Mexico, specifically in the northern state of Nuevo León, there is a wide range of non-governmental organizations aiming at assisting people with disabilities. While many are perceived as serving more for their quest for personal prestige than the interests of the target groups,[2] none is dedicated to women in particular.

Methods and Procedures: A Qualitative Approach to the Issue

In accordance with the purpose of understanding processes rather than arriving at predictions and statistical projections, first- and second-hand data were gathered in the city of Monterrey, the largest city of the northern state of Nuevo León, and its outskirts. More specifically, data were obtained from schools, from the Department of Special Education and from another government-sponsored training programme relating to the Ministry of Social Development.

Through repeated visits in the field since the primary contacts in spring 1999 until completion of a first stage in early fall 1999, semi-structured and open-ended face-to-face interviews were conducted with a convenient sample of students, their families and professionals involved in their training and acting as key informants.

The interviews, conducted in Spanish and taped with permission, remained anonymous. Information was collected about the social status of people with disabilities, opportunities for women with disabilities through the education system, barriers to these opportunities and their social background. In considering the social strata and hardship (Meyers et al., 1998) of the family, neighbourhood, monthly income, making ends meet, utilities and amenities among others served as indicators. In Mexico the official classification in five strata by INEGI is based on housing characteristics.

A documentary search provided statistical data limited to the schools of special education, namely the Centres for Training and Special Education (CECADE, Centro de capacitación de educación especial) renamed Centres for Multiple Attention (CAM, Centros de atención múltiple) and Units of Support to Regular Schools (USAER, Unidades de apoyo a escuela regular). Recurrences in speeches were taken into account in the analysis and part of the verbatim is quoted in Spanish.

Public Training and Education Opp
A Look at Female Enrolment

The training and education opportunities are made available to people with disabilities through specific programmes. They are basically aimed at providing practical skills and knowledge likely to equip disabled people for an independent living. Attending these programmes is free of charge for people involved with the education sector but involves some costs such as registration, monthly fees and the purchase of required accessories for others.

Education is assumed to be an inalienable right and, as such, its access should not be denied. However, a striking evidence of discrimination is the predominance of male participation in the programmes offered. With few exceptions, female enrolment at all levels is lower than male enrolment and this holds true for vocational schools from the Department of Special Education, CAM and USAER. In the population at large, the 1990 census reveals an illiteracy rate of 9.6 per cent for men and 15 per cent for women and a more pronounced differentiation at the ages 12 and over (SEP, 1993: 24).[3]

Female Under-Representation: A Recurrence in Monterrey and Its Outskirts

In the network of public education, the centres that aim at training young people with disabilities for entry into the labour market offer activities such as sowing, kitchen work, handicraft, and also placement after completion of the four-year training. Seven are located in the city of Monterrey and its outskirts. Professionals from the Department of Special Education talk about an overall 35 per cent of female enrolment.

An examination of recent statistics (1999–2000) reveals similar trends from pre-school (only level where attending school is not compulsory) to secondary and complementary, the highest levels. Table 14.1 shows the enrolment of disabled students at various levels in Centres for Multiple Attention (CAM).

Barry

In all cases, enrolment is higher at the primary level and lower at the secondary one. As far as gender is concerned, an exception is noticeable at the USAER (Table 14.2) where the number of women enrolled is greater than the number of men for visually impaired (43 vs. 38) and blinds (17 vs. 9).[4]

At a smaller scale also exists a similar government-sponsored initiative undertaken by retired teachers and representing an exception in terms of a predominant male enrolment.

The Training Programme by Retired Teachers

Designed and carried on by the elderly who are retired teachers, this programme offers training in the making of handicrafts besides importing basic writing, reading and mathematics skills. In addition, it enables the learners to generate their own income through door-to-door sales or with the help of their acquaintances.

However, their insertion in the formal labour market is a challenging task partly due to recruitment practices that consist of assessing all the applicants through the same tests of reading, writing and computing aptitudes, despite their distinct experiences[5] and developmental dispositions (e.g., slower learning).

Through its over-representation of young women, this programme looks atypical. Out of the seven participants (see Table 14.3), only one is a man in his early 1930s and whose motor disability, consequence of a mis-prescribed medicine, appeared when he was 15 years old. The six others are females with poliomyelitis sequel, Down's syndrome, learning and neurological disabilities.

Among them is a woman who is more alert than others and who exercises a certain leadership, which causes her to be considered the 'boss' of the group. According to the informants, this is a result of her family environment where she is stimulated by her brothers and sisters. In addition, her mother is a teacher in the community service programme.

Table 14.1 Students from Centres for Multiple Attention (CAM), 1999–2000

| Level | Blind | | | Visually Impaired | | | Deaf | | | Hypoacoustic* | | | T. Neuromotor | | | Intellectual Disability | | | C.A.S.** | | | Others† | | | Total Per Level | | |
|---|
| | M | W | T | M | W | T | M | W | T | M | W | T | M | W | T | M | W | T | M | W | T | M | W | T | M | W | T |
| Initial | 6 | 2 | 8 | 7 | 4 | 11 | 14 | 6 | 20 | 1 | 2 | 3 | 22 | 17 | 39 | 67 | 60 | 127 | 0 | 0 | 0 | 46 | 24 | 70 | 163 | 115 | 278 |
| Pre-school | 4 | 0 | 4 | 2 | 1 | 3 | 6 | 3 | 9 | 5 | 4 | 9 | 47 | 32 | 79 | 81 | 52 | 133 | 0 | 0 | 0 | 18 | 12 | 30 | 163 | 104 | 267 |
| Primary | 9 | 7 | 16 | 2 | 1 | 3 | 15 | 20 | 35 | 9 | 7 | 16 | 52 | 40 | 92 | 390 | 281 | 671 | 2 | 0 | 2 | 96 | 51 | 147 | 575 | 407 | 982 |
| Secondary | 0 | 0 | 0 | 0 | 0 | 0 | 0 | 4 | 4 | 0 | 0 | 0 | 0 | 0 | 0 | 8 | 3 | 11 | 0 | 0 | 0 | 2 | 0 | 2 | 10 | 7 | 17 |
| Workshop | 13 | 10 | 23 | 6 | 3 | 9 | 8 | 5 | 13 | 5 | 7 | 12 | 45 | 14 | 59 | 369 | 214 | 583 | 0 | 0 | 0 | 117 | 43 | 160 | 563 | 296 | 859 |
| Complementary Attention | 3 | 10 | 13 | 5 | 5 | 10 | 86 | 49 | 135 | 68 | 46 | 114 | 120 | 105 | 225 | 224 | 157 | 381 | 0 | 0 | 0 | 241 | 100 | 341 | 747 | 472 | 1,219 |
| Total Disabilities | 35 | 29 | 64 | 22 | 14 | 36 | 129 | 87 | 216 | 88 | 66 | 154 | 286 | 208 | 494 | 1,139 | 767 | 1,906 | 2 | 0 | 2 | 520 | 230 | 750 | 2,221 | 1,401 | 3,622 |

Source: Department of Special Education.

Abbreviations: M – men; W – women; T – total.

* A form of lighter hearing impairment.

** Dominant attitudes or abilities (literally alumnos con capacidades o actitudes sobresalientes).

† Autistic characters

Table 14.2 Students from Units of Integration to Regular Schools (USAER), 1999–2000

Level	Blinds			Visually Impaired			Deaf			Hypoacoustic			T. Neuromotor			Intellectual Disability			C.A.S.			Others			Total Per Level		
	M	W	T	M	W	T	M	W	T	M	W	T	M	W	T	M	W	T	M	W	T	M	W	T	M	W	T
Initial	0	0	0	3	0	3	1	0	1	5	3	8	5	3	8	12	7	19	0	0	0	3	2	5	29	15	44
Pre-school	0	4	4	2	9	11	7	5	12	10	12	22	33	26	59	81	64	145	2	0	2	35	23	58	170	143	313
Primary	9	11	20	32	29	61	100	77	177	114	76	190	154	92	246	656	511	1,167	0	0	0	154	82	236	1,219	878	2,097
Secondary	0	2	2	1	5	6	19	7	26	4	8	12	3	1	4	20	12	32	0	0	0	2	1	3	49	36	85
Total Disabilities	9	17	26	38	43	81	127	89	216	133	99	232	195	122	317	769	594	1,363	2	0	2	194	108	302	1,467	1,072	2,539

Source: Department of Special Education (Alumnos Integrados En Usaer).
Abbreviations: M – men; W – women; T – total.

Table 14.3 Community Work Training Programme

Programme	Creation/ Location	Activities	Participants			Social Background	Motives of Absenteeism
			M	F	T		
Community works by retired teachers	1993 ISSSTE Monterrey	Vocational and formal education	01	06	07	Low income/ Upper low income/ Middle income	Transportation[*] Health

[*] This is a key issue and according to the informants, most parents, beside the lack of time, also lack the necessary means.

The Family Environment: Material and Mental Conditions

The Public Education System, aware of the importance of the family in making its attempts at reforms successful, associates the parents of disabled people in the training programmes. Indeed, the family is key to more than an initiative of change for better. Yet, concerns remain about ideals and aspirations when it appears that families themselves are challenged at material and cognitive levels.

Socio-economic Status and Hardship

Enrolment in the programmes involves the payment of symbolic fees[6] and acquiring the teaching material is facilitated by donations received by the Department of Special Education. However, regular attendance is challenging because of the transportation which affects the parents' finances and schedules. Though it may appear cheap, public transportation is a burden in the long term, especially when, due to the location of the schools, two buses—locally called 'camion'—are required for one way. This results in spending for four camiones for a roundtrip on a daily basis.

This situation is made more difficult when the operators of the camion reject the discount card 'la credencial' presented by the young people with disabilities participating in the training programmes. This is explained by the fact that the operators do not consider this kind of attendance as a regular school. Therefore, the validity of these

discount cards differs among people who are supposed to have the same rights.

When neither the parents nor the person with disabilities can depend on the means of transportation, the experience is not easy to handle. One of the females who used to attend the community work programme managed by the retired teachers, could not walk, did not have a wheelchair and her parents did not have a car. So, she needed to be helped from her house to the first floor of the building where the classes take place. This is another form of burden for the parents which make them give up, even if the location of the school is at a walking distance.

A look at the socio-economic background of the parents shows that the predominant social strata to which they belong are called middle and low ('medio por abajo') corresponding to upper low ('media baja') and low ('baja') levels with monthly incomes up to five minimum wages approximately.[7] Considered in isolation, the income may not be enough to explain the choices they have to operate, sometimes to the detriment of their children. Hardship interferes and is invoked as far as the establishment of hierarchy in priorities are concerned. As indicated, it would be first a boy, second a girl, and ultimately a disabled whatever may be the sex.

Though most of the parents interviewed do not have to pay a monthly rent and manage to meet their basic needs, the budget for grocery could sometimes be too tight. Beside, the purchase of medicine is another difficulty faced by those who do not have a medical insurance covering their offspring.

Realities for families belonging for the most part to lower strata according to objective indicators and the statements of the key informants are so uncertain that their enthusiasm for their disabled children gaining knowledge, developing skills and later earning an income in a context of deprivation could be taken for granted. Yet, these same realities lead the parents to make painful choices, sometimes to the point of locking them in the house and leave for work.

Emic Views, Contradictions and Constraints

According to some of the key informants, people with disabilities are more visible in public places, which was uncommon a few decades ago. However, some families in rural areas still prefer to keep

their children hidden. Getting rid of them is a relief even if the practice is no longer the same as before. A teacher from one of the programmes recently received a child born with a disability as a gift because he was a problem for the mother: 'Me regalaron uno hace poco. La mama no quiere guardarlo.'[8]

Their self-rating of the impairment of their children influence their decision of whether it is worthy to let them be in contact with the outside world. The ability to be involved in vocational training, formal education and other outdoor activities depends on it. Reasoning in terms of inability—'no pueden' (they can't)—applies even to those eligible to be home-bounded according to this kind of assessment. As a result, doing chores is unattainable; they rather need assistance varying from moderate to round the clock.

The lack of confidence also results from the mixed nature of schooling: 'desconfianzan ... Dicen esta escuela tengo miedo porque hay jóvenes' ('They don't trust They say I'm afraid of that school because of the young men'). As a matter of fact, exposure to the curriculum also means exposure to frequent contacts with people from the opposite sex,[9] which makes the parents feel insecure about the risks of out-of-wedlock pregnancies. Some parents are 'over-protectors' and scared by the idea that their daughter would be assaulted in school.

With this frame of mind, the concern of the parents is more than the inaptitude of their female children to benefit from the curriculum itself. The protection conferred by home confinement is no longer guaranteed: school is not a safe place for the vulnerable girl child ('la niña'). This holds true for the streets where these weak beings ('seres debiles') could be object of sexual assaults.

The propensity of young girls, women and children with disabilities to be at a much greater risk of being sexually abused within residential facilities, the family circle and in society at large, has been established and the relationship with issues of control and power more than sex is well documented (Cole, 1984; Longo and Gochenour, 1981).

As contradictory as it might appear, parent's attitudes towards their disabled children as immature and at risk of getting pregnant on the one hand and refusing to believe in their potential to achieve something on the other are the basis of family reluctance to facilitate empowerment. This cognitive-based tendency to keep them inside the house as much as possible, in conjunction with unfavourable

socio-economic conditions, is almost representing a change in continuity since change from within is delayed.

Changing Perceptions and Laws vs. Persistent Attitudes

It would be a dishonesty not to acknowledge the evolution in the situation of people with disabilities in Mexico and worldwide. Regarding the current advances, it is now believed that the battle for establishing the social model is over and, after this victory, other main steps remain to be considered. Striving to move forward should also involve more concern for the status of women in order to develop strategies conducive to reverse the negative double discrimination undermining their quality of life in a no-woman's land to which they are relegated (Hannaford, 1989).

Without jumping into the debate about independent living and its relevance for developing countries (Willcox and Willcox, 1999), we have to acknowledge that the achievements in the North and the South are not comparable in many aspects. Within developing countries, in addition to the specificity of the social stratification and their reflections on the pace of improvements in the quality of life of people with disabilities, there are two levels of speed in social and mental progress.

In Mexico, the perceptions about people with disabilities are undergoing changes. New laws passed, social policies implemented and reforms undertaken in their interests are the expression of a recognition of diversity and the willingness to bring about positive change. However, how deep and sustainable could their impact be, when hampering material conditions and mental predispositions are still persistent at the family level and within other components of the society, is something that needs to be pondered and dwelt upon.

Attitudes and practices affecting the lives of young people with disabilities, realities to which some key informants refer as a culture ('la cultura') is not confined to the family. Even some teachers referred to students in their mid- or late 1920s as 'esta niña' without even realizing it. The disharmony in the speeds of change needs adjustments; otherwise, independence, self-determination and full participation in the community, as desirable as they could be, will remain at the stages of pious concepts and wishes for many.

Conclusion

Contrary to some of the more developed countries where statistics on disabilities issues are up-to-date, complete and accurate, those available in Mexico are scarce, general and somewhat subject to controversy. However, the lack of specific national data on women with disabilities is not a deterrent to conduct analyses from a perspective of gender. Qualitative lenses with their limitations and strengths are complementary to reducing the existing gaps and deficiencies in this realm.

In this frame, the findings—transferable but not generalizable—not only revealed a discrepancy in male–female enrolment in education and training programmes, but also the contribution of the family, the primary unit of socialization and social support, to a situation which is not conducive to an equal empowerment of young people with disabilities. The conditions of deprivation of the families as well as their emic views on people with disabilities enhance the jeopardy they face.

In a developing country, where the persistence of poverty and social inequalities intersect with development, well being and many other aspects of human life, it is important to gain an understanding of how poverty, hardship and biased perceptions influence the attitudes and behaviours of the family. They appear to act as oppressive (external and internal) forces impeding greater access to and control over resources conducive to empowerment. In this particular case, it is formal education and skill-training activities.

In terms of implications, these findings inspire concrete suggestions pertaining to role models likely to impact fossilized perceptions of them as 'roleless' (Deegan and Brooks, 1985). Though unknown in proportions, some people with disabilities have succeeded in climbing the social ladder in Mexico, and among them are women. These few good examples of participation and independent living are appropriate to act as role models for other women with disabilities, their families, the community and decision makers.

The shift from the medical model to the social model of disabilities is an undeniable progress. However, there is the danger of taxing vegetate in rhetoric and truism about societal discrimination and marginalization, while some sociological realities are not properly understood or keenly taken into account. It remains important to consider the material and mental barriers such as poverty, hardship

and internalized negative attitudes from within because if we have to go further in the social model and achieve sustainable changes, the family environment is unavoidable.

Notes

1. These rights called, 'derechos urbanisticos', stipulate the obligation to adapt town planning and architectural designs to the needs of people with disabilities.
2. Declarations by some professionals with disabilities. They were also key informants.
3. Similar features are addressed in Salinas et al. (1995: 13).
4. The first national school for the disabled in Mexico, Escuela nacional para ciegos, was especially for the blinds. This was the achievement of former president Benito Juarez (1861–63 and 1867–72).
5. Most of the women have acquired sewing skills at schools from the special education system but they still have a hard time in getting jobs that require these kind of skills. While the 'job' fits them, the regular scenario that they are faced with is a theoretical examination and a promise to be called later.
6. The inscription fees are $50 pesos and the monthly fees are $15 pesos. The latter amount varies according to the decision made by a committee composed of parents. (Approximately, $10 pesos is equal to US$1.)
7. The minimum wage is currently $35.09 pesos daily. Every year (1 January) it is raised by 10 per cent.
8. It literally translates into: 'They offered him to me as a gift a little while ago. The mom doesn't want to keep him.'
9. Some students have told their teachers that they can just be friends but not boyfriends or girlfriends unless the parents allow it to happen: 'Son amigos a dentro de la escuela. Les decimos son novios si tus papas te dan permiso.'

References

Batliwala, S. (1994). 'The Meaning of Women's Empowerment: New Concepts from Action', in G. Sen, A. Germain and L.C. Chen, eds., *Population Policies Reconsidered: Health, Empowerment, and Rights*. Boston, Mass.: Harvard University Press, pp. 127–38.

Caldwell, J. and P. Caldwell (1994). 'Patriarchy, Gender and Family Discrimination and the Role of Women', in L.C. Chen, A. Kleinman and N.C. Ware, eds., *Health and Social Change in International Perspectives*. Boston, Mass.: Harvard University Press, pp. 339–69.

Cole, S.S. (1984). 'Facing the Challenges of Sexual Abuse in Persons with Disabilities'. *Sexuality and Disability*, 7(3/4): 71–88.

Convive (1996). Programa nacional para el bienestar y la incorporación al desarrollo de las personas con discapacidad. Comisión nacional coordinadora. Informe nacional de actividad (Mayo de 95–96). Dirección de communicación social, D.F., Mexico.

Deegan, M.J. and **N.A. Brooks** (1985). *Women and Disability: The Double Handicap*. New Brunswick, NJ: Transaction Books.

DIF (1997). *Las personas con discapacidad en el DIF hoy*. Mexico, D.F.: Sistema nacional para el desarrollo integral de la familia.

Guajardo, E. (1999). *Inclusión y democracia social. Primeras jornadas internacionales de educación para la diversidad 'Integración educativa'*, Monterrey: Secretaría de Educación Pública.

Hanna, W.J. and **B. Rogosvsky** (1993). 'Women with Disabilities: Two Handicaps Plus', in M. Nagler, ed., *Perspectives on Disability*. Palo Alto, CA: Health Market Research, pp. 109–20.

Hannaford, S. (1989). 'Women, Disability and Society', *Interface*, June, pp. 10–12.

Instituto Nacional de Estadística, Geografía e Informática (2000). XII Censo General de Población y Vivienda 2000. Resultados Preliminares, INEGI, Estados Unidos Mexicanos. Aguascalientes: INEGI.

Longo, R.E. and **C. Gochenour** (1981). 'Sexual Assault of Handicapped Individuals', *Journal of Rehabilitation*, 47: 24–27.

Lonsdale, S. (1990). *Women and Disability*. New York: St. Martin's Press.

Mason, K.O. (1984). *The Status of Women: A Review of Its Relationships to Fertility and Mortality*. New York: The Rockfeller Foundation.

Meyers, M.K., A. Lukemeyer and **T. Smeeding** (1998). 'The Cost of Caring: Childhood Disability and Poor Families' *Social Service Review*, 72(2): 209–33.

Morris, J. (1993). 'Gender and Disability', in John Swain, Vic Finkelstein, Sally French and Mike Oliver, eds., *Disabling Barriers, Enabling Environments*, pp. 85–92. London: Sage Publications.

Salinas, B.L. et al. (1995). *Los derechos humanos de la mujer en las leyes nacionales mexicanas*. IV conferencia mundial sobre la mujer. Acción para la igualdad, el desarrollo y la paz. Pekin: Comité nacional coordinador.

Secretaría de educación pública (1993). *Educacíon básica primaria. Plan y programmas de estudio*, México, D.F.: SEP.

Tiffany, S.W. (1979). 'Introduction: Theoretical Issues in the Anthropological Study of Women', in S.W. Tiffany, ed., *Women and Society. An Anthropological Reader*. Exeter: Eden Press Women's Publications, pp. 1–35.

Willcox, D. and **S. Willcox** (1999). *Independent Living and Developing Countries* [online posting]. Available from http://www.independentliving.org/.

Young (1988). *Gender and Development: A Relational Approach*. Oxford: Oxford University Press.

15

Standing on Our Own Feet

Shoba Raja, Emily Boyce and William Boyce

Millions of Indian women, particularly from poor home, lead an existence of extreme subservience with very little control over their lives. In such a situation, women who are disabled face not only the usual discrimination against gender, but also discrimination due to their disability. The combined effects of poverty, gender and disability generate intensely negative social forces that affect their lives and make the physical and emotional barriers they have to overcome extremely formidable.

This paper is based on a study of the lives and experiences of nine women with disabilities in the city of Bangalore in southern India. Three women were enrolled in a two-year, orthotic/prosthetic technician-training programme, jointly conducted by two NGOs working in the field of disability in Bangalore. The ultimate goal of this training programme was to help the women set up a mobility aids workshop in Bangalore. The study was done collaboratively by the Association of People with Disability (one of the two NGOs that conducted their training) with Queen's University, Canada, through its International Center for the Advancement of Community-Based Rehabilitation. The findings come as a ray of hope for disabled women in India and, indeed, the rest of the world.

The women were all aged between 17 and 29, and belonged to both rural and urban backgrounds. Except one, all the women came from relatively poor homes. Of the nine women, five had post-polio locomotor disability; one had locomotor disability due to spinal infection; one had speech impairment in addition to a locomotor disability; one with locomotor disability due to post-gangrene amputation

of both legs; and one was diminutive and short. All of them were mobile, seven with the help of mobility aids.

The women bring to the situation a tremendous spirit of optimism, enthusiasm and courage. The study also reveals that several family attitudes towards women, their disability, education, independent development and marriage—attitudes perhaps peculiar to India and almost always assumed to be negative—have actually had a liberating impact on their lives.

For most Indian women, more so if they are disabled, opportunities for development and growth are limited and restricted by the fact that they remain 'protected' in their parents' home unless they marry. This paper describes the personal, social and professional development of these nine women, six of whom opted to leave their families during the training period and live together as an independent group.

The years spent in the programme and in independent group living brought immeasurable changes for these women. It was a time of learning, of forming friendships, of changing personal values and, as we shall see, of dealing with hardship, negotiating differences and becoming independent. The women's development was vastly influenced by numerous and interlocking factors: their family backgrounds and personal histories, their initial value systems, their experiences with others, their experiences at work and, most importantly, their living situations.

Some of the questions addressed broadly in this research study were: How do training and independent group living experiences influence personal, social and professional development in young disabled women? How do such experiences affect family relationships and contribute to social awareness in young disabled women?

Individual audiotaped interviews were conducted with the young women on two occasions, separated by approximately eight months.[1] The first session occurred soon after the women joined the programme and the second occurred near the end of their first year of training. Other group discussions, which were part of the socialization and health education training, were also videotaped and transcribed. In addition, informal talks and visits to the hostel by the researcher provided valuable insights on the emerging changes in their day-to-day lives. The data used for the paper were in three languages (Kannada, Tamil and Hindi) and were transcribed and translated into English. The data were initially coded using categories

developed by the research team. The complete transcriptions and coded data were then analysed.

The data analysis provided insights into several aspects of development in the women's lives, which were categorized into five key areas:

1. Changes in family relationships,
2. Changes in the women's self-perceptions,
3. Development as a social group in the hostel,
4. Social consciousness, and
5. Confidence and skill at the professional level.

The women experienced many personal changes in their self-image, attitudes and motivations. Also independent group living proved to be an empowering alternative for the young women. Such opportunities for group living is rare for young Indian women, more so for women with disabilities. The findings of the study show that the practical, personal and social development that is possible in such a situation is an invaluable experience that may be relevant not only for young women with disabilities but also for non-disabled women, particularly in India and other. South Asian societies.

Family Background and Tradition

In India, family background and the ensuing social standing, religion, caste, customs, values and practices continue to be important factors in determining the way an individual defines herself/himself and sees her/his identity in community or society. With the exception of one trainee, all the women came from rural and/or working-class backgrounds. The exception was Sheeba[2] whose family owned plantations (small–medium) and lived in a rural estate house with farm labourers and servants. (During the training Sheeba also lived alone in a women's hostel close to the centre.) In five of the nine families, the father was deceased. In four of these five families the death had occurred recently (1993–95) and the income levels of these families had dropped significantly in the following years. Only one of these families received a pension and another one where the mother supported the family. The others became dependent on contributions from siblings and extended family members.

The financial circumstances in the women's families, family relationships, family values and the women's upbringing were factors that influenced the women's decision to train, in getting permission to train and specifically their decision and ability to reside in the group hostel.

Despite the poor financial circumstances in eight of the women's families, only two of them had actually joined the programme in order to contribute to the family income. Although many intended to contribute financially to their households, these women did not feel that their families depended on them to earn and support them. However, most of the women felt there was a definite need to begin learning a trade which would offer them future financial security. Seven of them said that even before deciding to come for training they had become aware of the fact that they would not be provided for forever and that they were already burdening their families. As Divya put it:

> Father will buy, mother will buy. How long will that go on? We feel bad to ask. But if we earn, we don't need to ask even for 10 rupees. Earlier, I used to stay with my sister. She had to get everything for me. Now, if I earn, I can buy some things and give them to my mother.

Many of the women expressed distrust that their male siblings would continue to support them, especially after the death of both parents. The women strongly believed that their brothers would stop supporting them since they would have to took after their own wives and children. The women also expressed deep distrust of their sisters-in-law (in some cases to-be sisters-in-law) in addition to their brothers:

> Yes, my brother told me this, 'I will earn, I will take care of you for life.' But I said, 'After your wife comes, you will have to look after her, not us. You may continue to look after me, but I will earn. I cannot trust you. I will learn to work and earn myself.'

Significantly, none of the women's families had any solid plans for their daughters to marry. This undoubtedly played a role in the families' readiness to allow their daughters to train and live outside the family home. None of the women had been encouraged by their families to marry, nor had any of their families arranged a marriage for them. Only Alisha had been previously engaged, but the engagement had been broken when her parents could not provide the dowry that was demanded. As a consequence, this woman's family became opposed to the idea of her marrying, which was a shared sentiment among four of the other women's

families. The other families were not opposed to their daughters marrying, but expressed concern about the reality of a marriage prospect, and in any case preferred that their daughters became self-sufficient first.

The women's gender and disability together played a significant role in parental encouragement. The families seemed resigned to the idea of the women's decreased potential for marriage and expressed concern that the women needed an education because they were likely to remain single in the future. This attitude towards disability, which surfaced in most of the families, resulted in encouragement and support of the women's decision to train. Opposition, when it came, was mainly in the form of opposition to their living away from their families and concern about their being able to cope with this. Notably, Sheeba's parents were judgemental about her working as a prosthetic/orthotic technician. They strongly expressed the view that she should finish college so that she could get a more 'professional' job.

Contrary to the common impression that disabled women were neglected by their families, not one of the women had faced rejection or neglect from their own immediate families. In fact, many of them said they had been 'pampered' or 'treated as a child' because of their disability. As Kantamma told the researcher:

> [Mother] even brings coffee to me. I am not allowed to remove the lunch plate. If by any chance I removed the plate, my father used to scold my sisters-in-law, 'Her legs are not all right, why do you allow her to work? What is wrong with you people?' My brothers and my father used to scold them, saying, 'Don't make that child do things.'

Changes in Family Relationships

A majority of the Indian families provide a secure and loving base where the individual is nurtured. Families, each within their means, rarely fall short when it comes to providing physical care, love and affection. But, the 'families' contributions to the well being of women with disabilities go well beyond merely providing assistance and being carers. They play a major role, through their actions, attitudes and values, in the way a woman with disability looks at herself and what she aspires to and expects of herself (Hema, 1996).

Most of the women spoke of how the training had brought about perceptible change in their lives. These changes are more extensive and evident in the case of the women who stayed as a group in a hired house. Several key themes became apparent in evolving relationships.

New Dynamics of Support and Conflict

Family support for the women, throughout the duration of their training, manifested in different ways. In the case of women who stayed in hostels, their families made the effort to visit them often, even when they had to travel a long distance. Family support was actively sought out by the women and actively given by their families.

Many of the women reported special moments in which their families showed great pride in their accomplishments. Mythili, who lived at home, told the interviewer about the gesture of her father (who was usually apathetic about her work) when he saw an article in the newspaper that described the women's training at the NGO:

> I brought that newspaper and showed it to him, saying, 'See, it has come in the paper.' On seeing it he said, 'My name may not appear in the paper, at least my daughter's name has come.' He shook my hand.

Apart from taking pride in their daughters' 'accomplishments', almost all the women said that members of their families were actively interested in what they were doing at work and also in the hostel and that their families asked them many questions about their experiences at the training. Kantamma explained how her mother had noticed her progress and encouraged her:

> Earlier I was not going (out). Now my mother herself sends me. She says, 'You go, have courage, go walking. Why do you feel shy? Make up your mind to walk, go somewhere and talk.'

Issues of family conflict were few and far between and generally did not appear due to disputes or interpersonal tension. For the hostel women family opposition was mainly because their families missed them and desired longer and more frequent visit home by the women. The infrequent short visits caused some of the families to ask the women to discontinue their training. Chandrika, who had been living with her mother and brother, said her brother continued to be embarrassed because she refused to stay home and be provided for:

> Now when I go home, he (brother) says, 'I will look after you, stay here. What will people say when they find that I am not looking after you? They will say there is only one girl and two boys (in the family). Can't they look after her?' But I think I don't need these boys to look after me.

Only Sheeba's parents, who initially opposed the training because they preferred that she go to college, continued to pressure her to quit the training.

Changes in Family Perceptions

The changes that occurred in the way the families saw their disabled daughter now were subtle, yet very significant. The families' perceptions—before and after the commencement of the training—were marked through in the kind of everyday interactions and casual conversation the women had with family members. Earlier conversations at home revolved around issues in their household and extended families. Now the women were being asked how they made prosthetics, what kind of patients they were treating, how they prepared food in the hostel, among other things. The families had begun to perceive the women as autonomous individuals, whose identities were centred in their work and their independent group living as well as their families.

In two families where there were disabled members among the immediate or extended family, the women's advice and help was sought in deciding what to do. Their families had begun to perceive them as knowledgeable at the vocational level, and, therefore, in a position to provide technical assistance to others.

Respect and acknowledgement of the women's professional independence surfaced in others ways as well. In several cases, the women's progress caused other female members of their families to decide that they too would seek work. An example of this kind of change was Nusrat, who not only belonged to a Muslim family but was also the first woman in her entire family to have ever worked. After completing one year at training, Nusrat's female cousin began to work as well.

The families of the women in the hostel also began to perceive the young women as being self-sufficient in the domestic sphere. According to the women, although they were still spoilt when they went to visit their families, their parents acknowledged that they had now learnt to cook and carry out other domestic chores. When asked by

the researcher why this pampering still occurred, each of the women said that it was because she was missed by her family, or was treated as a guest and not because her family thought her incapable or too fragile to do housework. The women's families had stopped pampering them solely because they had disabilities.

Personal Development

Two factors, in the life of a woman with disabilities, appear to be very important; they make a difference to whether she can use her abilities, realize her potential, and come up to her own expectations. The first factor is physical: Do the nature and the level of a woman's disability, combined with the reality of her environment, make it possible for her to venture outside her home without too much difficulty? The second factor is social: How do people in her family and community view her disability? (Hema, 1996).

In the case of the nine women under study, mobility was not the primary problem. None of them had disabilities severe enough to restrict their movement within or outside their homes. So, access in a physical sense, had not been a problem. However, there are vital aspects to a woman's life (irrespective of whether she is disabled or not) that lie beyond physical requirements that affect her self-esteem, self-image and her own expectations. Here again, the attitudes and perceptions of her immediate family and the specific circumstances of her day-to-day life within the family and community play a major role in determining whether she has opportunities for personal development or not.

Each woman came into the training situation with her own level and variations of personal development. The training situation and the hostel experience (for six of the women) offered unforgettable opportunities, which the women used innovatively and remarkably well, to develop their self-esteem and self-image. Their attitudes to disabilities, marriage, gender and to live independently changed significantly.

Initial Levels of Development

The women's upbringing and family backgrounds seemed to play a significant roles in their levels of self-esteem, self-image and the

direction of their goals. For example, the support that they received for an education ensured that the women had a high motivation level to succeed. All of them had felt themselves capable of succeeding academically. All of them when they were young had an aspiration to be educated. The discrepancies between the women's goals and their actual levels of education were, to a large extent, a result of circumstances (factors such as travel problems and inability to pay school fees). Only Sheeba spoke of the extreme mental depression she felt about her disability. As she grew up this had affected her academic performance so much so that she had to quit college much against her parents' wishes.

The women's motivations to pursue their education were linked to their motivations to eventually find employment. The desire for future financial independence was a common sentiment amongst all of the women, even before they had begun the training.

A few of them were aware of their decreased marital potential. However, all of them had an accurate understanding of how disability would affect their future options. Before joining the training, the women's attitudes towards marriage were similar to their parents'. A few of them said that they did not wish to marry while the rest remarked that they did not have any active plans to marry.

The women's decisions to live in the hostel were based on the locations of their parents' homes. Only one of them had lived independently prior to this and only two of them had experience of doing domestic work and cooking. Second, to a large extent, they did not have the means to live independently. Thus, their commitment to taking this training opportunity and subsequently finding employment opportunities helped them to make their decision in the face of their fears and arrived as to how they would cope these problems.

Almost all of the women reported a low self-image while describing the way they felt about their disabilities before joining the training programme. However, this did not mean that they felt so impeded by their disabilities that they could not function independently and succeed in finding employment. Instead, their self-images seemed to be a result of having lived in communities where disability was rare or stigmatized. The sentiment 'I felt like I was the only one' was expressed by eight of the nine women. (The woman who did not feel this way was Alisha who grew up with a father and sister with the same disability.) All of the women said they had brooded about their

disabilities and about how this would affect them in the workplace or in their chances for marriage.

Personal Growth

The women's personal qualities changed in many ways in the course of their training and also in their experiences of living independently. Their attitudes evolved considerably in relation to: (a) their disabilities, (b) their thoughts about marriage/gender, (c) their independent living skills, and (d) their self-perceptions.

Disability

The women's self-image improved as they spent more time in contact with others with disabilities. There were two reasons for this improved self-image. First, when they saw others more severely disabled than they were they felt themselves more privileged. This contributed to their motivation to continue their work as orthotic technicians. As Divya put it:

> Earlier we said, 'Why is it like this for me?' Now we look at others worse than us and feel sad for them. To an extent we are OK. God has been kind. So, for people more disabled than us, we must work, make them stand, or they keep sitting on the wheelchair.

After having been at the receiving end all their lives it appears that the women also felt privileged and empowered because they now saw themselves as healers and providers of aid.

Second, the women's self-images improved simply from working and living with other women with disabilities. The women no longer felt lonely or isolated while living with their families. Of great significance here is that for the women who did not live together in the hostel, this sense of loneliness continued to arise periodically because every evening they had to travel back to their neighbourhoods in which few people were disabled. Sheeba, who lived in another hostel, continued to feel self-conscious about her disability because none of her companions there were disabled. Mythili, who lived with her parents, reported that she stayed indoors when at home in the evenings. The women who stayed in the group hostel, however, did not report feeling isolated anymore and expressed that they now felt as though they were capable and normal as anyone else. Niluofer told the researcher:

> Yes, there is a difference. At home I used to think among so many brothers and sisters, I am alone like this. After coming here, I realized that I need not sit in a wheelchair, I need not sit at home. At least I have legs to walk. I have some strength in my hands and legs. I can work. I hope to further improve. Now I don't think that I have a disability.

The experience of independent group living and of being surrounded by other women with disabilities, seemed to facilitate an improved self-image on a more constant basis.

Marriage

Society and culture in India is a complex thing. It is impossible to project any one point of view as being typically 'Indian' while describing most of the things here. This is also true when it comes to issues such as negotiating a marriage, which may depend on several factors such as educational levels, social class and family values. However, arranged marriages are still the norm and this puts women with disabilities at a disadvantage. When a marriage alliance is negotiated between two families, the presence, nature and the level of physical disability of the prospective bride assumes importance (Hema, 1996).

Women with disabilities and their families' ideas, expectations, fears, anxieties about marriage are often based on the observations of marital relationships of others, mostly of non-disabled women, rather than on first-hand experience. Before the training, the women's ideas on marriage/gender were similar to those of their families. Also, they tended to speak about marriage and economic independence together as either/or options. But all of this seemed largely notional.

The women's attitudes became more defined and opinionated as they became increasingly self-sufficient with the experience of training and independent living. Marriage, as a means to future security, became less important and their ideas of how they would negotiate employment with their husbands (if they did get married) took on a more authoritative and independent tone. They had come to value their current freedom and independence, and they were unwilling to have this taken away by a husband. When asked if she would marry, Divya replied:

> If someone asks like that I will say no. I want to be with Mother till the end. After that, I will be fine, enjoying and free. I can eat when I want, do what I want, watch TV. Marriage means I have to took after all different people ... so many things to do, problem [laughs]. Now I just keep my bag on the table and sleep. Can I do that after marriage? Not possible. We won't have so much freedom.

None of the women were resigned to the idea that their husband would have the ultimate authority to decide whether or not they could work. In addition, they also asserted that they would refuse to marry if the dowry was higher than the normal amount.

Independent Living Skills

By staying in a hostel, the women acquired living skills that were not possible for the others who lived with their families or on their own. They learnt how to manage a household efficiently. Even those who did not have any prior experience of cooking, cleaning or doing other domestic chores learnt them quickly. The women also learnt how to cope with separation from their families. The closeness of their group, as friends and co-workers, had facilitated a dispersal of the initial loneliness they had felt:

> Mother says, 'So you don't think of us family members at all.' So I say, 'There is no time. As soon as we go, we start working. When we come back to the hostel, we have to study and talk with friends. Since we should feel that we are staying away from home we keep ourselves busy by reading, talking about work and all those things.'

Long-distance travel was a new experience for the women living independently. None of them had travelled unchaperoned before, but now they found themselves riding the bus and the train almost every month to visit their families without too much difficulty and anxiety.

The women developed the skill of managing their finances efficiently. They also became experienced consumers at the market, acquired knowledge about the value of goods and even saved small sums which they gave to their parents.

In addition, the women came to enjoy living independently and found themselves in a position where they could not imagine depending on their families in the same way again or even going back to their previous roles within their families. As Divya told the researcher:

> If we are at home we cannot just be sitting. We have to do the housework. But here we learn to work in something like this—and it fetches money too We go out, come back and rest ... take our turn for cooking.

The Women's Self-Perceptions

Despite the huge changes that have come about in the attitudes, situations and opportunities for women in the last two decades in

India, a majority of women still have a subservient social role, which they have internalized. For women who are disabled, this role is compounded by their disability, which increases their sense of vulnerability and dependency.

Seen against this background, the changes in self-perceptions the women developed in relation to their role in the families within a relatively short period (one year) was remarkable. Their feelings of complete dependence, economically, emotionally and for security on their parents had been substituted by a feeling that they could support their parents sufficiently and offer them provisions and security in the future. All the women now perceived themselves as autonomous earners and potential contributors to the family income. Women, particularly those who had lost their fathers, had come to see themselves as being more devoted and responsible for maintaining their mother's well being than their brothers and sisters. This, despite the fact that they had other male siblings. Chandrika was vehement as she said:

> I have this desire to tell her (Mother) not to go to anyone, not even to my younger brother ... I told mother, 'I won't leave you in anybody's house. It want to earn myself and keep you. You should not have any difficulties.'

Group Development

Group Cohesion

As mentioned earlier, physical care and assistance (where required) for women with disabilities is mostly provided by her family. It is in the understanding of her emotional needs that families often fall short. Very few families seem to be able to deal with this subtle yet deep emotional conflict that arise for women with disabilities. Most women with disabilities have to find their own ways of coping. This is an area where both the women and their families are still seeking answers (Hema, 1996). The women's experiences in group living seemed to fill the big void which exists in this crucial area for the disabled women.

At one level, the important practical requirements of everyday life like filling water, cleaning bathrooms/toilets and shopping made it necessary for the women to adjust, cooperate and compromise. They had to learn to accept and work through each other's and abilities, disabilities, and individual differences in cooking styles, preferences, languages, and religious practices. This required them to develop a

certain level of maturity, a willingness to give and take. Group cohesion, which was highest for those women who lived together, helped them to cope being away from their families and also to get along in the training process. In the evenings they discussed about the day's events and did their homework together. This facilitated their learning processes. In contrast, living at home impeded development of group cohesiveness, as was the case with Mythili:

> ...[My] father drinks a lot; he is totally out when he comes home in the evening. Because of this I have no time to study. Till three in the morning he keeps talking ... I am not able to get up and study in the morning.

At another level, the group living provided the women with opportunities to share their emotions and thoughts with peers who were themselves disabled. For the first time they could share relationships that did not entail dependency, protection or looking after.

The women unanimously reported that they now reacted differently to teasing, questions and pity when these were directed at them in social or public settings. They recognized that these questions were most often a result of mere curiosity. They also said that they no longer accepted pity from others or internalized it as valid.

The women in the hostel came to genuinely care about each other's well being and did what they could to emotionally and physically support each other. An example of this occurred when Niloufur fell ill. She developed pain in her good leg and was sick the whole night. The rest of them were up the entire night looking after her, feeling extremely anxious and afraid as to what the problem was. They also missed each other when they went home for visits.

A slight breakdown in the group's cohesiveness was felt when it was suspected that Kantamma was having an affair. She was first asked to leave the training but later allowed to continue and abide by the new rules which were introduced in the hostel. These placed a lot of restrictions on the women. Although the women initially felt angry with the NGOs management for having been treated unfairly and monitored excessively, their anger soon shifted towards Kantamma whom they had warned prior to the incident. Articulating this to the researcher, Divya said: 'If one makes a mistake, everyone else has to hang their heads [in shame].'

Despite the tension which resulted within the hostel following these events, all six of them said they would still prefer staying together in the hostel, even after the inauguration of their workshops.

Group Adaptation and Cooperation

The women who lived in the hostel displayed great improvements in their ability to adapt and cooperate as a group. Three systems were set in place in the hostel, which allowed all members of the group to learn and contribute their share in household management. These included the 'partner system' for cooking, the 'mess system' for the collective purchase of groceries each month, and the system for carrying water and doing other tasks (such that the women contributed depending on their levels of physical ability):

> There is a tap next to our room. Kantamma, Divya and Niloufur cannot get water from that tap. But Chandrika is OK. Rema can also lift. Only I can lift alone. So Rema will lift the water, give it to Chandrika and she gives it to me and I carry it.

In addition, the women learned to adjust and compromise amongst themselves when it came to their duties regarding cooking and cleaning are concerned. As Nusrut said:

> I used to scold her, 'Don't you feel ashamed to throw clothes around? You are grown up, even elder to me. If you change clothes, fold it again and keep.' She says, 'When I come back, I have to wear it again, so why fold?' Now I have changed a little and they have also changed. So now Niloufur and Chandrika clean the bathroom daily.

All in all, group adaptation and cooperation within the hostel was extremely high and differences in routines, abilities and languages among the women were eased by their creativity in solving problems and their willingness to adjust to each other's needs.

Sociability

The sociability levels of the women, who lived as a group, developed far more and positively than those of the women who lived otherwise. In the beginning when the researcher had spoken to them, eight of them had said that they felt isolated and embarrassed at functions. Rema said:

> I never used to go out. I never attended marriages. I used to feel shy because of my disability. In my house I am the only one who is disabled, and I used to feel very bad.

Living in this new situation for a few months, all the women in the hostel reported that they had developed the feeling of being accepted, and had become confident to venture out into the town. They went out on social outings as a group and did not feel alone or personally affronted if someone stared at them. Together, they were able

to ignore the fact that people might be perceiving them as different and were able to carry out their business with the feeling that they had social support. Contact with other people with disabilities, people who did not judge each other based on their physical abilities, was of great benefit in raising self-esteem and in developing social skills.

However, the home environment and peer group determined the ability to transfer this self-esteem and sociability to other settings. Most of the women who stayed elsewhere continued to feel apprehensive and shy when they left the security of the training situation after each day of work. This is evident from what Mythili had to say:

> These people are also like us. They also have disability. We can adjust among ourselves. But in the other group they may say, 'No. She won't come fast …. We want to walk fast.' Only here I am like this. Only here I am talkative. There [in her hometown] people say, 'Oh! That girl! Very silent girl!'

While visiting their parents, the women felt more confident to attend social functions and to visit friends and relatives.

The women's feelings and reactions to people's questions also changed. Their response to people pitying them was now of surprise and sometimes resentment. Although they had pitied themselves before, now their reaction was to think about how absurd it was when they felt perfectly capable.

Growth in Social Awareness

Developing awareness about issues that affect one's life is the first step towards empowerment. Going beyond this, to gain insights into these issues, of how they can affect the lives of whole groups similar to oneself, can help in seeing beyond oneself, which, in turn, can help putting things into proper perspective.

Initially, the women had a good understanding about how issues surrounding gender, poverty and disability affected their own life options. However, after coming into contact with a group of disabled person while in training and in the hostel, the women expressed more insights about how disability, poverty and gender interact and affect whole groups of people.

Disability as Incapacity

The women's understanding of social perceptions surrounding disability developed significantly throughout the course of the training,

beyond their own personal experiences while in public, at school, at large functions, etc. These new insights helped the women to understand their past experiences, to understand their present situations and direct their motivations in the professional arena. For example, the women reported that in future they would ensure that parents of disabled children who came to them would be told that it was not their fault that their children were disabled. Many of the women expressed an increased drive to succeed as prosthetic/orthotic technicians to disprove the popular perception that disability was equivalent to incapability.

Poverty, Access to Education and Disability

Many of the women came from rural or poor backgrounds and had themselves been unable at times to receive treatment or orthotic aids due to their families' economic status or lack of knowledge about their options. The training situation and increased contacts with other disabled people made the women increasingly aware that poverty, lack of educational opportunities and illiteracy were key factors which inhibited some people from knowing or finding measures which would prevent disability.

Gender, Marriage and Disability

The women showed increasing understanding of how physical impairment decreases a disabled woman's marriage prospects. They were also aware that potential husbands might only be interested in receiving a dowry and not be sincere in their intentions to marry them. Gender dynamics within marriage, such as unequal division of labour, husband's authority and wives' dependence were cited as common deterrents to getting married. The women also firmly believed that they, as disabled women, were at a higher risk for marital abuse, even though they had never been married. Expressing this concern, which is a poignant evidence of their elevated social consciousness, Kantamma said:

> My aunt's daughter is very good looking. She is already married. Her husband does not look after her properly. He beats her, saying 'I will marry somebody else.' That is why I feel that if life can be like this even when people are able and good looking, then what to do with people like me? These thoughts come to my mind always.

Professional Development

Professional development is more than just earning more. It offers new environments, new interactions, expanded roles and identities and opportunities to gain information, knowledge and new skills. For women who have always been at home, it can open up a whole new world.

Technical and Patient-Care Skills

The women learnt technical and patient-care skills as part of their training and their interest and motivation to use these skills successfully increased as the training progressed. Physical limitations and initial difficulties in learning soon subsided, as the women grew more experienced. The women also built up physical endurance, besides benefiting from their new lightweight orthotic appliances, provided by the NGO.

As the women's contacts with their clientele increased so did their ability and confidence to serve their needs. They also began to perceive themselves as being better equipped to handle the personal, interactional aspects of patient care, both because they had now acquired experience and because they too had disabilities.

The women felt that they could offer emotional support effectively to distraught parents of disabled children by telling them about the experiences that they themselves had been through as children and how their parents had learnt to deal with their needs. As Kantamma explained:

> I'll try to console them. Try to make them feel better …. Some parents say, 'Oh! My child is like this. I feel so depressed.' I must give them courage. I will tell them, 'Look at us. We are also disabled. Because of this, we have joined the training programme. You must also join this training. Our parents also felt bad like you. But all are now happy. We will look after and help in the growth and development of the child.'

The women also began to see themselves as role models for their older patients. Their own experiences with disabilities, and their own processes of becoming mobile and self-sufficient, allowed them to offer more empathy to their patients as well as practical suggestions which suited their patients' individual needs.

Interest and Motivation

Apart from the women's increased confidence and skills, their attitudes towards the work also underwent significant change. In the beginning, the women had, for the most part, joined the training in pursuit of employment. After the training was underway, all the women told the researcher that the work interested them very much. Besides becoming more interested in the details of making appliances, there was a growing belief amongst the women that their work was socially valuable and necessary for the well being of the disabled community. Through their experiences at work they were able to help others directly. Besides they were becoming aware of the great need that existed for their services. Over time, the women's interest in their work and their commitment to the disability cause transcended their priority of finding employment as an economic necessity—this was true particularly for the women in the group hostel. It appears that simply being surrounded by talk of work and by their co-workers, even at night, contributed to their professional development and interest. While for the women living in their own homes their work remained just work, to the hostel women being prosthetic/orthotic technicians became a way of life.

Conclusion

Information about people with disability—their needs and their aspirations—based on systematic studies in rare in India. As for women with disabilities, it is only recently that their issues are gaining recognition, attention and deeper perceptions. In the absence of such accurate information, myths and misconceptions about women with disabilities continue to exist among the women themselves, their families and others in the community. For those working in the field of disability, lack of data has meant planning programmes based on generalized impressions about their needs, emotions and aspirations. This means interventions for women with disabilities have, so far, not been based on an understanding of the combined impact of gender and disability in their lives—an impact that has been believed to be, for the most part, completely negative and uninspiring.

The nine women in the study belonged to different religions, castes, and spoke different languages. What they did have in common was their gender and their disability. And these two issues have been the focal points of their lives—in the past and, as they and their

families see it, in the future too. As this article has demonstrated, in certain ways this has worked to their advantage as compared to their non-disabled counterparts, especially when it came to their education, their taking up employment, having an independent income, etc. In fact, it was this advantage which was crucial to their being able to have the opportunity of the training and even more the stimulating experience of living independently.

The fact that the women and their families consider that the women's future has 'options' is in itself significant, considering their rural and low socio-economic backgrounds. For if 'gender' had been the only issue in their lives, marriage would have been a future 'certainty'. The nine women's simple yet pragmatic acceptance of their situation has come about through years of family and societal attitudes ingrained into them. The training and group living experience has made this acceptance more motivated and dynamic in its practice, by offering them an opportunity for personal, social and professional growth.

The women's gender and disability have combined to bring 'options' into their lives. Can opportunities lead them to real 'choices'?

Postscript

A month after the final interviews, one of the women, who lived at home with her parents during the training, eloped with her boyfriend. After this elopement, two of the women living in the group hostel were asked to move back to their parents' homes as they too were suspected of having boyfriends and of potentially eloping. They subsequently had to travel from their homes in the outskirts of Bangalore each day for the rest of the training period. This involved changing two–three buses each way, which they reported as being difficult because of their disabilities. They also said that they missed living in the hostel and feeling close to their friends.

In August 1997, the women completed their training and received their certificates as prosthetic/orthotic technicians. On 10 August, the workshop was formally inaugurated at Cheshire Homes in Bangalore.

Notes

1. The interviews were conducted between August 1996 and March 1997.
2. The names of all the women in the study have been changed.

Reference

Hema, N.S. (1996). 'Hopes and Dreams: The Situation for Women with Disabilities in India', in Driedger Diane et al., eds., *Across Borders*. Canada: Gynergy Books.

16

AMUDO and the Vecinos Project: Striving Together to Meet the Needs of Indigenous Women with Disabilities in Oaxaca, Mexico

Catherine A. Marshall, Claudia Santiago González, Lourdes García Juárez* and Susanne M. Bruyère*

The state of Oaxaca is located in the southeast of Mexico. It is considered, together with Guerrero and Chiapas, as one of the extremely poverty-stricken Mexican states in terms of social, economic and educational infrastructure. It is also a state with a large and predominant indigenous population. In Oaxaca, society has historically allowed men more opportunities to develop than women. Now at the beginning of the twenty-first century, there are changes, and women have more opportunities to participate in the socio-economic context. However, this is not true for women with disabilities in Oaxaca. It is very difficult for women with disabilities to demonstrate that they can participate in all areas of life—social and professional. This is to a large extent due to the lack of education among them. For men with disabilities, it is difficult, but they can participate.

Parents have all too often felt that girls were very fragile and needed protection: they were not allowed to go in the street alone, even to school. Typically, the disabled women in Oaxaca have no

* The authors share second authorship.

more than an elementary school education. In the past decade, girls with disabilities have had more access to educational opportunities. Meanwhile, there is a large population of women with disabilities in the age group of 25 to 35, who are illiterate and unemployed, a peculiar problem with the indigenous women. Women with disabilities in Oaxaca must seek for opportunities in all areas of life in order to improve the quality of life for themselves, their families as well. They should strive for their human rights.

Women as well as men have an equal right to fair working conditions. Women must establish their rights to choose their employment and working conditions, without any kind of pressure or discrimination. When women with disabilities have the good fortune to find employment, they should strive for the right to training which will help them to climb the corporate ladder and improve their economic conditions. This does not happen in Oaxaca because both the government and the private initiative have a poor concept of promotion. Jobs are given to favour a person without giving a thought of such facts like ability and experience. It is generally considered a noble action to have hired a woman with a disability, and so it is thought that nothing more should be expected or demanded. However, at the same time, having hired a woman with a disability provokes a situation of resistance to promoting her because of the fear that any new or additional responsibilities could worsen her disability. Popular belief considers persons with disabilities to be weak and sick. To compound the problem, it is generally believed by employers that a wheelchair does not make an attractive appearance.

Because of these misconceptions, jobs carried out by women with disabilities in Oaxaca are monotonous, servile and low salaried. There is a need to consider self-employment as a more efficient medium for the disabled women to achieve favourable economic development. Women with disabilities need some kind of employment where they do not have to work double to justify their salary, where they do not have to prove that they are physically apt for the work, and where they do not have to repeatedly demonstrate their competence. Women with disabilities, who already have employment, must avoid being hidden from public view or kept to themselves out of the sight of customers. On the contrary, they must participate in serving the public and make integration a daily reality. This is being accomplished in Oaxaca City, the capital, where women with disabilities are forming a new and an open culture. Their counterparts in the rural areas have to face

greater and varied problems as the opportunities extended to them are limited.

Birth of AMUDO

In Oaxaca City, a group of young people with disabilities got together with the objective of breaking the cages in which, due to ignorance or unjustified shame, their families had shut them in. The leaders of this group were Germán Pérez Cruz and Pedro Flores Rey. These young men convinced their parents to join them, and were able to start their work for disabled persons. Their informal group was called Asociación Acceso Libre [Free Access Association] and they dreamt of forming a complete rehabilitational centre to help and integrate people with disabilities into socially and economically productive lives. In August 1993, they met Gabriela (Gaby) García Juárez who, after two years of rehabilitation following a fall which left her paraplegic, had begun re-integrating into her family's daily life. Gaby joined this group of young people because she needed a job; she had two children to care for. Nevertheless, it was at Access Libre that Gaby stuck upon the idea of forming La Asociación de Mujeres con Discapacidad de Oaxaca (AMUDO) [The Association of Women with Disabilities in Oaxaca]. Gaby started to work on developing AMUDO so that women like herself could recoup their dignity and make a place for themselves in the society. AMUDO would strive to educate and train women with disabilities so that later they could take care of themselves. Thus the objective was to provide employment and hands-on training.

The first project of AMUDO was the formation of a textiles-painting workshop, but the group lacked finances. By knocking on doors, they were able to reach a women's group of volunteers from Teléfonos de México, represented by Mrs María de los Ángeles Viloria, who made the first donation to AMUDO. Thus the textiles-painting workshop became a reality with a group of 10 women on 10 October 1994. Products made in the workshop have found a market in the United States. Gaby said that AMUDO came into being when women with disabilities 'became aware that there was a social segregation'—that women with disabilities did not even have the opportunities that men with disabilities chanced upon. For women with disabilities, it is difficult to find conditions in which their needs as

women are valued. Working together, Acceso Libre and AMUDO have achieved considerable success in making the dreams of Germán, Pedro and Gaby a reality.

On 11 March 1996 Gaby received the Princesa Donaji Prize awarded by the Asociación de Mujeres Periodistas de Oaxaca [Association of Women Journalists of Oaxaca] in recognition of her work for women with disabilities. Shortly thereafter, in August 1996, Gaby fell sick and died the same month. Her death was a great loss for her children, her companions in the struggle, and, above all, the many projects which she left unfinished. In the last years of her life, Gaby manifested her commitments for uplifting the conditions of women with disabilities. She instilled the sense of need in Oaxacan women with disabilities to subsist on their own. She discovered a great sensibility in them in the creation of art (textiles-painting workshop), taking note that women need to use their creativity in order to find ways to sustain themselves.

We have come to respect the rights of people with disabilities to set their own agenda and to carry out their own interventions. We also respect the reality of different cultures—the vast difference in the cultures of Mexico and those of the United States. Yet there is a problem when respecting culture and disability. Self-determination results in discrimination against the human rights of women with disabilities. The Vecinos Project has successfully worked for several years in Oaxaca with the leaders (primarily men) of the disability rights movement. We have successfully influenced local legislations physical access of public as well as private buildings, developed community awareness regarding the needs of people with disabilities, and have successfully won funding through the Kellogg Foundation to develop a rehabilitation centre run by people with disabilities—a model intervention programme which deserves recognition at the national level. Yet, we women at the centre speak in whispers. The disabled man, who is the director, becomes easily enraged if he sees us working together. Since Gaby's death, he has refused to allow the systematic development of programming directed at meeting the special needs of women with disabilities. Support is needed from those who can assist the men and women with disabilities in understanding that women, as well as men, have the right to develop their voices, to become leaders, and to impact their communities at the local as well as the national levels.

The Vecinos Project

Since 1994, the Vecinos y [Neighbours and] Rehabilitation Project
(funded by the National Institute on Disability and Rehabilitation Re-
search, Office of Special Education and Rehabilitative Services, U.S.
Department of Education) has demonstrated that there is much to
be gained from the two neighbours, the United States and Mexico,
working together to address the issues related to disability. The Veci-
nos Project can be viewed as a case study of international develop-
ment at the local level which, while seemingly successful in advancing
disability rights, has been less than successful in ensuring the rights
and economic development of women with disabilities.

The purpose of the Vecinos Project has been to

(a) establish the feasibility of conducting major research and
 training projects involving indigenous people with dis-
 abilities in Oaxaca, Mexico; and

(b) develop and strengthen a programme of information ex-
 change between Mexico and the United States involving
 experts in the field of rehabilitation and native peoples.

The first three years of the Vecinos Project focused on different
geographic regions in the state of Oaxaca. The various phases of re-
search touched upon the needs of adults with disabilities and the re-
sources available to them. During Phase I, which begun in September
1994, 232 individuals with disabilities were surveyed in three different
geographic regions of Oaxaca, specifically, the capital [Oaxaca City],
the mountains [Miahuatlán], and the coast [Puerto Escondido]
(Marshall et al., 1996). Phase I represented a collaborative effort be-
tween Vecinos researchers and volunteers of Acceso Libre. As one
outcome of the research, Acceso Libre was incorporated as a non-
profit organization in order to receive a grant from the W.K. Kellogg
Foundation. The grant allowed them to offer vocational rehabilita-
tion and independent living services to indigenous people with dis-
abilities in and around Oaxaca City, as well as to reach out rural,
indigenous communities. In May 1998, Acceso Libre funded two rep-
resentatives, including the mother of a young man with cerebral
palsy, to give a presentation and exchange experiences at Fiesta Edu-
cativa, a bilingual special education conference held in Los Angeles.
The Acceso Libre presentation was entitled, 'South of the order,
Models of Excellence' and was very well received.

The rural Mixteca region of Oaxaca was selected for Phase II of the Vecinos project—a collaborative effort between Vecinos researchers and the Asociación de Discapacitados de la Mixteca [Association of People with Disabilities from the Mixteca]. A total of 140 persons were surveyed during this phase (Marshall, Gotto and Galicia García, 1998). Phase III took place in the rural and remote village of Totontepec Villa de Morelos in the Mixe district of Oaxaca (Marshall, Gotto and Bernal Alcántara, 1998). This collaborative effort was initiated by volunteers in Totontepec, members of the Instituto Comunitario Mixe [Mixe Community Institute], and Vecinos researchers. The team surveyed 64 persons with disabilities, besides conducting five ethnographic in-depth interviews with persons with disabilities and five corresponding interviews with a family member. One outcome of Phase III was the development of a community support group for people with disabilities and their family members. The last phase, Phase V, focused on understanding and documenting the needs of indigenous women with disabilities.

During each phase of the Vecinos y Rehabilitation Project, a concerted effort has been made to send indigenous people with disabilities from Mexico to the United States as well as to bring rehabilitation experts from the United States to Mexico in order to develop and strengthen information and knowledge exchange. During Phase III, Ela Yazzie-King, a disability advocate from the Navajo Nation, participated in an information exchange programme with the Mixe in Totontepec. At the conclusion of her participation in the Totontepec public forum, she commented, 'The indigenous people of Oaxaca frequently demonstrate self-reliance in the face of minimal fiscal resources. American Indians need to re-learn self-reliance, a quality lost after years of dependence on federal government programmes, which often turn out to be short-term' (Marshall, Gotto and Bernal Alcántara, 1998: 91).

Ultimately, it is hoped that the exchange of information and knowledge that has occurred as a result of the Vecinos y Rehabilitation Project will help to shape culturally appropriate and cost-effective rehabilitation programmes that serve indigenous people with disabilities both in Mexico and in the United States. Similarly, it is hoped that the information gained through this study will help to inform policy makers, in both the United States and Mexico, as well as other parts of the world with indigenous populations, that

rehabilitation intervention must accommodate the cultural needs of indigenous people with disabilities.

The First Three Phases of the Project

Data collected on women with disabilities during each of the first three phases of the Vecinos Project are briefly summarized, highlighting a progressive move in concentration from the urban capital of Oaxaca City to the rural Mixteca region, to the rural and remote Sierra Mixe. All survey instruments were developed locally with input from the various participating communities; thus, the information obtained through different phases of the research is not uniform. However, we attempt to highlight those data that were collected on indigenous women with disabilities in Oaxaca. The information clearly indicates that indigenous women with disabilities lack appropriate access to education and employment. Anecdotal evidence, gathered by the principal investigator over five years of working in Oaxaca, indicates that women with disabilities in Oaxaca have very low self-esteem. However, their self-esteem reported an increase with an increase in educational level and employment opportunities. This further increased after they took part in an information and knowledge exchange programme with other disabled women during an international forum for women with disabilities held in Washington, D.C., in June 1997.

Phase I

As stated earlier, Phase I research ($n = 232$) was conducted over three geographic regions of Oaxaca. The Phase I data analysis included all females ($n = 72$) in some of the results; subsequent phases separated adults from children for all variables. In the Phase I research, a majority of females [78 per cent (56)] surveyed were from the capital. Three-quarters of all female respondents were adults[†] [74 per cent (53)]. Women made up 23 per cent of the study population sample.

Illness was the major cause of disabilities among all females [61 per cent (44)]. Only 19 per cent (14) of the females had a disability

[†] The term 'adult' was defined as 15 and older in this research because age 15 is considered working age in Oaxaca and by the Mexican census; the term 'women' refers to adult female age 15 and older.

due to accidents; 18 per cent reported having congenital disabilities. Polio [32 per cent (23)] was the single most common disability among females. Over half of the females [56 per cent (40)] reported that they received no assistance in regard to their disability. The majority of women [72 per cent (38)] surveyed were single; 26 per cent (14) reported that they had a dependent. A majority [58 per cent (31)] reported having no income. Just over a third [36 per cent (19)] of the women were employed; however, information was not collected in regard to the quality of the employment, e.g., whether or not employment was full-time or part-time, seasonal, or with benefits. A plurality of the women [43 per cent (23)] had only an elementary-level of education; 11 per cent (6) of the women had no education while only 4 per cent (2) of the women had a professional or university education.

Phase II

Phase II research ($n = 140$) was conducted in the Mixteca region (Marshall, Gotto, and Galicia García, 1998), a rural area of indigenous people and about three hours' run from the capital. Of the 140 research participants, 34 per cent (48) were female; 65 per cent (31) were adults. Thus, women made up 22 per cent of the study population.

Of the 31 adult indigenous women with disabilities, a large majority [74 per cent (23)] lived in the rural areas, and were originally from the areas of San Sebastián, Tonalá, Tezoatlán de Segura y Laguna, Yetla, El Naranjal, Llano Grande, and Santiago Huajolititlán. The rest [26 per cent (8)] belonged to the urban centre of Huahuapan de León. All of the women were Mixteca. They reported an average age of 32 years, but ranging from 15 to 70; however, only two of the women might be considered 'adolescents'.

A large majority [70 per cent (16)] of the women were single. The majority [83 per cent (19)] of the women reported that they were dependent upon someone for their socio-economic well being. Just over a quarter [26 per cent (6)] of the women were responsible for, on average, one dependent, with a range of between one to four dependents.

The plurality, or most of the rural women [35 per cent (8)], reported their disability as cerebral palsy, followed by polio [13 per cent (3)] and vision impairment [13 per cent (3)]. On average, the women

reported having had their disability for 21 years, with a range between 4 to 42 years. The majority [52 per cent (12)] reported having a congenital disability, followed by just under a third [30 per cent (7)] having a disability due to an illness, and the remainder [17 per cent (4)] having a disability due to an accident. Parts of the body resulting in functional limitations are presented in Table 16.1.

Table 16.1 Parts of the Body Affected by Disability in Rural Indigenous Women

Affected Area	Percentage of Individuals (%)	Number of Individuals	Percentage of Responses (%)
Lower limbs	26	6	21.4
Speech	26	6	21.4
Brain	22	5	17.9
Lower right limb	13	3	10.7
Vision	13	3	10.7
Lower left limb	9	2	7.1
Upper left limb	4	1	3.6
Upper right limb	4	1	3.6
Other	4	1	3.6

Note: Number of responses = 28. Some of the 23 individuals had more than one part of the body affected.

All of the women with the exception of one [96 per cent (22)] had only an elementary-school education or less; almost half [48 per cent (11)] had no education. One woman had gone on beyond elementary school to complete high school. The vast majority [87 per cent (20)] of the women did not have an income; those who did have an income [13 per cent (3)] were employed. Positions included housekeeping (2) and temporary/odd jobs (1). The woman with the highest level of education was not employed.

All of the respondents reported that there were no resources or service systems to help them with their disability. Specific needs of the respondents are listed in Table 16.2.

During the survey, the women were asked, 'In your opinion, what are the most urgent needs of people with disabilities?' In response, they referred primarily to medical attention [39 per cent (9)], followed by education and vocational training [22 per cent (5)], and employment opportunities [17 per cent (4)]. With regard

Table 16.2 Rehabilitation Needs of Rural Indigenous Women
with Disabilities

Area of Need	Percentage of Individuals (%)	Number of Individuals	Percentage of Responses (%)
Physical rehabilitation	74	17	27.0
Employment	65	15	23.8
Health care	48	11	17.5
Education	44	10	15.9
Emotional support	44	10	15.9

Note: Number of responses = 63. Some of the 23 individuals had more than one
rehabilitation need.

to employment opportunities, one woman commented, for example,
that people with disabilities needed to be able 'to count on real sup-
port since we have been forgotten by society'.

Research participants were also asked to comment on how the
survey could be improved? Rather than commenting on the survey
instrument, the women were interested in receiving concrete assis-
tance. For example, one woman requested, 'Tell us where we should
direct ourselves for our needs.' A woman with vision impairment
demanded that courses are developed for people with disabilities.
Another woman with vision impairment wanted a 'centre of special-
ized attention' for women with disabilities. One woman with an am-
putation, who identified education and vocational training as pri-
mary needs of people with disabilities, asked, 'Can you assist me in
my community or give me a grant?' One woman with cerebral palsy
commented that she would like 'to be able to count on a centre of
special education'; two other women with cerebral palsy stated that
centres for physical rehabilitation were necessary.

Phase III

Phase III research ($n = 64$) was conducted in the rural and remote
area of the Sierra Mixe (Marshall, Gotto and Bernal Alcántara, 1998).
A total of 30 women, or 47 per cent of the study population, re-
sponded to the survey. The ages of the women ranged from 15 to 92
years, with an average age of 50. A large percentage of the women
[43 per cent (13)] were 60 years old or older. A majority of the
women were single [53 per cent (16)]. All of the women were Mixe

and resided in the village of Totontepec. One of the women did not report which languages she spoke; however, 97 per cent (29) of the women reported that they spoke their native language, Mixe. In addition, 47 per cent (14) of the women spoke Spanish. The majority [87 per cent (26)] of the women said that their preferred language was Mixe.

The majority of the women [93 per cent (28)] with disabilities either had no education or only a grade school education. Indeed, the majority [53 per cent (16)] reported having no education. Four (13 per cent) of the women reported having an income. All of these women received their income through part-time employment as seamstresses or maids. Three of the four women reported that they were treated well by their employers, but one reported that she was not satisfied with the way that she was treated. All of the employed women reported that their incomes were not enough to meet their living expenses or their disability-related needs. Almost a quarter of the women [23 per cent (7)] reported that they had an average of 1.6 dependents while 83 per cent of (25) of the women reported that they were dependent on another person for their living expenses.

A plurality [33 per cent (10)] of women reported having vision impairment (not including blindness) followed by those with arthritis [23 per cent (7)]. The most common cause of disabilities among the women was congenital [40 per cent (12)]. Accidents were the cause of 30 per cent (9) of the disabilities and illnesses caused 23 per cent (7) of the disabilities. Two of the women [7 per cent] did not report the cause of their disabilities. The majority of the women [93 per cent (28)] said that there were no disability-related services available to them in Totontepec. However, two [7 per cent] women said that they had access to private institutions or other unspecified services. The areas of the body that were most commonly affected by disabilities among the women were vision [53 per cent (16)], hearing [23 per cent (7)], speech [17 per cent (5)], and lower limbs [17 per cent (5)].

Table 16.3 demonstrates that the most pressing needs of the women with disabilities were family support [50 per cent (15)], medical attention [50 per cent (15)], physical rehabilitation [27 per cent (8)], and health [20 per cent (6)] respectively.

Table 16.3 Rehabilitation Needs of Rural and Remote Indigenous
Women with Disabilities

Area of Need	Percentage of Individuals (%)	Number of Individuals	Percentage of Responses (%)
Medical attention	50	15	23.1
Family support	50	15	23.1
Physical rehabilitation	27	8	12.3
Health	20	6	9.2
Employment	10	3	4.6
Training	10	3	4.6
Education	7	2	3.1
Psychological support	3	1	1.5
Other	40	12	18.5

Note: Number of responses = 65. Some of the 30 individuals had more than one
rehabilitation need.

Lessons Learnt

Based on the findings of the first three phases of the Vecinos Project,
it appears that women in Oaxaca have very minimal education and
access to employment. Their disabilities tend to be related to illnesses
such as polio and to congenital problems such as cerebral palsy. An-
ecdotal data gathered over a five-year history of working in Oaxaca
has evidenced that women with disabilities do not have high self-
esteem but that their self-esteem rises with educational and employ-
ment opportunities. Their self-esteem also rises after contact with
other women with disabilities whom they consider successful and/or
attractive. The association of self-esteem, physical attractiveness, sex
appeal and employment become clearer in a traditional culture
where society still dictates that a woman applying for a job should
possess 'buena presentación' [attractive looks].

The Vecinos Project illustrates the importance of carefully con-
structed qualitative research in designing the needs of the popula-
tion under study. It also illustrates the need for maintaining good
baseline data on disability prevalence, needed services, and the
disabled persons' perception of the impact of their disability on
employment outcomes.

People who are engaged in designing culturally relevant inter-
vention to address the identified needs of the disabled must have
knowledge of existing employment and civil rights legislation that
can provide protections. Each intervention designed for the target
population (i.e., medical, education and training, and employment)
must take into account the existing cultural context, availability of re-
sources and potential barriers for particular populations. Again, at
each step in the intervention process, knowledge of existing issues in
the target service sphere (e.g., health care, education, workplace)
that impede successful involvement of the general population
should be identified. Such barriers may even pose problems in ac-
cessing and engaging women with disabilities (e.g., lack of accom-
modation, sexual harassment, sex or disability discrimination, etc.).

This research also highlights the need of engaging at the local
level to study persons with disabilities, and creating a way to enable
them to contribute to the development of social policies at the local,
state, and national levels. It is hoped that this model will uniquely
contribute to the design of relevant service delivery systems that can
truly meet the needs of the target population and facilitate their em-
powerment and betterment of living, learning, and earning capacity
that they so richly deserve.

Conclusion

The work of AMUDO and Acceso Libre is now known at both local
and international levels. AMUDO representatives have been invited
to participate in different meetings and congresses, one of which was
the International Congress La Discapacidad Hacia el Año 2000 [Dis-
abilities in the Year 2000]. In 1996, AMUDO participated in the
Congreso Interamericano Sobre Discapacidad [Interamerican Con-
gress on Disability] held in Tucson, Arizona, where Gabriela García
Juárez discussed the craft and organizational work of AMUDO.

In 1997, a group of women with disabilities from AMUDO par-
ticipated in the International Forum on Leadership for Women with
Disabilities held in Washington, D.C. It was here that the idea of con-
stituting a forum for addressing the needs of disabled women in
Latin America was born. AMUDO had the opportunity to host this
Latin American forum in Oaxaca in November 1998.

AMUDO is aware that poverty is a global problem, and not just limited to Mexico. We live in times where we have to seek opportunities to improve our living conditions. According to the 1990 Mexican National Census, the average educational level in Oaxaca is 4.6 per cent; this means that the majority of the general population has just finished primary school or the first or second year of secondary school. Many women with disabilities who need training or a job do not know how to read or write. This is noticed particularly in the rural communities of Oaxaca. Most of the women with disabilities have either never started their education or never finished their basic primary or secondary studies. AMUDO has therefore taken up the task of reducing the educational gap that exists among women with disabilities. Carried out as an adult literacy programme, it works with women who are 15 years of age or older. Women are grouped based on their disabilities and are taught through mutual support—that is, persons with a higher level of education help to teach their classmates. The families of the people with disabilities are also involved in the process.

AMUDO has achieved reasonable results in the education of women with disabilities. We now want to take this interactive educational programme to the remotest corners of Oaxaca. In fact, we have already signed agreements with the Consejo Nacional de Educación Profesional Técnica [National Council of Professional Technical Education] and Centros de Capacitación Técnica Industrial [Technical Industrial Training Centres] to help disabled women in finding scholarships in educational institutions.

We at AMUDO started off in our mission with almost nothing except our creativity. We have succeeded in creating our own fountainheads of resources to achieve new and independent paths to self-support. We try to maximize the opportunities for the independence of women with disabilities by enabling them to work from their homes. However, in a country like Mexico that officially recognizes the high employment rate, we must explore new avenues of subsistence for people with disabilities.

We have achieved many things together, but we have many more to achieve. We have to find resources to fund our projects and to pay our members. We also need to have the necessary resources to apply our educational models among the far-flung communities in the state. Only by joining our efforts and networking with others in

the struggle will we be able to ensure a just world for women with disabilities.

References

Marshall, C.A., G.S. Gotto and J.A. Berna Alcántara (1998). Vecinos y Rehabilitation (Phase III): Assessing the Needs and Resources of Indigenous People with Disabilities in the Sierra Mixe. Final Report. Flagstaff: Northern Arizona University. (Available in English and Spanish from the American Indian Rehabilitation Research and Training Center, Institute for Human Development, Northern Arizona University, P.O. Box 5630, Flagstaff, AZ 86011.)

Marshall, C.A., G.S. Gotto and O. Galicia Garcia (1998). Vecinos y Rehabilitation (Phase II): Assessing the Needs and Resources of Indigenous People with Disabilities in the Mixteca Region of Oaxaca, Mexico. Final report. Flagstaff: Northern Arizona University. (Available in English and Spanish from the American Indian Rehabilitation Research and Training Center, Institute for Human Development, Northern Arizona University, P.O. Box 5630, Flagstaff, AZ 86011.)

Marshall, C.A., G.S. Gotto, G. Pérez Cruz, P. Flores Rey and G. García Juárez (1996). Vecinos y Rehabilitation: Assessing the Needs of Indigenous People with Disabilities in Mexico. Final Report. Flagstaff: Northern Arizona University. (Available in English and Spanish from the American Indian Rehabilitation Research and Training Center, Institute for Human Development, Northern Arizona University, P.O. Box 5630, Flagstaff, AZ 86011.)

About the Editors and Contributors

The Editors

ASHA HANS is Director of the School of Women's Studies and Professor and Head of the Department of Political Science, Utkal University, Bhubaneswar. A Fulbright Scholar and recipient of the Kathleen Ptolemy Award from York University, Canada, her work has been mainly focused on issues of gender and international relations. Her latest book is *Tribal Women: A Gendered Utopia*.

ANNIE PATRI is currently Spinal Cord Injury Rehabilitation Coordinator at the Shanta Memorial Rehabilitation Centre, Bhubaneswar. She was formerly a Physiotherapist at the Indian Spinal Injuries Centre, New Delhi, where she was associated with the INSPIRE project on rehabilitation and documentation of people with spinal cord injuries. She has presented a number of papers at national and international conferences.

The Contributors

JOSÉ AZOH BARRY is an independent researcher based in Nuevo León, Mexico.

MEENU BHAMBANI is Lecturer of English at Government College, Kishangarh, Rajasthan, India.

EMILY BOYCE is a student of women's studies at York University, Toronto, Canada.

WILLIAM BOYCE is Director of the Social Program Evaluation Group at Queen's University, Kingston, Canada.

SUSANNE M. BRUYERE is Director of the Program on Employment and Disability at the School of Industrial and Labor Relations, Cornell University, USA.

MADELEINE A. CAHILL is Associate Professor of Communication at Westfield State College, Massachusetts, USA.

ELIZABETH P. CRAMER is Associate Professor, School of Social Work, Virginia Commonwealth University, USA.

ANN DARNBROUGH is a social activist based at London, England.

ELIZABETH DEPOY is Coordinator of Research and Evaluation at the Center for Community Inclusion and Professor at the School of Social Work, University of Maine, USA.

VANDA DIGNANI is National Board Member of the Italian Union of the Blind and Partially Sighted Women, Rome.

MICHELLE LA FONTAINE (d. 2002) was a freelance writer based at Oak Park, Victoria, Australia.

STEPHEN FRENCH GILSON is Associate Professor, School of Social Work, University of Maine, USA.

CLAUDIA SANTIAGO GONZÁLEZ is a disability consultant based at Oaxaca, Mexico.

JACQUELINE HUGGINS is Programme Officer of the National Alcohol and Drug Abuse Prevention Programme, Trinidad and Tobago.

LOURDES GARCÍA JUÁREZ is a disability consultant based at Oaxaca, Mexico.

SANDHYA LIMAYE is Lecturer at the Department of Family and Child Welfare, Tata Institute of Social Sciences, Mumbai, India.

SALMA MAQBOOL is Chairperson of Projects Pakistan Foundation Fighting Blindness, Islamabad.

CATHERINE A. MARSHALL is Director of Research at the American Indian Rehabilitation Research and Training Center, Northern Arizona University, USA.

MOBILITY INTERNATIONAL USA (MIUSA) is a non-profit organization whose mission is to empower people with disabilities around the world and to ensure their inclusion in international exchange and development programmes.

MARTIN F. NORDEN is Professor of Communication at the University of Massachusetts-Amherst, USA.

LINA PANE is Locum Social Worker for Specialist Care Services, Australia.

SHOBA RAJA is Research and Policy Analyst at BasicNeeds, Bangalore, India.

RENATE REYMANN is National Board Member of Deutscher Blinden und Sehbehindertenverband, Bonn, Germany.

STEPHANIE K. TAKEMOTO is a researcher at the University of California, Irvine.

Index